W9-CZV-250

CONSTRUCTING WORLDS

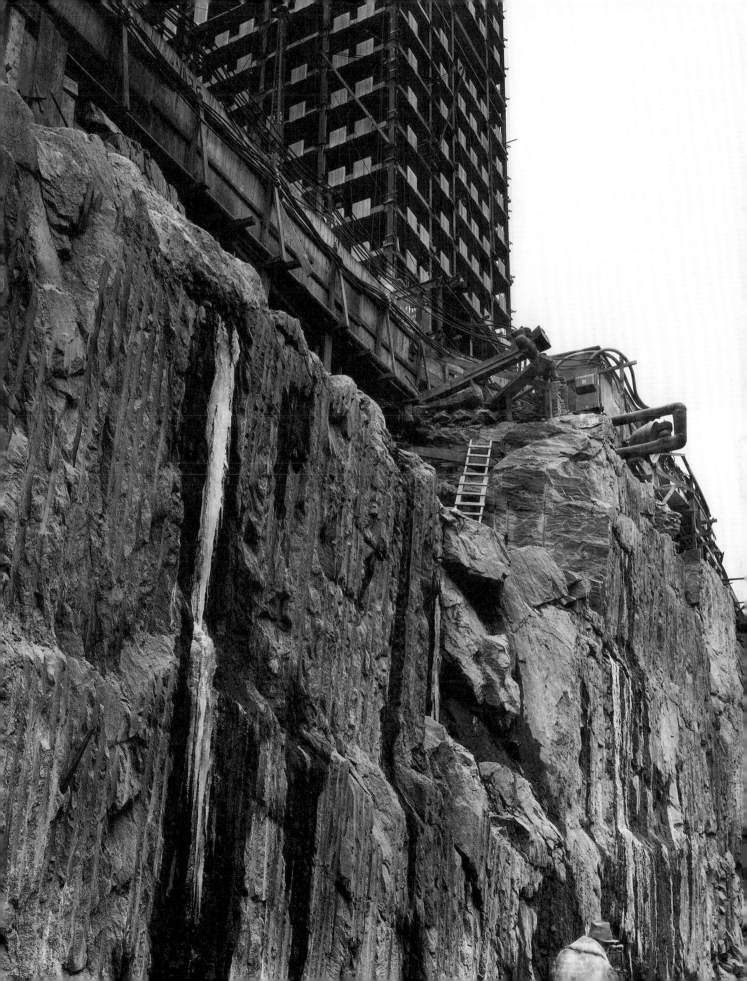

Edited by
Alona Pardo and Elias Redstone

PHOTOGRAPHY AND
ARCHITECTURE
IN THE MODERN AGE

Barbican Art Gallery

PRESTEL
Munich • London • New York

GRAHAM FOUNDATION

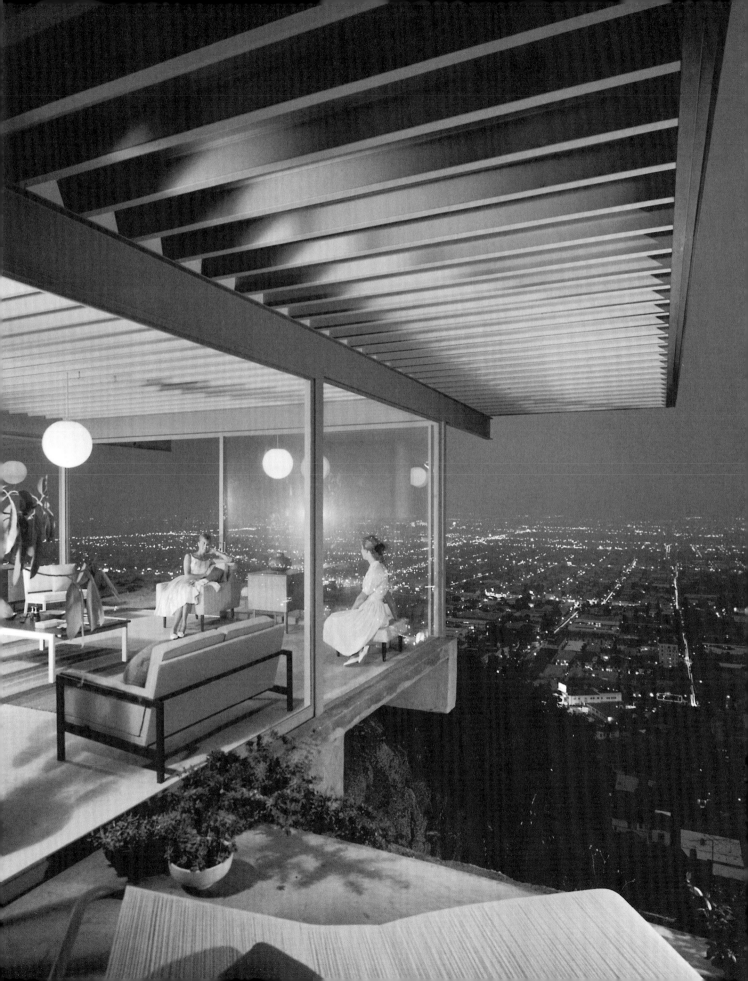

This edition published on the occasion
of the exhibition

Constructing Worlds:
Photography and Architecture in the Modern Age

Exhibition curated by
Alona Pardo and Elias Redstone

Barbican Art Gallery, London
25 September 2014 – 11 January 2015

Swedish Centre for Architecture and Design, Stockholm
20 February – 17 May 2015

barbican **ArkDes**

CONTENTS

13 Foreword

17 Introduction

27 Architecture as Photography: document, publicity, commentary, art — by David Campany

41 Berenice Abbott

53 Walker Evans

69 Julius Shulman

81 Lucien Hervé

95 Ed Ruscha

107 Bernd and Hilla Becher

121 Stephen Shore

137 Thomas Struth

151 Luigi Ghirri

167 Hélène Binet

177 Hiroshi Sugimoto

187 Luisa Lambri

197 Andreas Gursky

207 Simon Norfolk

219 Guy Tillim

231 Bas Princen

243 Nadav Kander

255 Iwan Baan

269 Essay Notes

273 Bibliography

278 Authors' Biographies

279 Credits

FOREWORD

People, architecture and landscape have dominated the photographic image, but it is architecture that unites the three, as the most significant, undeniable and often monumental and enduring trace of our presence on the planet. Consequently, since the very first photograph, architecture has proved to be a seductive subject for photographers. It has changed the way we think about architecture and even the way architects work.

This book, *Constructing Worlds: Photography and Architecture in the Modern Age*, a companion to the Barbican Art Gallery exhibition of the same name, brings together the work of eighteen extraordinary photographers who have been selected for their outstanding image making, in which architecture is both the protagonist and a silent witness. As such, the exhibition looks beyond the medium's ability simply to document the built world and explores the power of the photographic medium to reveal something else — something about who we are and the future that we are constantly shaping. Bringing together works from the sub-tropical landscape of eastern and central Africa to the sprawling metropolis of Los Angeles and the megacities of São Paulo and Shanghai, the works in *Constructing Worlds* delight and shock in equal measure.

Beginning with Berenice Abbott's ground-breaking photographs charting the birth of the skyscraper in New York, *Constructing Worlds* takes the reader on a global journey of twentieth and twenty-first century architecture, including: Lucien Hervé's subtle evocations of modernity as found in Chandigarh, by Le Corbusier; the luxury lifestyle of Julius Shulman's images of California's residences; the moving nature of Daniel Libeskind's Jewish Museum Berlin as seen by Hélène Binet; the recent dramatic growth of Chinese urbanisation recorded by Nadav Kander and the devastating effects of war in Afghanistan as expressed in the poignant images of Simon Norfolk.

Photography, with its unique ability to observe, record and document the great sea changes of our times, has been a hugely important part of our programme since the Barbican Centre first opened in 1982 – indeed for many years we were one of the few public spaces in Britain to promote the medium. The principal photography exhibitions for which we have been responsible include thematic surveys: 'American Images: Photography 1945–1980' (1984); 'Through the Looking Glass' (1989); 'Beyond Japan; A Photo Theatre' (1991); 'All Human Life' (1994); 'Who's Looking at the Family' (1994); 'African Photography' (1999) and more recently, 'In the Face of History: European Photographers in the Twentieth Century' (2006) and 'Everything Was Moving: Photography from the 60s and 70s' (2012).

These overviews have been complemented by a host of exhibitions devoted to solo figures at the forefront of the medium, beginning with Cecil Beaton and Eugene Smith (1986), Ansel Adams (1987), William Eggleston (1992) Bill Brandt (1993), Don McCullin (1997), David Bailey (1999), Martin Parr (2002), David LaChapelle (2002), Sebastião Salgado (2003) and Araki (2005) among others. Our passion for photography continues unabated.

Barbican is an increasingly appreciated iconic London landmark, something we seek to celebrate at every turn. The muscular hand-chiselled concrete walls and columns that characterise our public and exhibition spaces have almost necessitated that architecture and design should be a central plank in our programme. Solo exhibitions devoted to Daniel Libeskind (2005) and Alvar Aalto (2007) have co-existed with more nuanced curated shows such as 'Future City' (2006) and the cross-disciplinary and cross-generational 'The Surreal House' (2010) the first exhibition to explore the relationship between the architecture of domestic spaces and Surrealism.

Curatorially, we seek always to look at subjects afresh and see creativity as a porous, active force pollinating across and beyond borders. Viewed in this light, 'Constructing Worlds' was an exhibition and publication waiting to happen and it transpires that it is the first major study in the UK to probe this fertile territory. The old categories of social documentary and art photography are increasingly colliding, and architectural photographers who have built careers creating exceptional photographic imagery for clients in the industry are here seen as equals alongside photographic artists who have made architecture and the built environment more generally a major focus of their work.

An exhibition of this scale and complexity would not have been possible without the generosity and support of international museums, collections and galleries as well as individuals, including: Craig Krull Gallery, Los Angeles; David Campany, London; Eredi Luigi Ghirri, Reggio Emilia; Fondation Le Corbusier, Paris; Fondation Lucien Hervé, Paris; Getty Research Institute, Los Angeles; Howard Greenberg Gallery, New York; Library of Congress, Washington DC; Michael Hoppen Gallery, London; Monika Sprüth, Cologne; National Galleries of Scotland; New York Public Library, New York; Stephen Parnell, Sheffield; and Tate, London.

We are indebted, as ever, to the artists and photographers who have generously agreed to participate in this ambitious exhibition, including Iwan Baan, Hilla Becher, Hélène Binet, Andreas Gursky, Nadav Kander, Luisa Lambri, Simon Norfolk, Bas Princen, Ed Ruscha, Stephen Shore, Thomas Struth, Hiroshi Sugimoto and Guy Tillim. Our special thanks extend to their representatives who have made these loans possible: 303 Gallery, New York; Flowers Gallery, London; Gagosian Gallery, London/Beverly Hills; Matthew Marks Gallery, New York; Pace Gallery, New York; Sprüth Magers, London/Berlin; Stevenson Gallery, Cape Town; and Thomas Dane Gallery, London.

Our thanks are due to the eminent photography historian and curator David Campany for his insightful essay, and to the writers and curators who have contributed such lively texts on the individual photographers. We are also very grateful to Lincoln Dexter of Prestel Publishing, for his expert guidance in the execution of this book, and to Stefi Orazi for the book's elegant and confident graphic treatment. Equally we are grateful to the Graham Foundation for Advanced

Studies in the Fine Arts for their generous support of this publication. We would like to thank Kersten Geers and David Van Severen, with the invaluable assistance of Samuel Genet, of OFFICE who were engaged at an early stage of this project and have played a vital role in transforming the gallery into an exquisite architectural environment.

After London, the exhibition will travel to the Swedish Centre for Architecture and Design in Stockholm, which represents a new and important partnership for us. It is always refreshing to find like-minded institutions, and we are delighted that the exhibition, which we have nurtured so carefully into existence, will reach a new and discerning audience in Sweden.

Last but most definitely not least, I would like to thank Alona Pardo, Associate Curator at Barbican Art Gallery, and Elias Redstone, co-curator, for their vision and consummate professionalism. Ana Martinez, Assistant Curator, has organised this project expertly and diligently with the invaluable support of Exhibition Assistants Anna Ferrari and Tatjana LeBoff.

Jane Alison
Head of Visual Arts
Barbican, London, July 2014

INTRODUCTION

Alona Pardo and Elias Redstone

Since the earliest days of photography, architecture has been the medium's most willing accomplice. The long exposures required by the first cameras favoured the immobile and static attributes of buildings, making them a far more reliable subject than the human figure. This symbiotic relationship, partly born of necessity, has remained a constant in the history of photography and photographers — from the amateur to the professional — still feel compelled to document our ever-changing world in an effort to champion, critique and preserve the architectural present.

Charting this long and shared history, 'Constructing Worlds: Photography and Architecture in the Modern Age' brings together the work of eighteen exceptional photographers, who despite working across an expanse of time and space, are united in their determination to observe and record the complex environment in which we live.

The understanding that photography which takes architecture as its subject matter has the ability to communicate wider truths about society is fundamental to the work presented in this publication. It stands in direct opposition to conventional notions of architectural photography; that is, photography with the function to describe a building accurately so as to be understood and appreciated by as wide an audience as possible.

The exhibition traverses a broad spectrum of photographic approaches, from the commissioned architectural photography of Lucien Hervé and Hélène Binet, to the conceptual strategies of Ed Ruscha and Bernd and Hilla Becher, and the documentary realism of Walker Evans and Iwan Baan. However diverse their aesthetics, each artist or photographer challenges the orthodoxy of architectural photography, by not simply interpreting the intentions of the architects, but by revealing through the photographic medium the lived experience and symbolic value of our built world.

Although they are presented chronologically, intersecting themes and interests connect the artists and photographers across different generations and geographies. Mediating a range of aesthetic, personal, social, political and spatial relationships between the architectural subject, the photographer and the viewer, the works explore the urban and the suburban, the city and the street, the iconic and the mundane, military architecture and the architecture of authority, as well as mass urbanisation and globalisation.

The rise of the modern

Taking the viewer on a global journey through the twentieth and twenty-first centuries, the exhibition takes as its starting point the interwar years of the 1930s. This period was marked by economic, political and social uncertainty that saw unprecedented industrialisation and modernisation as well as the crippling economic crisis of the Great Depression in the USA, which sent shockwaves across the globe. Against this unstable backdrop, both Berenice Abbott and Walker Evans, living and working in New York, went on to create two iconic bodies of work that defined their age, Abbott with *Changing New York* (1935–39) and Evans with his work for the Farm Security Administration (1935–36). Turning their backs on the prevailing aesthetic of pictorialism, which they openly criticised for obscuring the 'real' in favour of creating a manipulated image, rather than simply recording it, Abbott and Evans introduced a photographic language that was distinctly modern in its very directness.

Abbott had learnt the art of photography in Paris, from her employer and mentor Man Ray. She returned to New York bringing with her not just European photographic sensibilities but also the archive of the grandfather of photographic Modernism, Eugène Atget, which she had acquired shortly after his death in 1927. Abbott recognised in Atget's images of Paris, as art historian Molly Nesbit notes, his ability to fill 'inhuman architectural photography with human experience'.[1] The same ambition drove both Abbott and Evans — to whom Abbott introduced Atget's work — in their documentation of New York and the Deep South.

Taking her cue from Atget, and struck by the photogenic qualities of New York, Abbott's images of this unequivocally modern metropolis captured a skyline punctuated by skyscrapers, which served as a metaphor for vast wealth. Abbott's photographs, with their dramatic angles, sought to interrogate this new urbanity by confronting the gritty underbelly, capturing the tenement blocks that reflected the city's social reality.

While Abbott was documenting the grand site of Modernism, Evans was on assignment for the Farm Security Administration, travelling through Alabama, Georgia, Louisiana and South Carolina, photographing the vernacular architecture characteristic of the Deep South — modest timber churches, street scenes, shops and signs. Evans's images reveal the hardship faced by Depression-era rural communities and can be read as a scathing commentary on American values.

Universally acknowledged as introducing an objective documentary approach to photography, which went on to influence a generation of photographers across the USA and Europe during the 1960s and '70s — among them Ed Ruscha, Stephen Shore and Bernd and Hilla Becher — Evans's indexical strategy highlighted commonalities and variations in architectural forms and presented a highly personal vision of architecture.

The post-war period ushered in a spirit of optimism in terms of photographic practises, embracing the seductive possibilities of colour photography and its subsequent widespread use in the illustrated press, which presented architecture as framing a contemporary lifestyle. Equally, Modernist architecture that reconciled rapid technological advancement with the modernisation of society gained in popularity after the Second World War.

1 Nesbit, Molly, *Atget's Seven Albums*, New Haven, CT: Yale University Press, 1992, p 192

Closely aligned with Californian Modernism, Julius Shulman became the poster boy for architects such as Charles and Ray Eames, Richard Neutra and Pierre Koenig, as they sought to promote their brand of Modernism. Carefully composed and artfully lit, Shulman's images promoted not only new approaches to home design but also the ideal of Californian living — a sunny, suburban lifestyle played out in sleek, spacious homes featuring glass, pools and patios, populated with the social archetypes of the day.

Whilst the exhibition starts resolutely in the USA, the Modernist project was not the exclusive preserve of the West. As Europe's empires collapsed after the Second World War, the wave of countries becoming independent was without precedent or parallel: one hundred new nations came into existence in the early 1960s alone. At the beginning of the 1950s, the first prime minister of independent India, Jawaharlal Nehru, commissioned the renowned Swiss-French architect, Le Corbusier, to design Chandigarh, a model city intended to symbolise a new India that embraced modernity and democracy.

An amateur photographer himself, Le Corbusier understood and harnessed the power of photography to articulate his personal vision. In 1949, when he was introduced to the work of Lucien Hervé, Le Corbusier proclaimed that he had the 'soul of an architect', and went on to collaborate with him for almost two decades, until the architect's death in 1965. Working in expansive series, as opposed to relying on a single image to represent Le Corbusier's architectural imaginings, Hervé's images portray the spirit of places rather than the actual buildings. Renowned for his contact sheets, which were hand cut and annotated, Hervé's process solicited a creative dialogue with the architect about how his buildings should be consumed and mediated. Hervé's contact sheets from his visits to Chandigarh in 1955 and 1961 record not only the completed buildings but also the process of construction itself: construction workers bathed in shards of light, forests of steel rods and the abstracted geometry of Le Corbusier's built works.

Celebrating the vernacular

The cultural and ideological mood shifted radically in the 1960s, giving way to a general malaise which manifested itself in photographic terms with artists seeking to reflect the everyday experience of the built world: here car parks, deserted streets and industrial ruin take centre stage. Influenced by the documentary tradition of Walker Evans, the artists discussed here are joined not only by their objective or 'no-style' photographic language, but also by their representation of peripheral spaces and structures.

Ed Ruscha's photographs of cultural curiosities, which took the form of swimming pools, gasoline stations, apartment blocks and parking lots familiar to the southern Californian landscape, were never intended to be exhibited as singular prints but were gathered together in a series of carefully designed photobooks. Infused with a cool aesthetic and in stark opposition to Julius Shulman's lavish colour photographs, Ruscha's third photobook, *Some Los Angeles Apartments* (1965) drew attention to the similarities and differences of his urban environment. Walker Evans's influence on the young Ruscha is evinced in this body of work, where images of sun-baked facades

and signage are taken as neutrally as possible, with buildings shot from across the street, more often than not with a frontal view, and deliberately excluding the human form.

Employing a device hitherto used to survey and map the chaos of the city, the aerial photographs presented in *Thirtyfour Parking Lots in Los Angeles* (1967) — taken by photographer Art Alanis on instructions by Ruscha — depict a sprawling metropolis resolutely defined by the motorcar. Their topographical and abstract nature questions American society's pervasive reliance on the automobile, which not only informed the shape of cities and roadside architecture, but more significantly led to the cult of the road trip being absorbed into American culture.

Fascinated by the empty suburban back streets and garish mass culture of 1970s America, Stephen Shore's explosive colour photographic series *Uncommon Places* (1973–79) examines the everyday world in unprecedented detail. This kind of intense focus had previously been reserved for grand landscape photographers, such as Ansel Adams, yet under Shore's photographic gaze the prosaic and mundane are elevated to the same status. Rather than focus on the dramatic mountains and lakes he passes on his epic road odyssey, Shore recounts the banal architecture that often interrupts the view.

Architectural photography in the strictest sense does little to articulate social space, and the studies by Bernd and Hilla Becher of factories, gas holders, water towers and other industrial sites were very deliberately denuded of people, function and activity. Rather, the Bechers appreciated the inherent beauty of these incredible objects, which they referred to as 'anonymous sculptures'. Their formal approach to photography over the last five decades is perhaps the logical apotheosis of Walker Evans's influence and has produced a comprehensive taxonomy of industrial structures that occupies a critical position in the intersection of photography, art and architecture. The legacy of the Bechers is also found in the practice of their students at the Kunstakademie in Düsseldorf, including the artists Thomas Struth and Andreas Gursky.

Recalling Atget's photographs of nineteenth-century Paris, Thomas Struth's early black-and-white deserted street scenes give rise to comparisons of urban phenomena on a global scale. Developed over long periods and across diverse locations, from London to Shanghai, Naples to Pyongyang, Struth's iconic series *Unconscious Places* (1977–2012) is a typological examination of urban space, revealing cultural nuances in the way streets are designed and occupied. His images of New York in the 1970s are particularly poignant, depicting the city in the trough of financial ruin.

Reflections on architecture

While the thrust of this essay has focused on photographers who by and large take an empirical approach to the recording of space, artists such as Luigi Ghirri, Luisa Lambri, Hiroshi Sugimoto and Hélène Binet have adopted a radically different critical position to their subject matter. These photographers have been inspired to interpret the work of modern and contemporary architects, providing layers of narrative and meaning to the physical space as a way of understanding

the architect's intentions in relation to the lived reality. The work touches on notions of iconography in architecture — challenging a building's perceived fame or infamy while at the same time reasserting its iconic status.

Working predominantly in Northern Italy in the 1970s and '80s, Luigi Ghirri employed photography as a tool to map the world around him. His lyrical colour images stand out against a European tradition of black-and-white photography and capture the iconic landscape of Italy in a tightly cropped, almost geometrical grid. A magazine commission to document architect Aldo Rossi's San Cataldo Cemetery in Modena was the catalyst for an ongoing and fruitful dialogue between Ghirri and Rossi based on shared conceptual and intellectual interests. Taken by the geometric forms and 'unpredictable vitality' of Rossi's architecture, Ghirri photographed his buildings across the region, taking a particular interest in their placing in the landscape.

Paying attention to intimate architectural details, and offered in response to the celebration of form and facade in so much architectural photography, Luisa Lambri's photography emerges from a curiosity about how people inhabit modern buildings. Having spent time in houses designed by Luis Barragán, Richard Neutra, Alvar Aalto and other Modernist architects, her photographs can be read as self-portraits, reflections on her own movement through space, with reference to the work of performance artists such as Francesca Woodman. Lambri's rejection of the often celebrated and recognisable exteriors of buildings in favour of presenting unfamiliar and often overlooked aspects of their interiors such as corners, windows and cupboards leads to unconventional readings of space. Frank Lloyd Wright's ambitious Californian Hollyhock House, for example, is distilled to a single surface: a glistening expanse of gold paint on a wall.

Hélène Binet's predominantly black-and-white photography has roots in the work of early modern photographers such as Lucien Hervé. An exploration of light and shadow in space, Binet's approach consists of creating suites of images which, when assembled as a series, construct a virtual experience of the whole. Her studies of fragments of Daniel Libeskind's Jewish Museum in Berlin are inescapably bound up with the history that the building was designed to memorialise. The photographs, taken as a trespasser while the museum was under construction, present Deconstructivist architecture in its purest form as a metaphor for the trauma and fractured history of the Jewish people.

Hiroshi Sugimoto reflects on some of the most iconic buildings of the twentieth century, from Le Corbusier's Villa Savoye to Frank Lloyd Wright's Solomon R Guggenheim Museum in New York, in an attempt to trace the emergence of the modern age through architecture. His blurred forms erode the facades and evoke the passage of time, muting the architectural details to offer an essence of the building. Sugimoto's images soften the concrete walls and harsh angles of Modernism, entombing the architecture in the process.

Bridging the transition to the final part of the exhibition, which explores contemporary urban conditions, Andreas Gursky's singular monumental photographs of individual buildings draw attention to collective behaviour in contemporary global cities, best exemplified perhaps by *Paris, Montparnasse* (1993). The photograph represents the Mouchotte Building, Paris's largest purpose-built residential block, designed by Jean Dubuisson in 1959, and a landmark project in the

history of post-war brutalist architecture. Composed by combining two photographs into a single composition, the image presents the viewer from afar with a giant patchwork block of an apartment building and close up with the representation of each little rectangle, in which the viewer can identify curtains and glimpses of interior details and inhabitants. The digital manipulation conveys an impression of impersonality and highlights the duality that lies at the very heart of the building and the image itself: with the facade presenting a closed, harsh Modernist exterior that hints simultaneously at the individuals who inhabit this unique place and the collective nature of that lived experience.

Cities in change

For the first time in history, more than half of the world's population now lives in cities and urban populations are likely to swell to 5 billion people by 2030. While the urban environment has proved a popular subject throughout the twentieth century, with attention focused on American and European cities, recent waves of urbanisation are providing new sites of research as the majority of urban growth is to be found in Asia and Africa. The final bodies of work in the exhibition are by photographers who document the shifting morphologies and infrastructures that have resulted from urbanisation and globalisation and who reflect on the contemporary experience of developing cities.

In the spirit of Berenice Abbott's documentation of New York in the 1930s, London-based photographer Nadav Kander has conducted a project to research changing landscapes across China, a country transforming at an unprecedented rate. Over a period of three years, Kander took multiple trips to chart the course of the Yangtze River from its mouth on the East China Sea to the source in the Himalayans and the cities through which it passes. His epic photographic project documents the lived experience of a country in the process of modernisation in a thought-provoking way, juxtaposing local inhabitants with the colossal architectural structures that permeate the ever-shifting landscape.

Kander does not appear to place himself within the subject directly, in the way that the presence of Lambri or Ghirri is felt in their narrative constructions, but stands back as an outsider. The small-scale figures in his photographs seem to reflect the helplessness of the individual amidst such colossal change and, although not overtly political at first glance, the apparently romantic images are imbued with dark undertones: the haze that hangs over the landscape, creating images evocative of JMW Turner or German Romanticism, is unnatural and the result of industrial pollution. While the scale and speed of transformation in China is hard to comprehend, Kander's images go some way to marking the changing landscape and illustrating the impact it is having on everyday lives.

Considering Africa's urban environment, Guy Tillim's acclaimed body of work *Avenue Patrice Lumumba* (2007–08) takes as its starting point the Congolese city of Kinshasa and its late-Modernist-era colonial buildings to explore architecture's power to transmit memory and the utopian dreams latent in these decaying structures. Equally, Simon Norfolk's project *Chronotopia* (2001–02) and his *Burke + Norfolk* series (2010–11) show how the scars of the past are revealed

in the architectural present. Photographing in Afghanistan in 2001, prior to the US military invasion, and again in 2010, Norfolk travelled with his cherrywood plate camera recording the charred and twisted remains of destroyed buildings that represent the desolation of war, the impermanence of civilisations as represented through architecture, as well as our fetishisation of the architectural and cultural ruin.

Urban transformations in Turkey and the Middle East are the subject of Bas Princen's photographic project *Refuge, Five Cities* (2009). Princen employs photography as a tool to research and critique changes in the built environment and, in a similar manner to the New Topographics, focuses his attention on the urban peripheries to explore how cities are expanding and taking new forms. Shooting in Istanbul, Cairo, Amman, Beirut and Dubai, Princen shifts his attention between gated suburbs and the worker camps that are driving urban expansion, to record the spatial and social polarisation increasingly evident in the contemporary city.

Iwan Baan's documentation of a 45-storey skyscraper in Caracas focuses on a single site to celebrate people's ability to adapt to contemporary urban conditions. Torre David has remained uncompleted since the Venezuelan economy collapsed in 1994 and has since been occupied by over 750 families who have carved out homes and created an informal vertical community, which provides an alternative model to the favelas through the reuse of redundant office buildings. The redemptive transformation of the tower into a residential and mixed-use environment also resonates with current issues of housing demand in London and other major cities, where questions are being raised over the supply of housing and provision of sustainable models for urban living. This body of work is especially poignant as, at the time of writing, officials have begun relocating residents to a new social housing complex outside Caracas.

Architecture and cities are shaped by man and in turn shape our lives. While the work presented in 'Constructing Worlds' spans a phenomenal period of change, from the 1930s to the turn of the twenty-first century, it is clear that many of the subjects and themes addressed are prevalent today: the economic and political forces shaping our built environment, the physical manifestation of communities, and the symbolic value and lived experience of architecture. Presented together, the photography in the exhibition sharpens our reading of architecture and urban environments as metaphors for the society that inhabits it.

ARCHITECTURE AS PHOTOGRAPHY: DOCUMENT, PUBLICITY, COMMENTARY, ART

David Campany

'Everyone will have noticed how much easier it is to get hold of a painting, more particularly a sculpture, and especially architecture, in a photograph than in reality.'[1]
Walter Benjamin

It may not be possible to 'get hold of' a building, at least not in the way that it might be possible to get hold of a painting or a sculpture. But through photography one might be able to get hold of architecture. By this I mean, and perhaps the cultural critic Walter Benjamin meant, that while a physical building is owned and used, a photograph of it is able to isolate, define, interpret, exaggerate or even invent a cultural value for it. We might go so far as to say that the cultural value of buildings is what we call 'architecture' and that it is inseparable from photography.

Walter Benjamin was writing in 1931, a decade or so into the expansion of the modern mass media. Via illustrated magazines and books, photography was establishing and spreading cultural value. Anything and everything was to be photographed and arranged on the page as a new and perhaps spurious kind of 'visual knowledge'. Just as Benjamin went on to suggest that the kind of art that will triumph will be the kind of art that looks good in photographic reproduction, architecture will not escape the same fate. In fact he concluded that buildings might be the ultimate art works in this new regime of the image. Of all the fine and applied arts it is built form that has the most to lose to photography (because the camera can never capture it, never 'get hold of' it) but as a consequence it also has the most to gain.

Emerging in Europe after the First World War, Modernist architecture travelled unevenly but globally via the printed page. For example, the establishment of what came to be called the International Style could not have happened without the photographic press. Moreover, it is often argued that it was through Modernism that architecture became profoundly, perhaps irreversibly complicit with its camera image. Architects began to design with photographic representation in mind and for good or bad the public began to understand the built world around them in photographic terms.[2]

We should remember that the mutual attraction of photography and architecture goes back to the very earliest camera pictures. Nicéphore Niépce's *View from the Window at Le Gras* (1826–27) was a lucid demonstration of the new medium's consummate translation of three dimensions into two, although it lacked the detail that soon became so characteristic. Here is Sir John Robison responding to his first view of a group of fine Daguerreotype images in 1839:

'The perfection and fidelity of the pictures are such that, on examining them by microscopic power, details are discovered which are not perceivable to the naked eye in

Joseph Nicéphore Niépce, *View from the Window at Le Gras*, 1826-27 (as documented in 2003)

the original objects, but which, when searched for there by the aid of optical instruments, are found in perfect accordance; a crack in plaster, a withered leaf lying on a projecting cornice, or an accumulation of dust in a hollow moulding of a distant building, when they exist in the original, are faithfully copied in these wonderful pictures.'[3]

In noting the cracks and dust, Robison had grasped that the technology of photography belonged to a different order from the aged world around it. Even so, that aging — patina and ruination — was thoroughly photogenic. Through the camera an old building would be subject to 'a clash with a time not its own.'[4] Since then, photography has been put to use recording the world's older buildings and ruins. It has also been used to document and promote new constructions that very much do belong to the time and technology of photography: Victorian bridges and glasshouses, monuments and towers in steel, high-rises and high-tech buildings.

Time and surfaces

While Modernist architecture celebrated industrial smoothness, Modernist photography explored a heightened interest in the surfaces of the world. A gleaming facade and the cracked hands that built it offer themselves up equally to a perfected lens and a glossy print or page. In 1924, Edward Weston, the supreme artist-technician of the high-modern photographic surface, declared: 'The camera should be used for a recording of life, for rendering the very substance and quintessence of the thing itself, whether it be polished steel or palpitating flesh.'[5] The same year, László Moholy-Nagy spoke of photography's rendering of 'the precise magic of the finest texture: in the framework of steel buildings just as much as in the foam of the sea.'[6] And in 1930 Pierre Mac Orlan observed: 'On the photosensitive plate, polished steel finds a still sleeker interpretation of its shining richness.'[7]

Mac Orlan was writing in a book of photographs by Eugène Atget. Those pictures contained no polished steel. To the contrary, Atget had turned his camera on the remnants of old Paris that had escaped the clash with the modern wrecking ball: old cafés and shop fronts, specimens of historic architecture, conjunctions of buildings accumulating over centuries into ad hoc neighbourhoods. Atget understood the urban fabric as something that exists over generations and is altered by use and weather. Photography and architecture were for him complex repositories of time. There was plenty of polished steel elsewhere in modern cities such as Paris, and plenty of photographers who saw their medium as its publicist or go-between.

Atget made his images quietly, usually on commission but also for himself. He may not have considered photography to be art but it was certainly an art. The medium was unique in its allowing for the intelligent balance of document and interpretation. Atget made images that seemed to lack explicit motive but shared a general condition of openness — a rhetorical muteness, let us say — that awaited completion by whoever bought and used them (industrial designers, urban planners, artists). The Surrealists appreciated Atget's evocation of a haunted city with its architecture at once inhabited

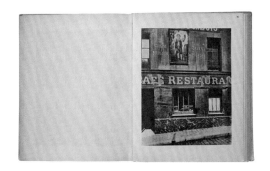

Plates from *Atget: Photographe de Paris*, Eugène Atget, 1930

Plate 64, 'Frivolités, Boulevard Haussmann, Paris' from *Boutiques*, 1929

Plate 2, 'Paris', 1927, from *MÉTAL*,
Germaine Krull, 1928

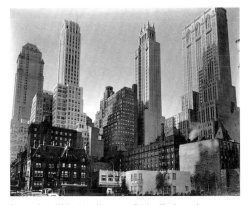

Berenice Abbott, *House of the Modern Age,
Park Avenue & 29th Street*, October 1936

Spread from 'Photographic Studies',
Walker Evans, in *Architectural Record*,
September 1930

and seemingly dispossessed. And they saw something of their desire for subversion (and subversion of desire) in those laconic and unadorned vistas.

Atget lived on the same street as Man Ray whose darkroom assistant, Berenice Abbott, was captivated by Atget's pictures. Upon his death in 1927, Abbott acquired a substantial part of Atget's archive. She took it back to New York where she exhibited it, published two books of it and eventually bequeathed it to the Museum of Modern Art.[8] Atget's contemplative disposition struck a chord with those seeking a more reflective relation to architecture, modern time and the city. The 1929 American stock market crash and ensuing crises sharpened the political and social consciousness of many artists. As a result, an equivocal take on progress — looking askance or awry at the white heat of modernisation — became an important part of serious photography. When Berenice Abbott began her own urban documentation in 1935, it was very much in the spirit of Atget. She published her grand project in 1939 as *Changing New York*. She wrote: 'How shall the two-dimensional print in black and white suggest the flux of activity of the metropolis, the interaction of human beings and solid architectural constructions, all impinging upon each other in time?' Abbott mixed images of new buildings with older examples, making bold views in which Manhattan's layered epochs of beauty and ugliness, of boom and bust, were laid bare. A striking example is *House of the Modern Age, Park Avenue & 29th Street* (October 1936).

Beneath a cluster of towers of varying merit nestles a two-storey show home built with the latest techniques and equipped with state-of-the-art gadgets. The public paid 10 cents each to visit the ten-thousand-dollar house, erected on a million-dollar vacant lot. The house was temporary but Abbott's photograph preserves the event and offers a pause for reflection. While America's offices went skyward, its homes would sprawl laterally to become an endless suburbia. The theatrical singularity of that show home belies the sheer quantity and formulaic repetition that came to dominate twentieth-century housing.

Abbott was friendly with Walker Evans, who took up photography in the late 1920s. At first the giant architecture of Manhattan attracted him. He made celebratory images of soaring verticals, dynamic angles and grid-like facades. They were reminiscent of the European New Vision photography of Moholy-Nagy and others, but like Abbott he soon stepped back to develop a more circumspect attitude. Modish affectation gave way to a more neutral, less forced way of thinking and photographing. He focused on provincial towns away from the extravagance of the big cities. A commission to record Victorian houses around Boston allowed him to develop his approach. In 1933 the results were exhibited, essentially as documents, in the Architecture Galleries of the Museum of Modern Art.[9] Five years later, Evans was the first photographer to be given a solo exhibition in his own name at MoMA, and more than half of his one hundred prints were architectural.

Evans understood that photography and architecture are related sign systems. Gathered as archives or arranged as sequences, images of buildings could be a path toward sophisticated statements about a society and the ways it pictures itself. He used his large-format camera to cut out and miniaturise facades as surfaces to be read.[10] The reading can be literal, symbolic or metaphorical, not least because

so often his photographs included writing and commercial signage. Such images can be understood as found montages that make thinkable the new tensions of modern life. Consider *Atlanta, Georgia. Frame Houses and a Billboard* (1936). Beyond the formal elegance of the picture it is a document thick with information. It shows a brutal barrier shielding houses from the noise of the growing number of automobiles. The porches of the grand but fading homes now have a blocked view, while the upper balconies overlook a charmless strip. The movie billboards lining the barrier are designed not for the residents but to catch the eye of passing motorists. Between the houses we glimpse the flat roofs of more recent buildings, and on the right there is a light-industrial chimney. Despite some architects' dreams of grand plans, it is pragmatism and happenstance that have defined the look of most of our towns. Evans played off his cool and steady gaze against the speed of unpredictable change, drawing attention to the composition of the world rather than his own compositional prowess. Measured, reflective and unforced, his photographs do not chase after progress: they study its visible symptoms.

Evans swung wide the doors for generations of photographers. *American Photographs*, the book that accompanied his 1938 exhibition is still in print. One can work in this idiom anywhere without risk of imitation, or the anxiety of influence. For example, Thomas Struth's city studies of the 1970s echo Evans' generosity of seeing and his attention to the telling minutiae of the streetscape.[11] But perhaps the clearest inheritor has been Stephen Shore, whose photographs made across the Midwestern United States in the 1970s share Evans' affection for American vernacular culture.[12] Made on long car trips, Shore's photographs treat buildings and automobiles as expressions of the same social and economic forces. In 1956 the cultural critic Roland Barthes had declared:

> 'I think that cars today are almost the exact equivalent of the great Gothic Cathedrals: I mean the supreme creation of an era, conceived with passion by unknown artists, and consumed in image if not in usage by a whole population which appropriates them as a purely magical object.'[13]

The aesthetic and principles of manufacture of any epoch are common to all its products. Modernity merely accelerates and integrates this. As a consequence, its architects have often been designers of other things as well: furniture, cars, trains, planes, electrical appliances, clothes and graphics. Figures as diverse as Charles Rennie Mackintosh, Mies van der Rohe, Frank Lloyd Wright, Charles and Ray Eames and Raymond Loewy were all exponents of this approach.

Photography is often at its most complicit when it is recruited to turn the constructed worlds of integrated design into promotional images. Julius Shulman was one of the most adept photographers of Modernist environments. It is through his commissioned images that we have come to 'know' the work of Richard Neutra, Charles and Ray Eames, Pierre Koenig, John Lautner, Rudolf Schindler, Raphael Soriano and Frank Lloyd Wright among many others. Forms of architecture and design that have already internalised the look and cultural value of photography are distilled by Shulman into media-friendly icons. But nothing dates more acutely than high style. Like modish advertisements in old copies of *Life* magazine, Shulman's photographs share

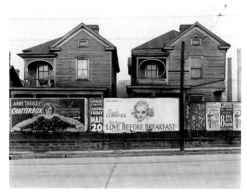

Walker Evans, *Atlanta, Georgia. Frame Houses and a Billboard*, 1936

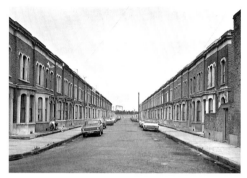

Thomas Struth, *Clinton Road, London*, 1977

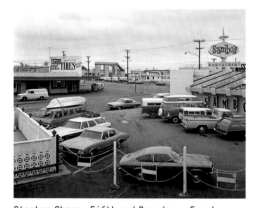

Stephen Shore, *Fifth and Broadway, Eureka, California, September 2, 1974*

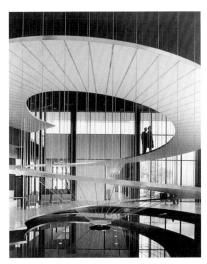

Julius Shulman, *Convair Astronautics*, *San Diego*, 1958

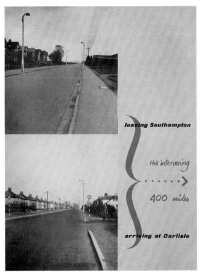

leaving Southampton

the intervening

...... >

400 miles

arriving at Carlisle

Spread from 'Outrage', June 1955, special issue of *The Architectural Review*, edited by Ian Nairn

the same aspiration as the designed worlds they represent and are subject to the same historical fate. Today such images do not so much promote as stand as documents of the taste and values of an era.

Second thoughts

It should be said that the architectural profession has always had misgivings about the cosy relationship between buildings and photography, and there has always been dissent. Sometimes it has taken the form of polemics against the conventions of architectural photography.[14] Other criticisms have emerged more implicitly within visual essays by architects and writers. For example, between the 1950s and 1970s Ian Nairn wrote excoriating attacks on the shortcomings of UK architects and planners, as well as heartfelt defences of places and ideas that were endangered or out of favour. His texts were often complemented by deliberately perfunctory images devoid of arty ingratiation. One of his most influential tirades was 'Outrage', a special issue of *The Architectural Review* from June 1955. Nairn railed against what he called the Subtopia of the post-war English landscape: '[A] mean and middle state, neither country nor town, an even spread of abandoned aerodromes and fake rusticity, wire fences, traffic roundabouts, gratuitous notice-boards, car-parks and Things in Fields.' Throughout the issue, deadpan snapshots embody the laziness, cynicism and lack of vision Nairn attempts to diagnose. Sometimes a couple of photos and a caption do it all. A notorious page of 'Outrage' carries two near-identical views down unloved streets, one captioned 'leaving Southampton', the other 'arriving at Carlisle', with the entire length of England implied between.

Just as the discipline of art history has intermittent doubts over its use of photography as innocent reproduction, so the field of architecture has sustained an important current of reflection about its use of images. In some respects the critical discourses established in the architectural press of the post-war decades paved the way for the rise of architecture in much wider discussions of culture, politics, art and value. This in turn led several architects to understand their own practices in broader cultural terms. In 1972, Robert Venturi, Denise Scott Brown and Steven Izenour published *Learning from Las Vegas*, a provocative call for architects to be more in tune with popular taste. The profession should be less heroic, less snobbish and more accepting of context and pragmatism, they argued. And they should not have their heads in the sand about the relation between money, built form and image (something perfectly explicit in Las Vegas!). The book's mix of text and photographs placed it in a long line of widely read but serious architectural manifestos that goes all the way back to Le Corbusier's *Vers une architecture* (1923), published in English as *Towards a New Architecture* (1927). While some see *Learning from Las Vegas* as an apology for raw capitalism and the market's dictation of the environment, it can also be read as a critique of all that. In architecture the line between the genuinely popular (i.e. democratic) and the populist (pandering to lowest common denominators of value) is particularly fine and requires constant vigilance.

Extending their ideas, Venturi, Scott Brown and Associates staged 'Signs of Life: Symbols of the American City' at The Smithsonian Institution, Washington DC in 1976. The exhibition approached the

American urban scene as a complex puzzle in need of decoding. Many towns had become postmodern collages of architectural quotation: English village windows and Italianate brackets sharing facades with colonial ironwork and classical balustrades. In the gallery space various images were placed in relation to real objects (neon signs, furniture, pieces of architecture). Stephen Shore, who was then deep into his photography of vernacular towns and buildings, was commissioned to make documents. A number of these were blown up and presented as near life-size substitutes for American streetscapes.

Like Atget, Abbott and Evans before him, Stephen Shore was interested in photographing the present for the benefit of the future. Such a task keeps the photographer alert to the interrelation of all the different components that may co-exist in an urban scene. He explains:

> 'There is an old Arab saying, "The apparent is the bridge to the real." For many photographers, architecture serves this function. A building expresses the physical constraints of its materials: a building made of curved I-beams and titanium can look different from one made of sandstone blocks. A building expresses the economic constraints of its construction. A building also expresses the aesthetic parameters of its builder and its culture. This latter is the product of all the diverse elements that make up "style": traditions, aspirations, conditioning, imagination, posturings, perceptions. On a city street, a building is sited between others built or renovated at different times and in different styles. And these buildings are next to still others. And this whole complex scene experiences the pressure of weather and time. This taste of the personality of a society becomes accessible to a camera.'[15]

Or, as the television critic A A Gill puts it, 'the built landscape is the great pop-up lexicon of who we are, humanity's diary. It's what we thought and hoped for.'[16] Yet we cannot assume that being accessible to the camera means the built landscape can be interpreted easily. Over centuries, architecture evolved symbolic languages that allowed buildings to declare their purpose, or at least codify it. Churches looked like churches, houses looked like houses, banks looked like banks and so on. However, with the beginnings of Modernism this began to be replaced by the idea that built form should follow function, along with a truth to the materials used. While this might imply a certain clarity or honesty, the modernising impulse also homogenises, tending towards rationalised modular forms that often cut the ties between function and legibility. This has been felt equally in the 'high' architecture of prestige buildings and the 'low' architecture of social housing and the factory. The modern show home photographed by Berenice Abbott in 1936 used the same principles as the modern office. In the knee-jerk reaction against such anonymity however, decoration often becomes purely cosmetic. Venturi, Scott Brown and Izenour called this the 'decorated shed', but decorated or not, the shed has become a source of anxiety about the run-away forces of rationalisation. Is it what we want everywhere, for everything?

Cover of *Learning from Las Vegas*, Robert Venturi, Denise Scott Brown, and Steven Izenour, 1972

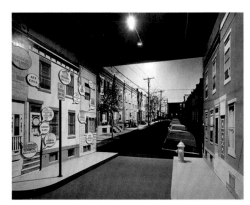

Exhibition installation view, showing photographs by Stephen Shore, of *Signs of Life: Symbols of the American City*, The Smithsonian Institution, Washington DC, 1976

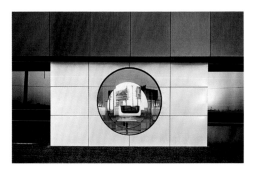

Lewis Baltz, 'North Wall Steelcase 1123 Warner Avenue Tustin', 1974, from *The New Industrial Parks near Irvine, California*, 1974

Recodings

In his quintessentially postmodern movie, *True Stories* (1986), David Byrne plays a wide-eyed guide to a world in which surface and meaning have come apart almost entirely. 'This is the Varicorp building, just outside Virgil', he tells us. 'It's cool. It's a multipurpose shape. A box. We have no idea what's inside there.' Byrne's disarmingly jolly delivery suggests something is wrong. A decade or so earlier, the California-based photographer Lewis Baltz had come to the same conclusion. His series *The New Industrial Parks near Irvine, California* (1974) documents the exteriors of small and medium sized industrial units of the kind we now find clustered on the edges of all modern cities. They are erected quickly according to standardised systems and designed to suit as many commercial needs as possible. The sparsely decorated exteriors give a thin illusion of calm and continuity. In reality the units can be rented to businesses long- or short-term, depending on the volatility of markets. This is Baltz describing his project:

> 'I was born in one of the most rapidly urbanising areas in the world: Southern California in the post-war period. You could watch the changes take place; it was astonishing. A new world was being born there, perhaps not a very pleasant world. This homogenised American environment was marching across the land and being exported. And it seemed nobody wanted to confront this. I was looking for the things that were the most typical, the most quotidian, everyday and unremarkable. And I was trying to represent them in a way that was the most quotidian, everyday and unremarkable. I certainly wanted to make my work look like anyone could do it. I didn't want to have a style; I wanted it to look as mute, and as distant as to appear to be as objective as possible ... I tried very hard in this work not to show a point of view. I tried to think of myself as an anthropologist from a different solar system ... What I was interested in more was the phenomena of the place. Not the thing itself but the effect of it: the effect of this kind of urbanization, the effect of this kind of living, the effect of this kind of building. What kind of people would come out of this? What kind of new world was being built here? Was it a world people could live in? Really?' [17]

Shot in deep focus and fine detail, Baltz's images are highly descriptive, even analytical. Across his series of fifty-one images, the distances between the camera and the subject are kept consistent, as is the light. Frontal and rectilinear, these pictures do not appear to contest the presumed objectivity of photography. Indeed, they provide as good a record as any of the surfaces of the things in front of Baltz's lens. Instead the problem of representation is displaced on to the world itself: what can we know when the appearance of our environment tells us so little about its meaning and function? As Baltz himself put it: 'You don't know whether they are manufacturing pantyhose or megadeath'.

Baltz came to prominence around the same time as Bernd and Hilla Becher, who photographed in a similar manner but were

interested in buildings where function was still inscribed in form and legible: lime kilns, cooling towers, blast-furnaces, winding towers, water towers, gas holders and silos. In a 1970 publication of their work, they state:

> 'We show objects predominantly instrumental in character, whose shapes are the results of calculation, and whose processes of development are optically evident. They are generally buildings where anonymity is accepted to be the style. Their peculiarities originate not in spite of, but because of the lack of design.'[18]

That book was titled *Anonyme Skulpturen (Anonymous Sculpture)* and through it the Bechers' work came to occupy a pivotal place at the intersection of photography, architecture and art. Its reception as art was part of a complex re-embracing of the typological series by a culture fraught with suspicion about utopian rationality. In such a setting, these cool photographic studies associated the documentary image less with the older 'new sobrieties' of the 1920s and '30s that they clearly echoed, than with the newer ambivalence of Minimalist sculpture and Conceptual Art.[19] The serial blankness of their work looked considered and random, didactic and obtuse, familiar and odd, smart and dumb. Most artists using photography at the time were opting for the dulled aesthetic of the anonymous, 'deskilled' amateur, but working in the guise of trained technicians the Bechers presented an equally rich puzzle for art. Their series or grids of highly crafted images erased all traces of signature style, while even their choice of subject matter was intriguing. Those industrial structures had no place in the official discourses of architecture, let alone art. Since then of course the interest shown in the vernacular by contemporary art, and the interest shown in the vernacular and contemporary art by architecture has grown immeasurably, along with the canonical status of the Bechers' work.

Nevertheless, it would be misplaced to assume that the Bechers' work was particularly of its time. In fact the difficulty of defining its time seems to be the source of its enduringly slippery fascination. Beyond subject matter, the characteristic feature is the even, flat light. In such light buildings are, as Richard Sennett put it in a discussion of the work of Thomas Struth, 'endowed with a life all their own'.[20] Weak light makes for wilful buildings, renders them insistent but inscrutable. Light is usually the animator of the world and photography its captor, but when the light refuses to animate the world appears dead, and the task that befalls the photographer is not to 'shoot' so much as embalm. To photograph in milky light is to photograph a world that appears to have already been plucked from time.[21]

That Northern Europe, the cradle of modernity's hurtling progress is for much of the time bathed in a light that almost eliminates shadow may not be without significance. This was the preferred light for much of the rationalised and informational imagery produced in the nineteenth century, where the absence of shadow was equated with impartial judgment. Clear, soft illumination was construed as liberating the world from the prejudice of chiaroscuro and the drama of shadows. Revelling in the wealth of visible detail made available, positivist science deduced objectivity from the inscrutable, and clarity of knowledge from the clarity of appearances. The Bechers stare at

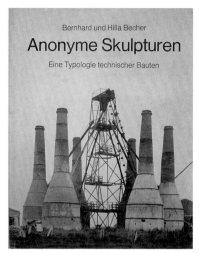

Cover of *Anonyme Skulpturen: Eine Typologie technischer Bauten*, Bernd and Hilla Becher, 1970

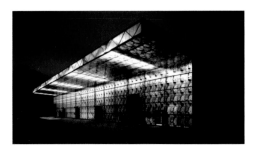

Thomas Ruff, *Ricola, Mulhouse*, 1994

things with an air of objectivity so outside fashion that their subjects almost stare back. Resisting the spectacle and modish artifice that has preoccupied Western art since Pop, they have extended and deepened the potential complexities of the impassive 'document as art' that were first sensed in the 1920s. Their work belongs to art and transcends it too. Moreover photography's ticket into the art of the last hundred years has been its flirtation with non-art and the document. The Bechers' anonymous photography of anonymous architecture fits this perfectly.

The photograph transformed

Through their teaching in Düsseldorf and through their profile in contemporary art, the Bechers have influenced generations of photographers interested in architecture. However, much of the work made in their wake has courted art much more openly and lost a degree of ambiguity on the way. For example while the Bechers infer the sculptural, much of Andreas Gursky's globetrotting output often makes quite explicit reference to it, while the sheer size of his monumental gallery prints affords them an obvious status as exhibitable objects.

Thomas Ruff's architectural imagery, typified by a photograph of Herzog & de Meuron's Ricola building in Mulhouse-Brunstatt, France, operates at a similar scale and is a complex example of the ever-closer alliance between those who make buildings and those who photograph them. In fact the Ricola building features a surface design derived from a photograph of a leaf by Karl Blossfeldt who, along with August Sander and Albert Renger-Patzsch in the 1920s, had championed the New Vision photography inherited by the Bechers. However, Ruff photographs this building at night, with the additional drama of artificial light under an acid purple sky. His image is a document, an art work and an advertisement.

Charting the increasing dominance of photography in the making, promotion and experience of architecture, the American cultural critic Fredric Jameson drew a distinction between what he saw as the openness of the architect's drawn plans and the closed tyranny of the photograph:

> 'The project, the drawing, is ... one reified substitute for the real building, but a "good" one, that makes infinite utopian freedom possible. The photograph of the already existing building is another substitute, but let us say a "bad" reification — the illicit substitution of one order of things for another, the transformation of the building into the image of itself, and a spurious image at that ... The appetite for architecture today ... must in reality be an appetite for something else. I think it is an appetite for photography: what we want to consume today are not the buildings themselves, which you scarcely even recognise as you round the freeway ... [M]any are the postmodern buildings that seem to have been designed for photography, where alone they flash into brilliant existence and actuality with all of the phosphorescence of the high-tech orchestra on CD.'[22]

Jameson was writing in 1991, at the cusp of a profound transformation that well-nigh collapsed the distinction between architectural design and photographic imaging. At that time several architectural firms were at the forefront of the development of computer software that would enable not just new methods of design but new modes of presentation and publicity. Today, buildings are often preceded by photorealist renderings that even mimic the characteristics of traditional lens-based images such as flare, differential focus and converging verticals. Construction sites are encircled with mural-sized depictions of buildings to come. These are photographic images with a future tense: this architecture will be.

Temporarily at least, the latest global recession has betrayed many such promises. For her series *London Dust*, Rut Blees Luxemburg has photographed the hoardings around the site of The Pinnacle, in the City of London, a particularly high-profile casualty of the halt on new construction in Europe. The planned 300-metre-high tower has stalled at the seventh floor. *London Dust* (2013) shows the glossy publicity fading and besmirched by the city's incessant grime.

Rut Blees Luxemburg, 'Aplomb',
from *London Dust*, 2013

The simulation of buildings can also be concrete. After eighteen months of negotiations, in 2005 Adam Broomberg and Oliver Chanarin secured access to a very secret place. Codenamed 'Chicago', it is a mock Arab town built by the Israeli Defence Force for training in urban combat. Hidden from view by the inhospitable Negev desert, 'Chicago' was where the Israeli military practiced its destruction of Palestinian settlements. Granted a matter of hours to photograph the facility, the duo chose the clearest and most optimal views; but rather than grounding this concrete reality, the extreme objectivity of their pictures has an unexpected effect. They flip us into the register of hyper-real simulation of the kind we associate with the aesthetics of 'virtual reality'. These are the forced monocular perspectives typical of violent video game graphics with their surveying 'point of view' shots. Indeed, the photographs share something of the video game's status as model — a fantasy of worldly control. What took place in 'Chicago' was the safe rehearsal of imaginary mastery, yet these photographs are also documents of a real place which now no longer exists (the Israeli military has since destroyed it and built a new training site).

Adam Broomberg and Oliver Chanarin,
Chicago #2, 2006

With its rather corporate connotations, computer-generated imaging remains largely a tool of mainstream practices, but there are examples of more overtly critical and resistant use. In 2009 the artist Victor Burgin was invited to make a piece of work in response to the city of Istanbul.[23] After several visits he became interested in the Taşlik coffee house and garden, constructed in 1947–48. Designed by Sedad Hakki Eldem, on a site overlooking the Bosphorus, it blends elements of seventeenth-century Ottoman architecture with twentieth-century Modernism. It was open to everyone. Then in 1988 it was dismantled to make way for a luxury Swissôtel. Part of the coffee house was re-built but in a different position, and now serves merely as an orientalist tourist restaurant. Working from drawings and photographs, Burgin resurrected the building virtually.[24] A 3D model conjures it up in all its democratic glory. Presented as a video projection titled *A Place to Read*, camera movements in and around the space are intercut with texts weaving together historical anecdotes and fictions that encourage the viewer to consider a brief moment in Istanbul's passage from Empire to contemporary global capitalism. 'A woman at the opening of the installation at the Archaeological Museum in

Stills from *Bir okuma yeri / A Place to Read*, Victor Burgin, 2010

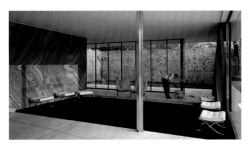

Jeff Wall, *Morning Cleaning, Mies van der Rohe Foundation, Barcelona*, 1999

Polly Braden, 'Appold Street', 2006, from *London's Square Mile*, 2005–2013

Istanbul was in tears', recalled Burgin, 'she had known the original coffee house as a child.'[25] Burgin's imagery promised no 'proof' in the traditional photographic sense, yet it elicited the same emotional charge. An image can resonate no matter what its material or technological base.

The revisiting of a lost building through archival documents also informs Jeff Wall's photograph *Morning Cleaning, Mies van der Rohe Foundation, Barcelona* (1999). The pavilion, designed by Mies van der Rohe for the 1929 International Exposition in Barcelona, is now a Modernist touchstone. It has a particularly complicated relationship with photography. Rather than housing an exhibit, the structure was intended to be the exhibit, a showcase for Mies' architectural thinking and 'an ideal zone of tranquility', as he put it, set apart from the bustle of the Exposition. It was also intended to be temporary and within a year it was taken down. However, in the ensuing decades its reputation grew, largely through photographs and the consolidation of Mies' reputation. In 1983 reconstruction began using photographs and original plans. The pavilion reopened in 1986 and in the 1990s several artists were invited to make responses to it, including Victor Burgin, Jeff Wall, Hannah Collins and Günther Förg. Wall photographed a man named Alejandro, one of the team of three responsible for keeping the pavilion clean. The morning routine was shot every day for two weeks, always from the same camera position. Wall's colour photograph is a composite image that allows all the detail of the shadows and highlights produced by the strong morning sun to be rendered correctly (something that is beyond a single exposure). The image still celebrates the building but it also sets itself apart. Unlike architectural photography of the 1920s, the point of view here is offset from the pavilion's geometry. Moreover, Wall pictures the space as a site of both 'high' contemplation and 'low' work. The cleaners must arrive and leave before the pavilion opens to the paying public. We see the black carpet is rucked, soap bubbles slide down the glass and the 'Barcelona Chairs'— designed by Mies for this building — are shifted out of place. This is a commentary on the legacy of high Modernism. As Wall himself notes:

'[These] buildings require an especially scrupulous level of maintenance. In more traditional spaces a little dirt and grime is not such a shocking contrast to the whole concept. It can even become patina, but these Miesian buildings resist patina as much as they can.' [26]

In some respects Wall's photograph is akin to one taken by Polly Braden for her recent series *London's Square Mile* (2005–2013). Through sunlight bouncing off glass offices we see a solitary man on a flight of steps. This is one of London's many corporate plazas, not far from the site of The Pinnacle, discussed earlier. Neither public nor entirely private, such in-between spaces are proliferating in many cities. Later in the day thousands of employees from London's financial markets will stream down those steps, but this man, alone in the early hours in a crumpled suit with a cigarette and plastic bag, is out of place. Perhaps he is taking a shortcut from one of the nearby social housing estates.

Such photographs are complex meditations on an all too familiar tension between architectural aspiration and lived experience. They

show us idealised spaces populated not by idealised occupants or affluent consumers but by those who often remain invisible. Somehow, somewhere along the line, powerful architecture lost sight of the democratic goals of its modern citizenry. Far too often we find ourselves at odds, or in deadlock, with the built world around us.

Pasts and futures

If we accept that the experience of architecture may now be inseparable from the experience of its imagery, and that photography may now belong to the very same networks of spectacle, it becomes clear that an independent and critical photography of architecture is as vital as it is endangered. My essay thus far has attempted to track something of this critical spirit from its origins in the 1920s. I end with an example that might point us toward future possibilities.

In 2009 the Swiss artist Jules Spinatsch photographed the annual Ball at the Vienna Opera House (the Wiener Staatsoper). Completed in 1869, the style of the building is typically neo-Renaissance, but its form is an idealised expression of mid-nineteenth century spectacle and power. By that time, opera had become an integral part of the social calendar for Europe's high society and political elites. The plan optimises the number of boxes viewable from each box and from the seats in the stalls. Since 1935 the annual Opera Ball has had an international standing as a rather smug and self-congratulatory dressing-up party for the day's dubious mix of politicians, businessmen, debutantes and imported celebrities. In the long and luxurious evening, attendees prop up their reputations and grease the wheels of power with an appeal to 'tradition'. Since the 1960s, the ball has been picketed by various groups objecting to its outdated values. Inside there is barely any need for a performance: all the seats in the stalls are covered over by a ballroom floor, while tiers of extra boxes are erected on the stage to complete the narcissistic, self-gazing circle. In 2009 Spinatsch suspended two interactive network digital cameras in the centre of the Opera House. They were programmed to track incrementally, taking in the entire space, ceiling to floor. One image was recorded every three seconds between the start of the Ball at 8.32pm and its conclusion at 5.17am: 10,008 photographs in total. While doing so, the cameras together completed two full rotations, so every spot in the opera house was covered exactly twice during the evening.

In 2011 Spinatsch installed his results as a 360° panorama in Vienna's Resselpark, Karlsplatz. The images were arranged as a chronological grid, the beginning of the evening wrapping around to meet its end. However, instead of placing the spectator at the centre surrounded by the view, Spinatsch put the panorama on the outside, inverting the space of the Opera House to allow viewers to encircle it. The socially exclusive interior is exposed to a democratic exterior. Subversively then, the cavorting elite is put on display for all of Vienna's citizens to see.

While we ought not overestimate the radicality or 'impact' of Spinatsch's gesture, his rethinking of the twin spectacles of architecture and hi-tech imagery is welcome. And if architecture and photography are destined to remain intertwined then we are obliged ask what it is we want from both.

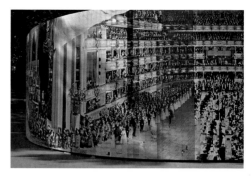

Installation view of the circular panorama
Vienna MMIX – 10008 / 7000, Jules Spinatsch,
Karlsplatz, Vienna, 2011

Notes

1 Walter Benjamin, 'A Little History of Photography', 1931, *Selected Writings: 1931–1934*, translated by Rodney Livingstone and others, edited by Michael W Jennings, Belknap Press of Harvard University Press, 2005, p 523

2 See for example Beatriz Colomina, *Privacy and Publicity: Modern Architecture As Mass Media*, MIT Press, 1996

3 Sir John Robison, 'Perfection of the Art, as stated in Notes on Daguerre's Photography', *The American Journal of Science and Arts*, Vol. 37, No. 1, July 1839, pp 183–185

4 As Denis Hollier put it, 'Like the mutilated classical statue, a photograph seems to result from the art work's encounter with a scythe of real time, showing the bruise imprinted upon an art work by a clash with a time not its own.' See Denis Hollier, 'Beyond Collage: Reflections on the André Malraux of *L'Espoir* and of *Le Musée Imaginaire*', Art Press, no. 221, 1997

5 Edward Weston, entry for 10 March 1924, in *The Daybooks of Edward Weston*, Aperture, 1973, quoted in Nancy Newhall ed., *Edward Weston: the flame of Recognition*, Gordon Fraser, 1975, p 12

6 László Moholy-Nagy, 'The Future of the Photographic Process', *Malerei, Fotografie, Film*, 1925, reprinted in English, MIT Press, 1969, p 33

7 Pierre Mac Orlan, Preface to *Atget: Photographe de Paris*, E Weyhe, 1930. In an article on contemporary photography from 1932, Marcel Fautrad declared: 'Life … is profoundly marked by Metal. METAL. METAL. Cold contact that bristles. And yet "an aesthetic is born of the surrounding need for metal"'. See Marcel Fautrad 'The Poetics of Metal', June 1932, reprinted in Janus ed., *Man Ray: the Photographic Image*, Gordon Fraser, 1977, p 219

8 See *Atget: Photographe de Paris*, E Weyhe, 1930; and Berenice Abbott, *The World of Atget*, Horizon Press, 1964

9 'Walker Evans: Photographs of Nineteenth-Century Houses', Museum of Modern Art, New York, 16 November – 8 December 1933

10 Clement Greenberg suggested that Evans' best pictures had 'backs' i.e. no receding perspectival space. See Clement Greenberg, 'The Camera's Glass Eye: Review of an Exhibition of Edward Weston', 1946, in Clement Greenberg, *The Collected Essays and Criticism, Vol. 2: Arrogant Purpose, 1945–49*, ed. John O'Brian, University of Chicago Press, 1986, pp 60-63. Jean-François Chevrier has called this kind of photograph an 'image-sign, a document-monument', and it recurs throughout Evans' work. Jean-François Chevrier 'Dual Reading' in Jean-François Chevrier, Allan Sekula and Benjamin HD Buchloh eds., *Walker Evans & Dan Graham*, Witte de With, 1992, p 19

11 The long list would also include photographers as diverse as Wilhelm Schürmann, Gabriele Basilico, Simon Norfolk and Sze Tsung Leong

12 Shore was given a copy of Evans' *American Photographs* for his twelfth birthday: 'It feels much deeper than just an influence. When I saw his work I recognised someone who thought the way I would think if I were mature enough to think that way.' See 'Ways of Making Pictures, Stephen Shore in conversation with David Campany', in *Stephen Shore*, Fundacio MAPFRE, 2014

13 Roland Barthes, 'The New Citroën', 1956, in *Mythologies*, 1957, Hill and Wang, 1972. Barthes was prompted to write by the arrival of the streamlined Citroën DS, its curves reminiscent of American designs of the era

14 See for example Michael Rothenstein, 'Colour and Modern Architecture, or 'The Photographic Eye', *The Architectural Review*, vol. XLIV, May 1946; '"Bliss it was in that Dawn to be Alive": An Interview with John Brandon-Jones', *Architectural Design*, vol. 10, no. 11, 1979; and Tom Picton, 'The Craven Image, or The Apotheosis of the Architectural Photograph', *The Architects' Journal*, 25 July 1979

15 Stephen Shore, 'Photography and Architecture', 1997, in Christy Lange et al, *Stephen Shore*, Phaidon Press, 2008

16 AA Gill, 'Brutal honesty is always the best policy', *The Sunday Times*, 2 March 2014

17 Audio interview with Lewis Baltz: www.lacma.org/art/nt-baltz. aspx. The early significance and influence of the *New Industrial Parks* series was secured through its inclusion the in the influential 1975 exhibition and book *New Topographics: Photographs of a Man-Altered Landscape* (along with the work of Bernd & Hilla Becher, Frank Gohlke, Henry Wessel, John Schott, Nicholas Nixon and Stephen Shore). See William Jenkins, *New Topographics: Photographs of a Man-altered Landscape*, International Museum of Photography at George Eastman House, Rochester, New York, 1975

18 Bernd and Hilla Becher, *Anonyme Skulpturen: Eine Typologie Technischer Bauten*, Art Press Verlag, 1970

19 An early article on the Bechers by the Minimalist sculptor Carl Andre two years later cemented the arrival of their work as art. See Carl Andre, 'A Note on Bernhard and Hilla Becher', *Artforum* vol. 11, no. 4, December 1972

20 Richard Sennett, 'Recovery: The Photography of Thomas Struth' in *Thomas Struth, Strangers and Friends*, Institute of Contemporary Arts, London/Institute of Contemporary Art, Boston/Art Gallery of Ontario, Toronto, 1994, pp 91–99

21 It should be said here that there has always been an 'expressive' tradition within the photography of architecture. This is Helmut Gernsheim's little paragraph entitled 'The Weather' from his book *Focus on Architecture and Sculpture, an original approach to the photography of architecture and sculpture*, Fountain Press, 1949: 'It will be evident from the nature of the work that the weather plays a most important role in the architectural photographer's life. Generally speaking, outdoor photographs should not be taken on a dull day: only sunlight lends life to form. The photographer may have to wait for days or even weeks until the conditions are as he wants them, but it will repay the trouble. Sometimes I have spent days at a hotel hoping that the sun would break through, and more than once it happened that I returned to London after several days of fruitless waiting, only to find that the very next day was fine and sunny.'

22 Fredric Jameson, 'Spatial equivalents in the world system' in *Postmodernism, or the Cultural Logic of Late Capitalism*, Duke University Press, 1991, pp 97–129

23 The occasion was the festival *Istanbul 2010: Cultural Capital of Europe*

24 Previously, Burgin had also made a video project in response to the Barcelona Pavilion

25 'Other Criteria: Victor Burgin in conversation with David Campany', *Frieze* no. 155, April 2013

26 Jeff Wall in Craig Burnett, *Jeff Wall*, Tate, 2005, pp 90–91

BERENICE
ABBOTT

──────**Berenice Abbott** (b. 1898, USA; d. 1991) was an artist enchanted by New York City. 'The tempo of the metropolis is not of eternity, or even time,' she wrote in 1935, 'but of the vanishing instant'.[1] A self-taught photographer with formidable resolve, in 1930 she began dedicating a day a week to documenting the city with her Century Universal, the lightest 8×10-inch view camera then available, which she equipped with a 9½-inch Goerz Dagor lens. The Depression made paid work infrequent and she lived a financially precarious existence; only after years of rejections from funders was she able to persuade the Federal Art Project (part of the Works Progress Administration) to take on her assignment. The black-and-white photographs that she took — nearly 1,000 images in total, belonging to 'WPA/FAP project number 265-6900-826', later titled *Changing New York* — went on to define both her career and the age.

Throughout her life, Abbott was an ardent defender of the power of photography as a descriptive medium. She made no secret of despising Alfred Stieglitz and his coterie of aesthetes, deriding pictorialism as 'the making of pleasant pretty pictures in the style of certain minor painters'.[2] She was equally suspicious of impromptu 'snap-shooting' and meticulously researched each of her architectural subjects. *Night View, New York* (1932), a photograph that looks down on to the city's skyscrapers, their lights piercing a cloak of darkness, is a case in point: to achieve this vertiginous, nocturnal composition she knew that there was only one location (the top of the Empire State Building), only one day (the December solstice) and only one hour (between 4:30 and 5:30pm) and still she had to use a special developer for the under-exposed negative.

Raised in Ohio, in 1918, at the age of twenty, Abbott escaped the Midwest for New York in 1918, where she was drawn to bohemian Greenwich Village, America's answer to Montmartre.[3] Odd-jobbing as a waitress and a bit player at the Provincetown Playhouse, she could barely maintain herself and in 1921, with just six dollars in her pocket, she boarded the *Rochambeau* for France.[4] Three years later her fortunes changed when she became a studio assistant to Man Ray. Learning first the skills of the darkroom, she progressed to the camera and began taking portraits of friends, reimbursing Man Ray for materials. This arrangement ended abruptly when well-heeled clients (who could easily afford Man Ray's fee) asked instead to sit for Abbott. Establishing her own studio, she took portraits of James Joyce and Jean Cocteau and in 1926 had her first exhibition at the Galerie Au Sacre du Printemps.

Man Ray introduced Abbott to Eugène Atget, the visionary flanêur of Montparnasse, who sought to document nineteenth-century Paris before the city succumbed to modernisation. Atget's 'documents' (which he sold for between 1 and 3 francs apiece) had a profound impact: he was, for her, 'an urbanist historian, a genuine romanticist … and a Balzac of the camera'.[5] In 1927, she took the only portrait that he ever sat for and when he died that year, she sought out and purchased his archive (1,400 glass plate negatives and 7,800 prints), becoming a life-long champion of his work. Returning to New York in 1929, hoping to find a publisher for the Atget archive, Abbott was struck by how the urban fabric of the city she so loved had changed in her eight-year absence. Inevitably then, the 'realism unadorned' of Atget inspired the spirit of her portfolio of New York.[6]

Abbott's Modernist compositions, with their flattened picture planes and dynamic angles, reflected the vibrancy of the city and New Yorkers seemed to respond to the mirror image she held up. In 1938, a major exhibition was mounted at the Museum of the City of New York and *Life* magazine ran a feature story on Abbott's attempts to capture 'the glory of American urban civilization'.[7] Yet in 1939, just as EP Dutton & Co. were publishing her book *Changing New York*, which was intended to be a guidebook for visitors to the New York World's Fair, the FAP advised that her funding was finished. Abbott dedicated the next twenty years of her life to capturing scientific principles, while sporadically attempting to market photographic inventions and writing instructional guides to photography, such as *The View Camera Made Simple* (1948). Only at the end of her life was she acclaimed as one of the great photographers of her age, and even on her death in 1991, her work remained largely unexhibited outside America.

EN

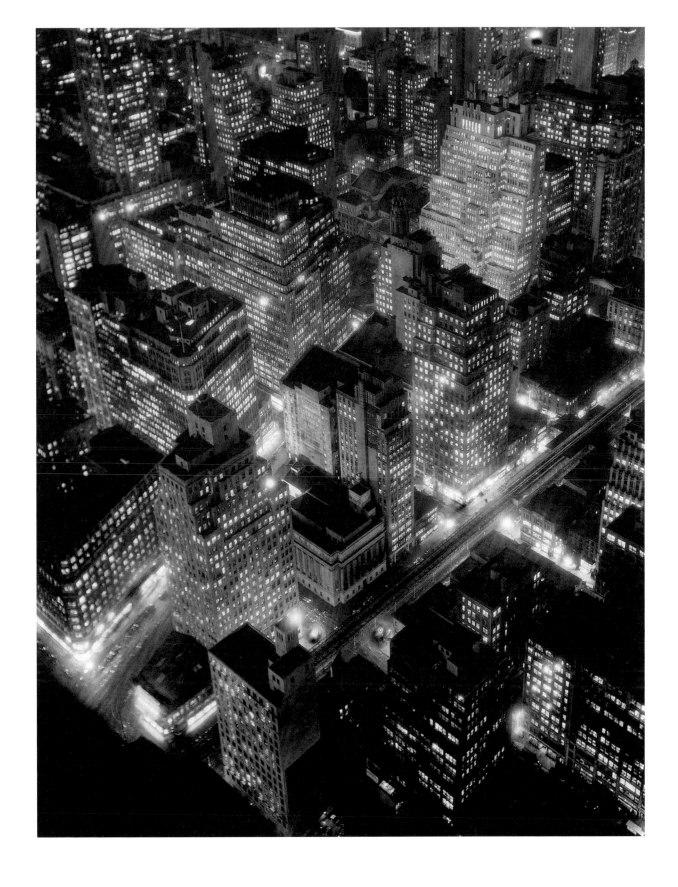

Night View, New York, 1932

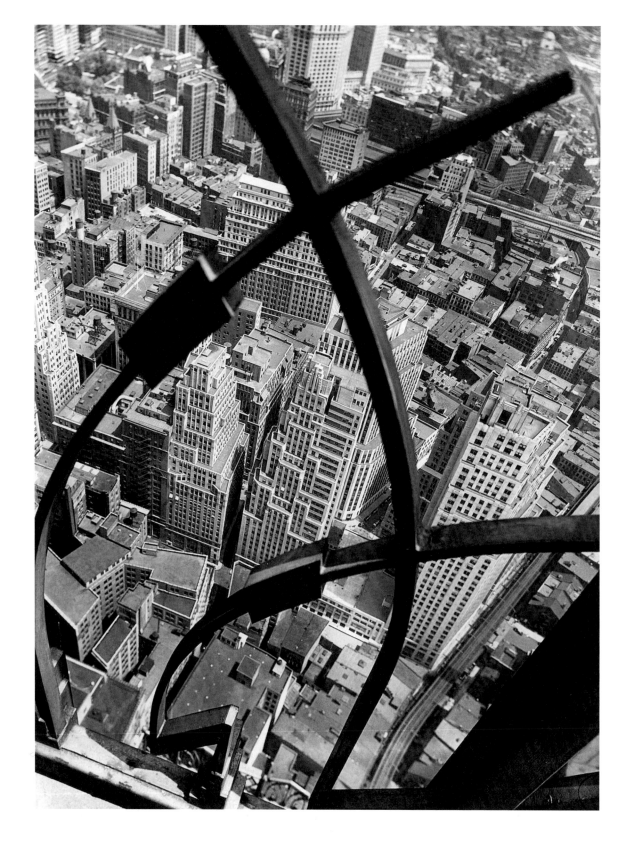

Above:
City Arabesque, June 9, 1938

Right:
Murray Hill Hotel: Spiral, November 19, 1935

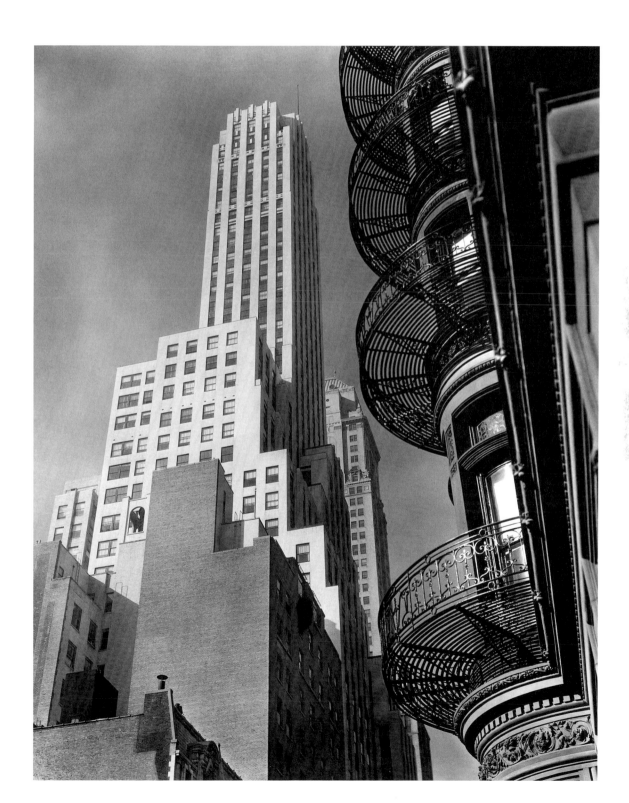

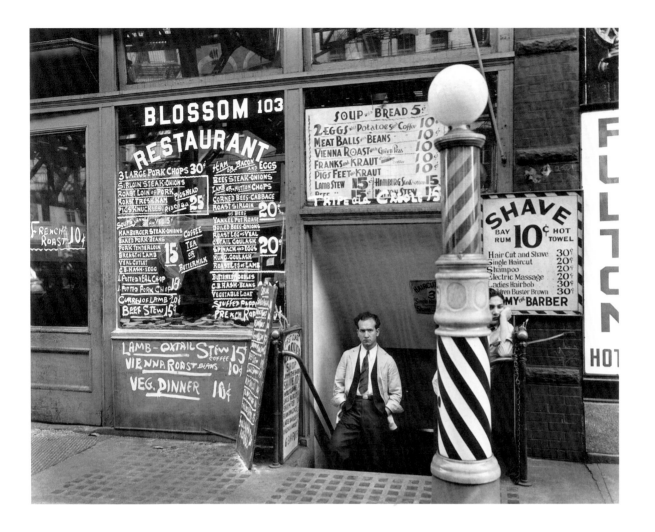

Blossom Restaurant, 103 Bowery, Manhattan, October 3, 1935

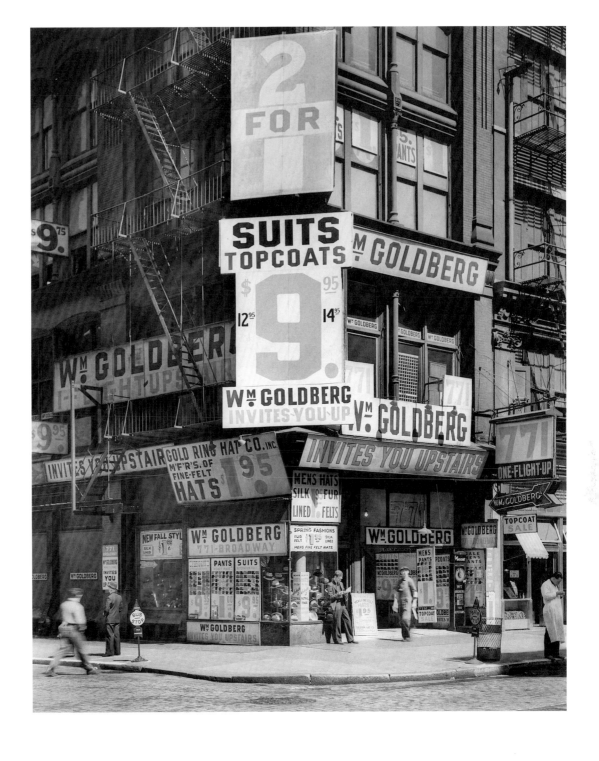

William Goldberg, 771 Broadway, Manhattan, May 7, 1937

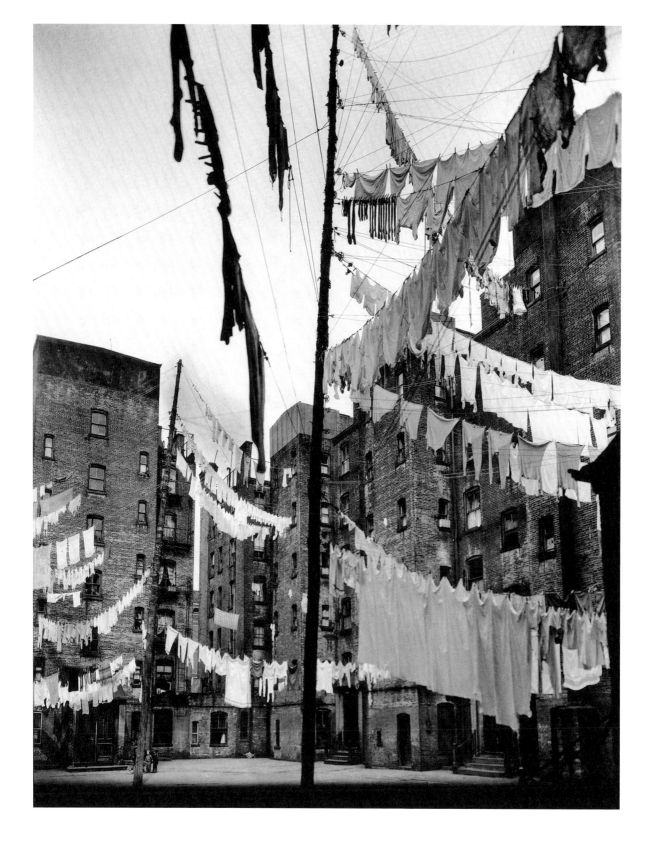

Court of first model tenement house in New York,
72nd Street and First Avenue, Manhattan, March 16, 1936

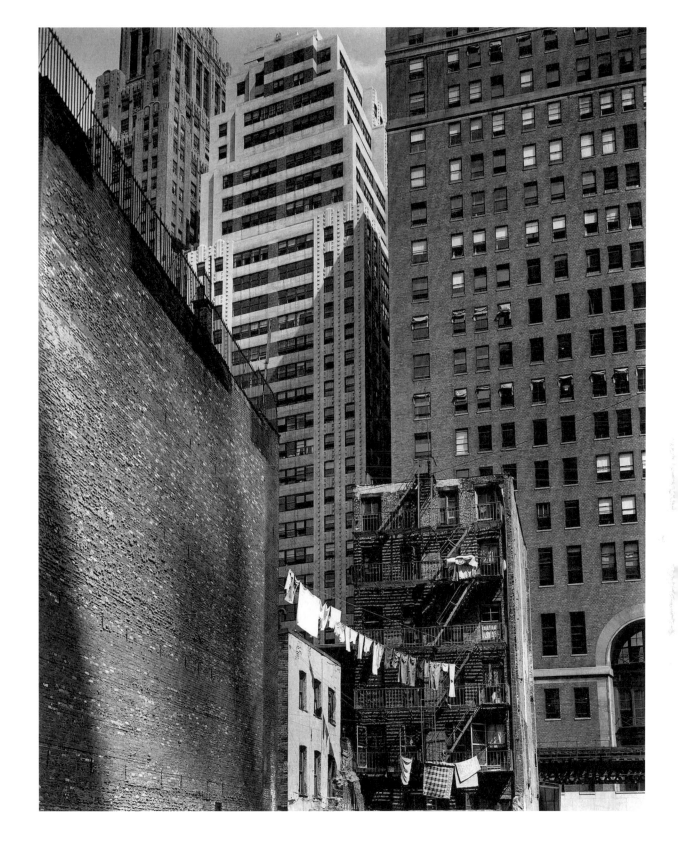

Construction old and new, from Washington Street,
Manhattan, August 12, 1936

WALKER EVANS

———**Walker Evans** (b. 1903, USA; d. 1975) was a frustrated writer who became an impassioned photographer. 'I just caught it, like a disease,' he recalled, 'thought about it and practiced it all the time, day by day'.[1] He began taking pictures in New York in 1928 as a salve for writer's block — a 'left-handed hobby' — but by 1930 he considered it a 'sort of profession'.[2] Inspired by the new idiom of Modernist literature, Evans created spare photographic compositions that could rival an author such as Ernest Hemingway, who boasted of prose 'so tight and so hard that the alteration of a word can throw an entire story out of key'.[3] In 1935, Evans was employed by the Resettlement Administration (RA) of the Department of Agriculture to undertake a survey of rural America; the extraordinary body of work he produced confirmed him to be a laureate of the documentary style.

The project began in 1934, when the wealthy entrepreneur Gifford Cochran, who owned a Greek Revival home in Croton Falls, New York, commissioned Evans to document the finest examples of the architectural style in the South. Within weeks, his patron returned home exhausted with his butler, allowing Evans to stray from his brief. In New Orleans, he captured the elaborate wrought-iron facade of a Spanish-colonial-style building and a Creole woman in a striped blouse framed by the zigzag-decorated doorway of a barbershop. In Louisiana, he broke into a plantation house to photograph the haunting decay of its ornate interior. The project progressed in 1935, when Evans was employed by the Department of the Interior to photograph New Deal subsistence homesteads in the South. Travelling to northern West Virginia, an area described by one journalist as 'the damnedest cesspool of human misery', he caught the apparent paradox of a grubby boy perched in a miner's cabin, insulated with strips of cardboard, garishly advertising products that his family could never afford.[4]

Signage exerted a special influence on Evans, whose father was an advertising executive (he had aspired to be an architect but could not afford the schooling). Born in St Louis, Evans moved to Toledo, Ohio, at the age of twelve, when his father took a job with Willy's Motorcar Company. He found the move traumatic — 'it must have produced a minor psychosis in me' — and was sent to Loomis boarding school, which he endured until he was expelled aged seventeen.[5] A voracious reader, he spent two terms at Williams College in 1922, where he immersed himself in the literary revolution championed by magazines such as *The Dial*. Following in the footsteps of his heroes — notably Ezra Pound and James Joyce — he moved to Paris in 1926, where he attended the French Civilisation course at the Sorbonne and frequented Left Bank bookshops. He returned to New York with a continental disdain for capitalist culture and intrigued by what America had become: as EE Cummings famously wrote, it was now the 'land above all of Just Add Hot Water and Serve'.[6]

A self-confessed Francophile, Evans was seduced by Eugène Atget's 'documents' of turn-of-the-century Paris, to which he was introduced by Berenice Abbott shortly after her return to New York in 1929. Here was a man who toiled without patronage, documenting the cultural essence of a city enshrined in the seemingly ordinary. Atget was the ultimate flâneur, a role defined by Baudelaire as 'an "I" with an insatiable appetite for the "non-I"', at every instant rendering and explaining it in pictures more living than life itself'.[7] Evans's distinctive style — 'straightforward', frontal images — was clearly indebted to Atget, while also emulating the postcards of vernacular architecture that he had collected since boyhood.[8] By the time Evans took up his post as 'Information Specialist' for the RA (later the Farm Security Administration) the influence of Civil War photographer Mathew Brady had also become pronounced. Indeed, one of his final tasks for the RA was to research the collection of 6,000 glass plate negatives acquired by the US War Department from Brady in 1875.

In 1938, Evans became the first photographer to have the honour of a solo exhibition at the Museum of Modern Art in New York. 'American Photographs' included 100 prints, largely dating from 1935–36, collectively presenting his uncompromising vision of the country. As Lincoln Kirstein wrote in his catalogue essay, in these pictures 'with all their clear, hideous and beautiful detail, their open insanity and pitiful grandeur … the physiognomy of a nation is laid on your table'.[9] Evans joined the staff at *Time* magazine in 1945 before becoming the editor of *Fortune*, where he remained for the next two decades. He was a professor at the Yale University School of Art from 1964 until his death in 1975. In 1994 the Walker Evans estate handed over its holdings to the Metropolitan Museum of Art in New York.

EN

Breakfast Room at Belle Grove Plantation,
White Chapel, Louisiana, 1935

View of Morgantown, West Virginia, June 1935

House and Steel Mill, Bethlehem, Pennsylvania, November 1935

Church, Southeastern U.S., 1936

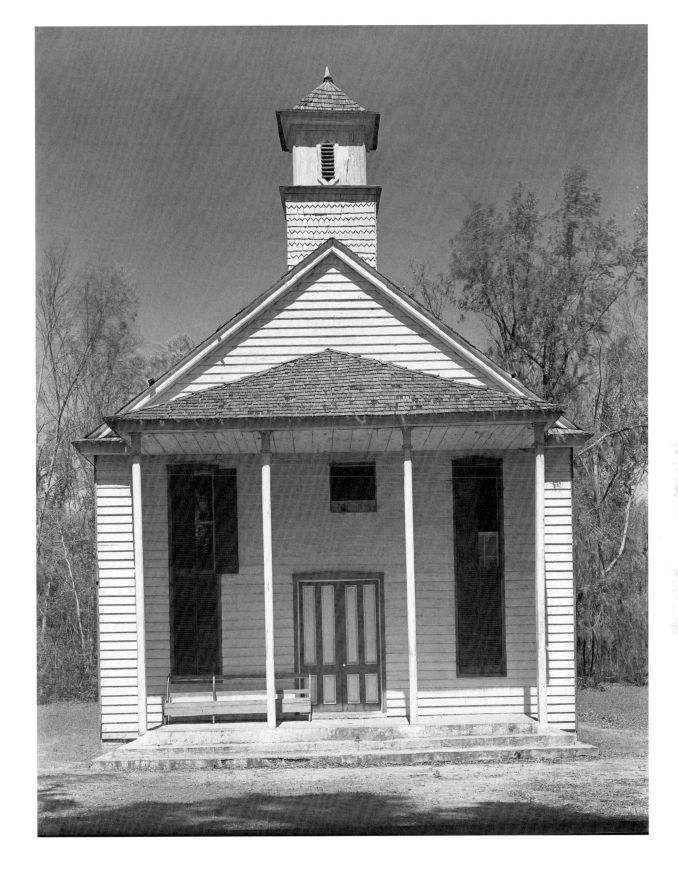

Negro Church, South Carolina, March 1936

Atlanta, Georgia. Frame Houses and a Billboard, 1936

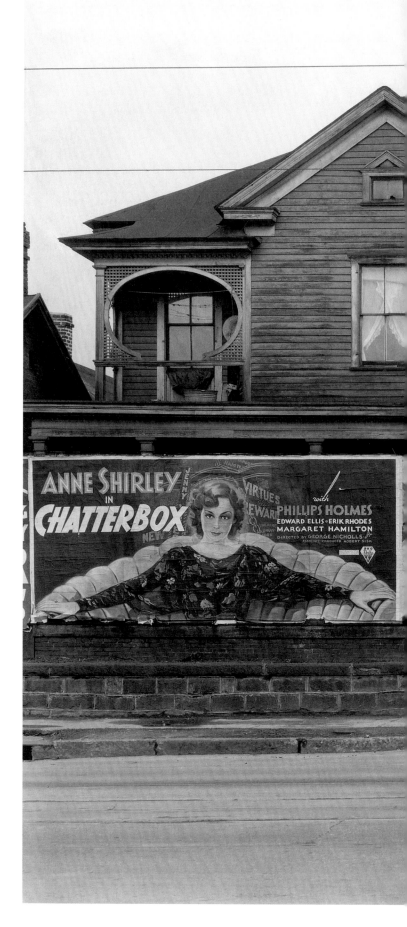

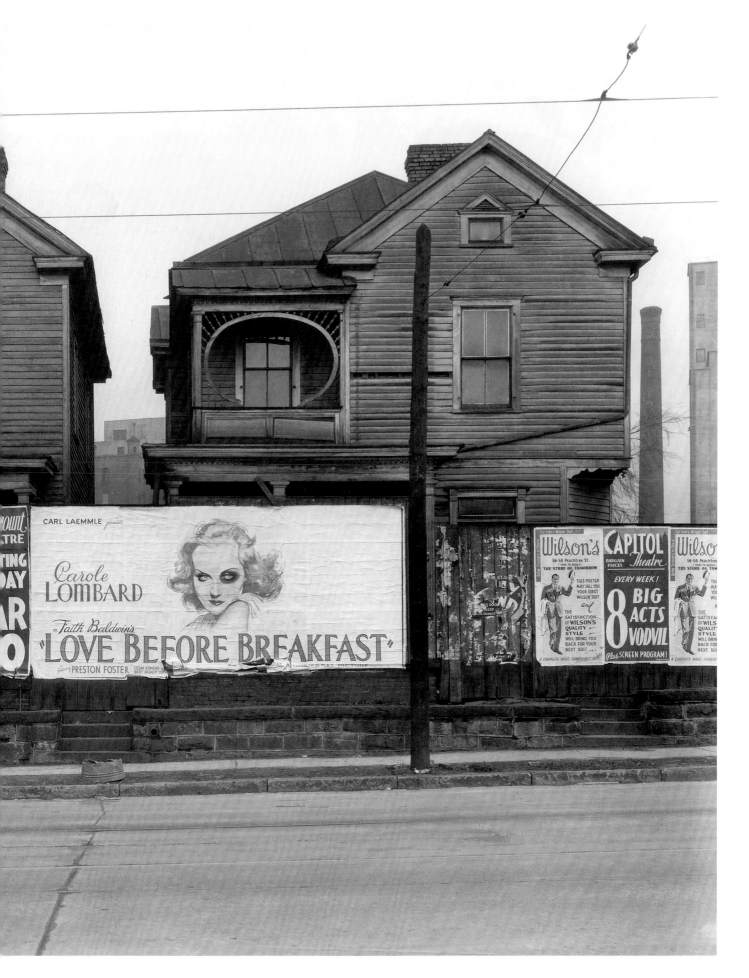

Roadside Stand, vicinity of Birmingham, Alabama, 1936

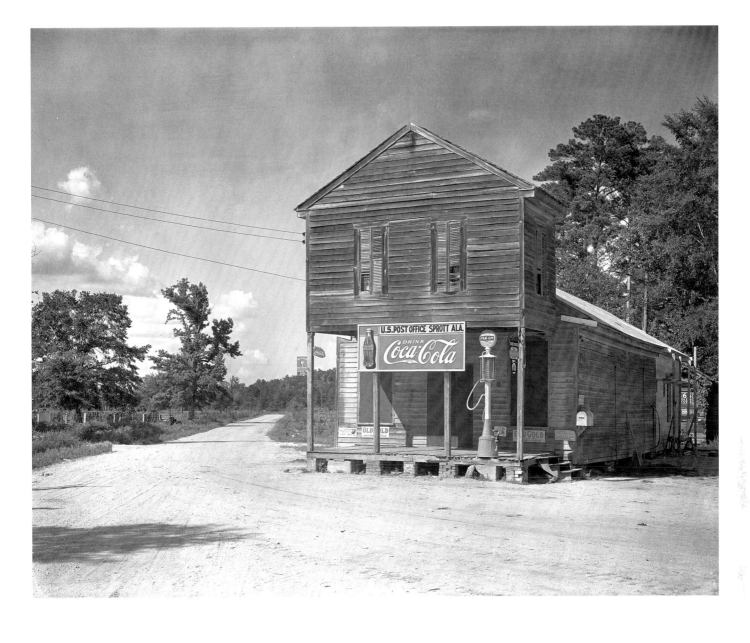

Crossroads Store, Sprott, Alabama [Post Office], 1936

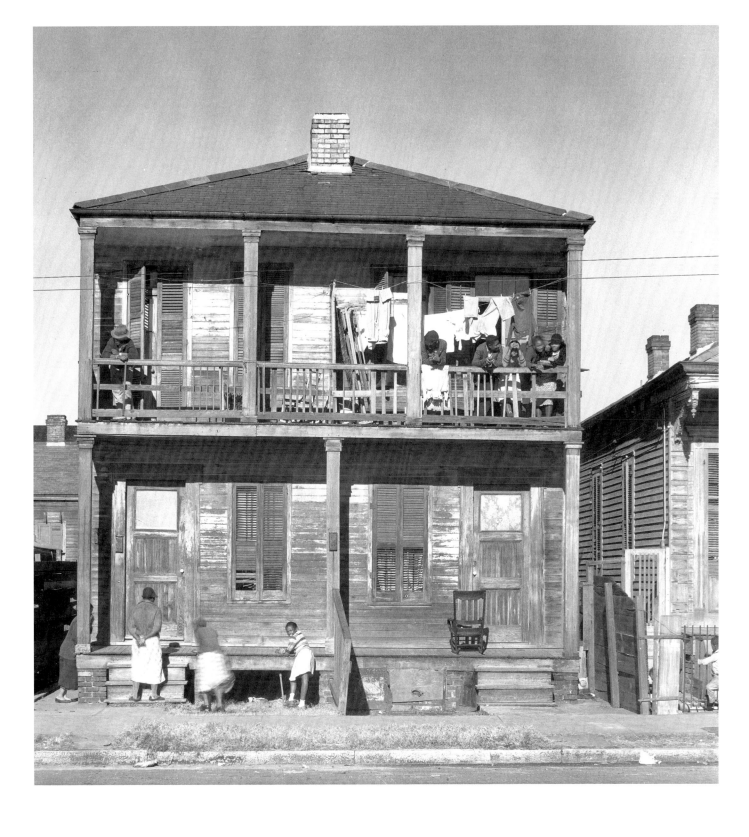

Negro House, New Orleans, Louisiana, March 1936

JULIUS
SHULMAN

——**Julius Shulman** (b. 1910, USA; d. 2009) was a powerful advocate for Southern-Californian Modernism. His sumptuous architectural photographs advertised a new post-war American lifestyle. Perhaps his most iconic images are those of the 'Case Study Houses', an initiative launched by *Arts & Architecture* magazine in 1945 to offer the public and the building industry a series of low-cost, Modernist housing models. Over its intermittent twenty-one-year existence, the Case Study House Program solicited contributions from such eminent architects as Charles and Ray Eames, Craig Ellwood and Eero Saarinen. Thirty-six prototypes were designed and twenty-four were realised, of which Shulman photographed fifteen. The mise-en-scènes that he created in these photographs did more than just capture the allure of each architectural subject — they seemed to distil the essence of an era. As the architectural critic Cathleen McGuigan notes, 'you can practically hear the Sinatra tunes wafting in the air and the ice clinking in the cocktail glasses'.[1]

While the Case Study House Program failed in its ambition to produce replicable dwellings (too little attention was paid to concerns such as the expense of so much glass or the compromised privacy of open-plan living) it triumphed in attracting publicity for the architects involved. Shulman was instrumental in this success (as they were in his), since his photographs could illustrate an article far more evocatively than any rendering or plan. A single photograph by Shulman, perhaps his most famous, is for example inseparable from the acclaim of Pierre Koenig's Stahl Residence — Case Study House #22. In this stark black-and-white composition, two women are caught in conversation, framed by the Minimalist lines of a cantilevered pavilion, which is perched on a promontory overlooking the lights of Los Angeles below. Taken just as the sun was setting, the image seems to be held in effortless suspense between light and dark, inside and outside, foreground and background, such that it feels both anchored in a specific moment (9 May 1960) and utterly timeless. As Shulman proudly acknowledged, it has since graced 'practically every architectural magazine'.[2]

Born in New York, Shulman grew up in California and spent years drifting in Berkeley, auditing university classes but never settling on a degree subject, before beginning his career almost by accident in March 1936.[3] His sister was renting a room to a young draughtsman working for the architect Richard Neutra, who was celebrated for his geometric yet airy West Coast Modernist style. When Shulman was invited to visit the Joseph Kun House (then under construction in the Hollywood Hills) he took his trusty Eastman Kodak Vest Pocket camera, but hardly expected Neutra to ask for copies of the six photographs that he took that day. Impressed by his 'amateurish' talent, Neutra recommended Shulman to Gregory Ain, Rudolph Schindler and Raphael Soriano — architects whose careers were in the ascendant and who would carry Shulman with them. This was notably evident in the Museum of Modern Art's 'Built in USA: 1932 – 1944', an exhibition surveying the work of leading International Style Modernists in America. Consisting almost entirely of images, a large proportion of which were by Shulman, the exhibition doubled as a showcase for photographic talent and, crucially, listed their contact details in the catalogue.

Shulman set up his studio in 1950 and was a great commercial success. He was popular with architects because he insisted on creating the 'optimum conditions' — which might have meant spending 45 minutes on an exposure, opening and closing the shutter while turning the house lights on and off, as he did for his famous shot of the Kaufman House in 1947. He believed in a 'process of idealisation, glorification and dramatisation' and was unapologetic about the techniques he used to achieve these effects, which included shooting on infrared film to accentuate the contrast.[4] He was also known to position beautiful students to make a house look casually inhabited and to shoot through nursery plants to give the impression of landscaping. The result was graphic images that reproduced well, making him popular with editors too.

Shulman was a canny businessman, who never discarded a negative and was still selling the first photograph he took on his Box Brownie, aged seventeen, some seventy years later. He officially retired in 1986, although (working with his collaborator Juergen Nogai) he continued to photograph well into his nineties, with assignments including Frank Gehry's Disney Concert Hall in Los Angeles and the Guggenheim Museum in Bilbao. In 2004 the Getty Research Institute acquired Shulman's archive of 260,000 negatives, prints and transparencies. He died, aged ninety-eight, in 2009.

EN

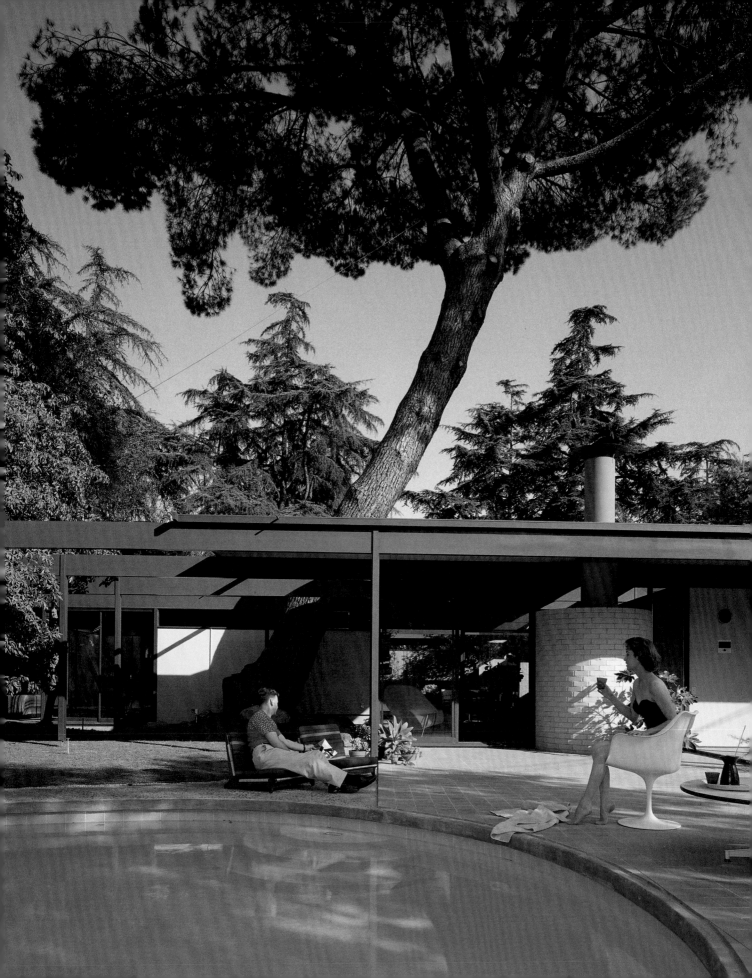

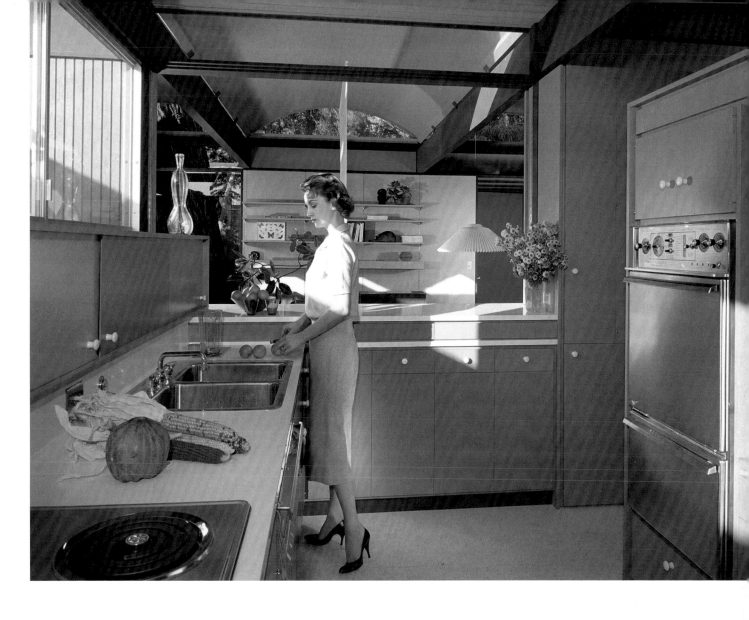

Above and left:
Case Study House #20 (Buff, Straub and Hensman, Atladena, California), 1958

Below and left:
Bailey House, Case Study House #21 (Pierre Koenig, Los Angeles, California), c.1959

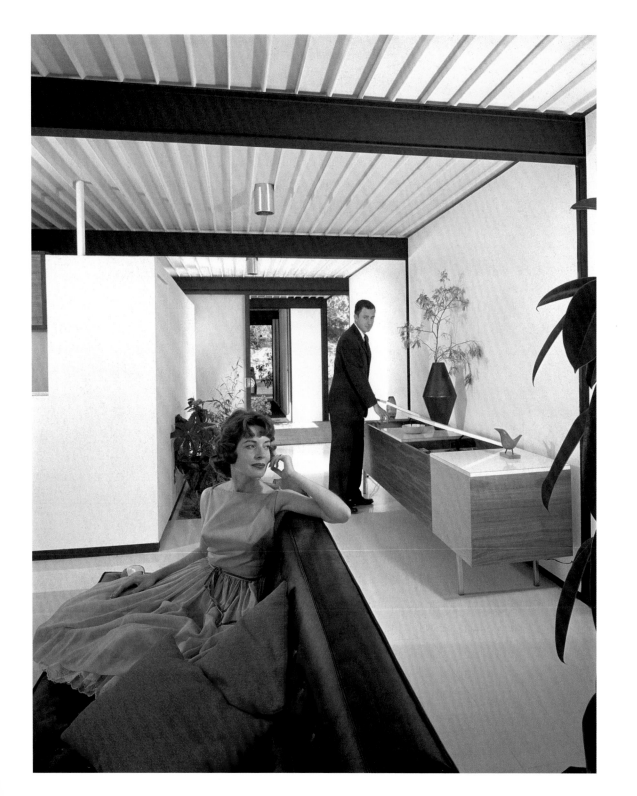

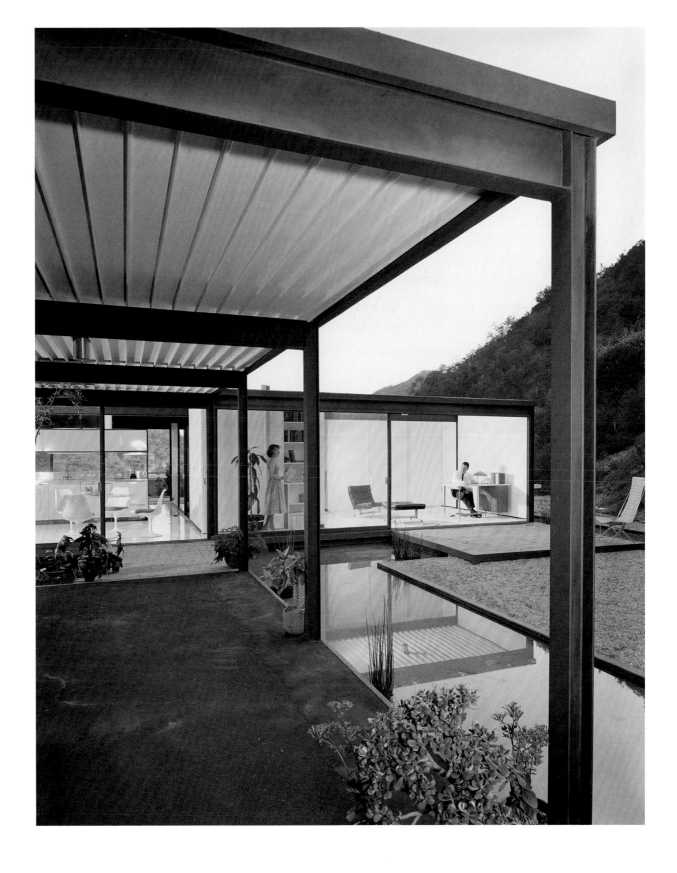

Stahl Residence, Case Study House #22
(Pierre Koenig, Los Angeles, California), 1960

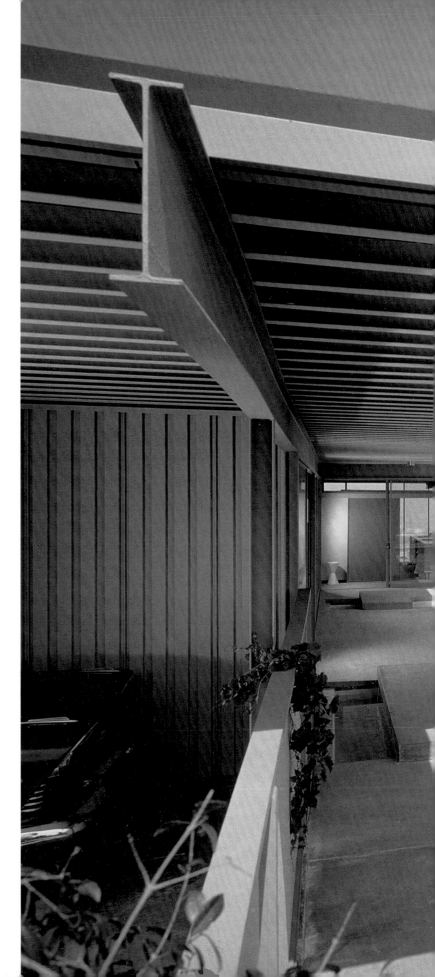

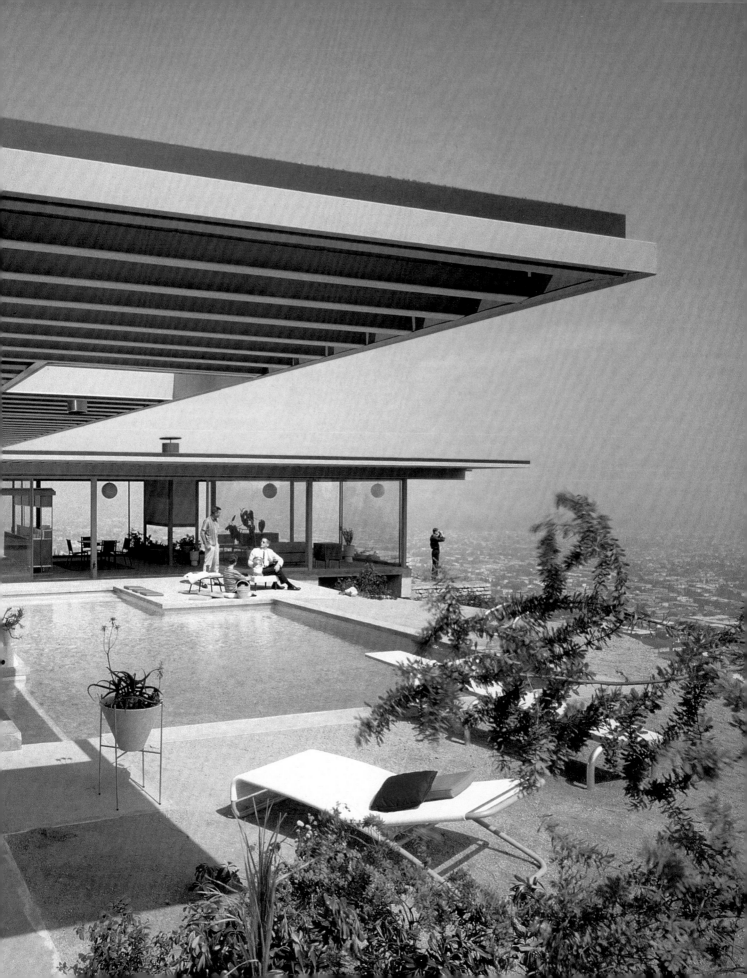

Below and right:
Eames House (Charles and Ray Eames, Los Angeles, California), 1950

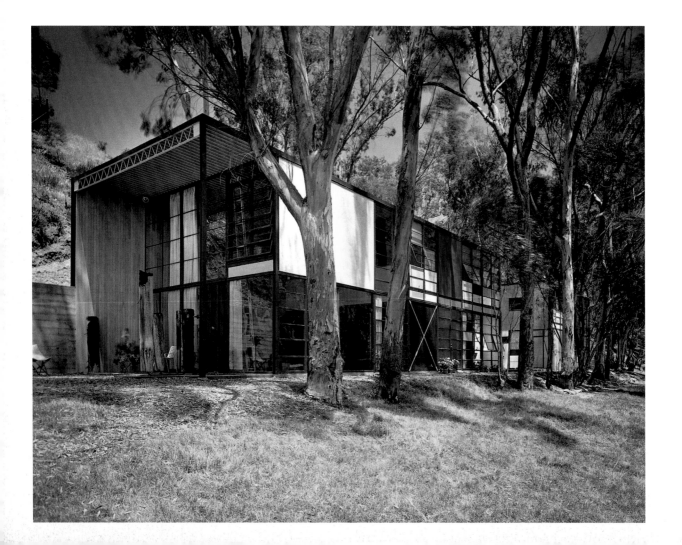

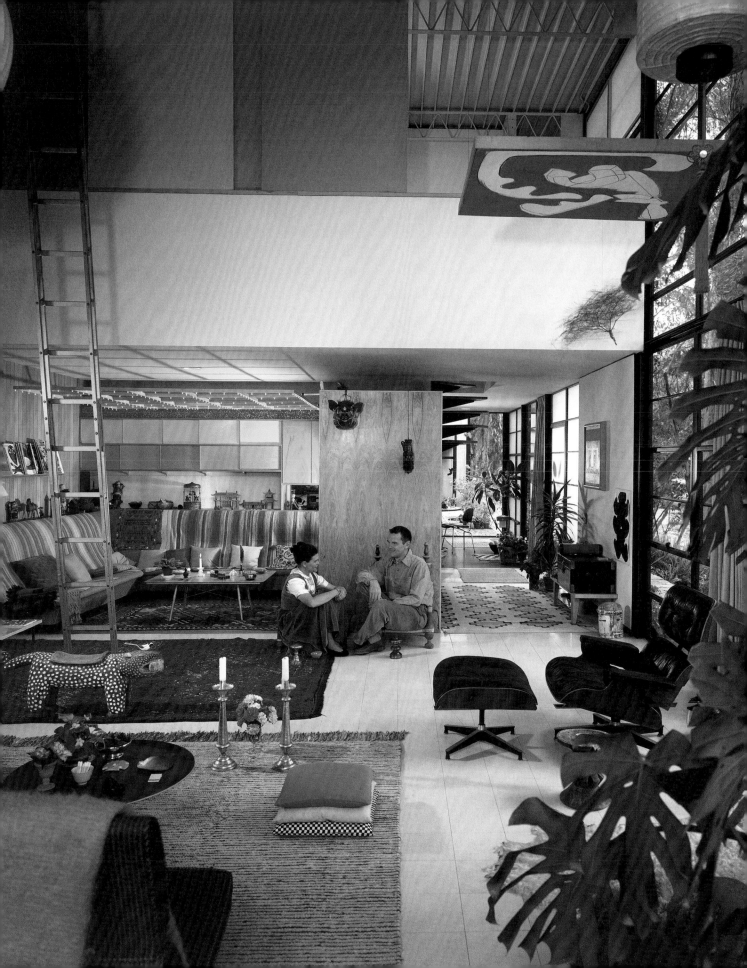

LUCIEN HERVÉ

————**Lucien Hervé** (b. 1910, Hungary; d. 2007, France) is best known for photographing the work of the maestro of twentieth-century architectural Modernism, Le Corbusier. From 1949, when he first saw the images of the Unité d'Habitation in Marseilles that Hervé took on his Rolleiflex 6 × 6 camera, until his death in 1965, Le Corbusier would work with no other photographer. Hervé shot the construction site in Marseilles on an assignment for *Plaisir de France* magazine, but the editor-in-chief rejected the images. That same day, 15 December, Hervé received a letter from Le Corbusier, thanking him for his contact sheets and declaring that 'Sir, you have the soul of an architect'.[1] The pair met later that month at the architect's Paris apartment at 24 rue Nungesser-et-Coli, where Le Corbusier gave Hervé his first 6 × 10 bellows camera. In 1955 and 1961 they travelled to Chandigarh, Le Corbusier's 'dream city', where Hervé used the dazzling Indian sunlight to compose high-contrast angular scenes, which condensed the aspirations of a newly independent nation.

Hervé, who was nicknamed 'Dr Caligari' by Le Corbusier, was deeply influenced by German expressionist film and by other filmmakers such as Sergei Eisenstein and Dziga Vertov. Borrowing from this visual language, he shot obliquely or very close up to create compositions coursing with energy. As Olivier Beer notes, he understood that 'one must take an indirect approach in order to apprehend the soul of a thing'.[2] With no formal training, Hervé never used a light meter and was known to take twice as many pictures as most photographers because of the number that would be incorrectly exposed. Drawn to natural light, he learnt to capture the texture of a concrete wall bathed in sunlight or to use shadows to structure a sight line. In Chandigarh, he focused on the High Court of Justice, the Secretariat Building and the Palace of the Assembly (which Le Corbusier considered his greatest work) as well as local vernacular architecture.

Born László Elkán, in south-eastern Hungary, he moved to Vienna in 1928, aged eighteen, intending to study economics. The following year, he joined his brother in Paris, where he became a designer, working for notable couturiers including Lanvin and Schiaparelli until, as an active member of the French Communist Party, he was forced to leave following the 1935 strikes. When the Hungarian photographer Nicolás Muller arrived in Paris in 1938, the pair collaborated on articles for *Marianne*. Initially responsible for writing copy, Elkán soon took on photojournalism too. Practising throughout the war (including a photo-essay published by *Vu* on life in the barracks), he was captured in 1940. When he escaped the following year, he joined the French Resistance and Lucien Hervé became his 'nom de guerre'. Resuming photography in 1947, he published work in reviews such as *France Illustrations* and *L'Art Sacré*. He also returned to an architectural subject that would punctuate his career: the Eiffel Tower. In his struggle to balance the elegance of the wrought-iron filigrees against the sheer force of modern engineering, Hervé was readying himself for his career with Le Corbusier.

Living by Mies van der Rohe's Modernist dictum that 'less is more', Hervé became an aesthetic purist, often concentrating on details to create bold abstracted images. In this respect he differed from contemporaries such as Ezra Stoller or Julius Shulman, who wanted to give the viewer the impression of being able to grasp in a glance the entire space, time and concept of a building. Influenced by the New Vision of Bauhaus artist László Moholy-Nagy (a fellow Hungarian émigré), Hervé believed that 'without exacting rigorous composition a photograph is nothing more than an anecdote'.[4] He would research each subject fastidiously, studying designs and renderings as well as 'walking the architecture'.[5] Although he disliked staging, he was certainly not averse to cropping his images; when Le Corbusier asked how he became a photographer, he is said to have replied 'with a pair of scissors'. His contact sheets have subsequently attracted considerable interest as evidence of the 'original cut'.

Although Hervé's work for Le Corbusier has tended to eclipse the rest of his career, he did photograph for other international architects including Alvar Aalto, Richard Neutra and Oscar Niemeyer, as well as architect-engineers such as Jean Prouvé. In 1965, shortly before Le Corbusier's death, Hervé developed Multiple Sclerosis. Although he continued to work, his son Daniel often accompanied him, for example in photographing for architect Pierre Puttemans in 1970. In 2002, the Getty Research Institute acquired over 18,000 of his negatives and colour transparencies, which prompted a spate of exhibitions: at the Hôtel de Sully (Paris, 2002), the CIVA (Brussels, 2005), the Fondation Le Corbusier (Paris, 2007) and the Palazzo Te (Mantua, 2009). Hervé died, aged ninety-seven, in 2007.

EN

High Court of Justice, Chandigarh, India, 1955

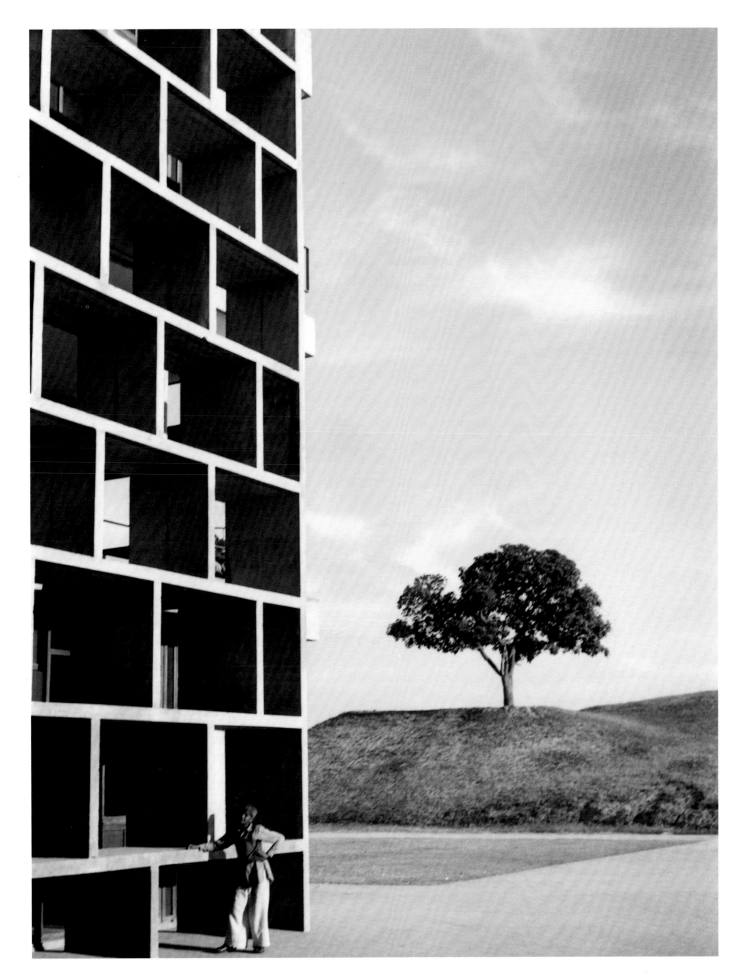

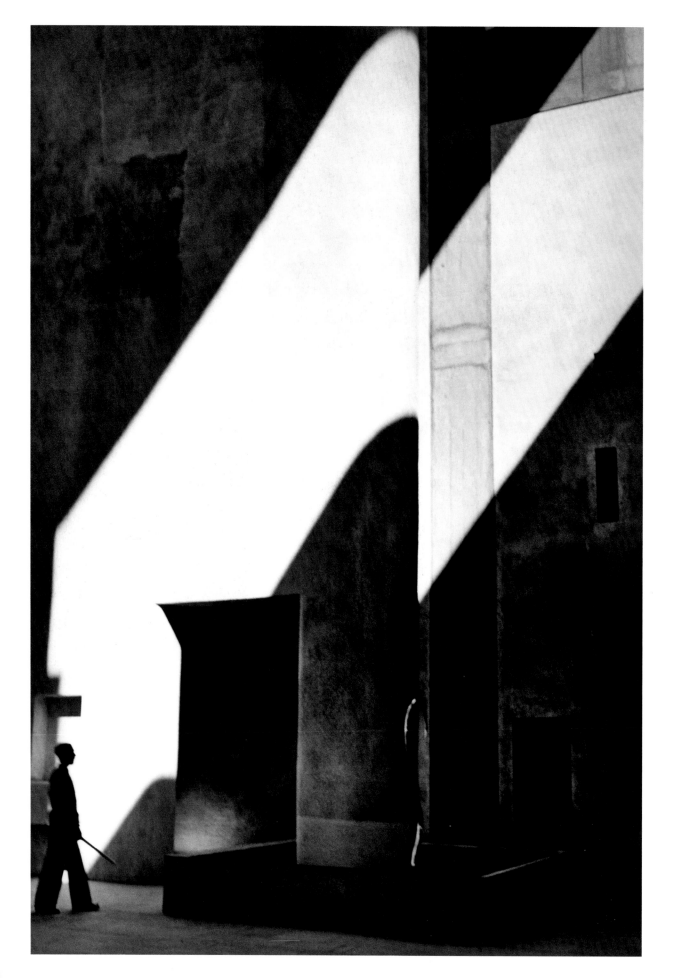

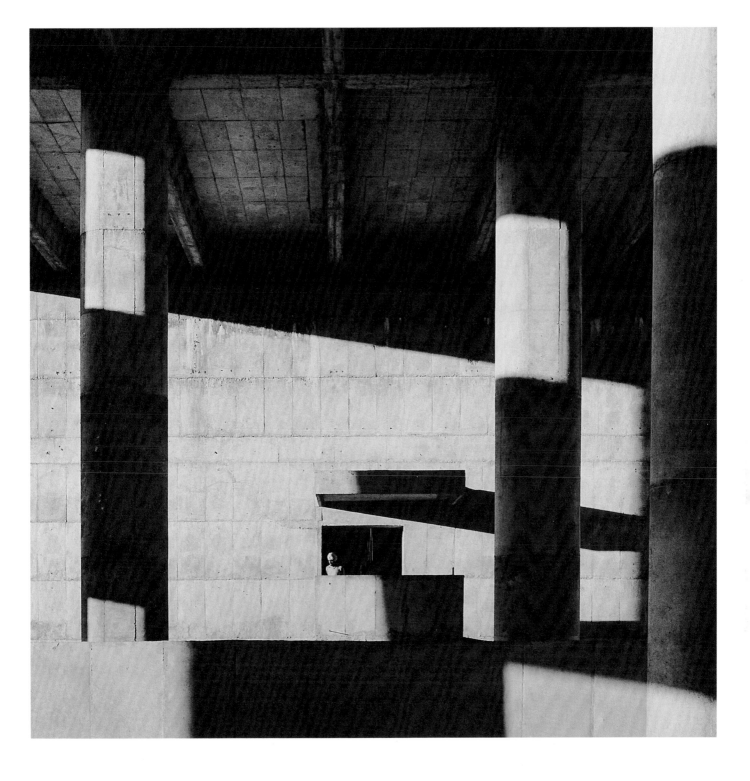

Left:
High Court of Justice, Chandigarh, India, 1955

Above:
Secretariat, Chandigarh, India, 1955

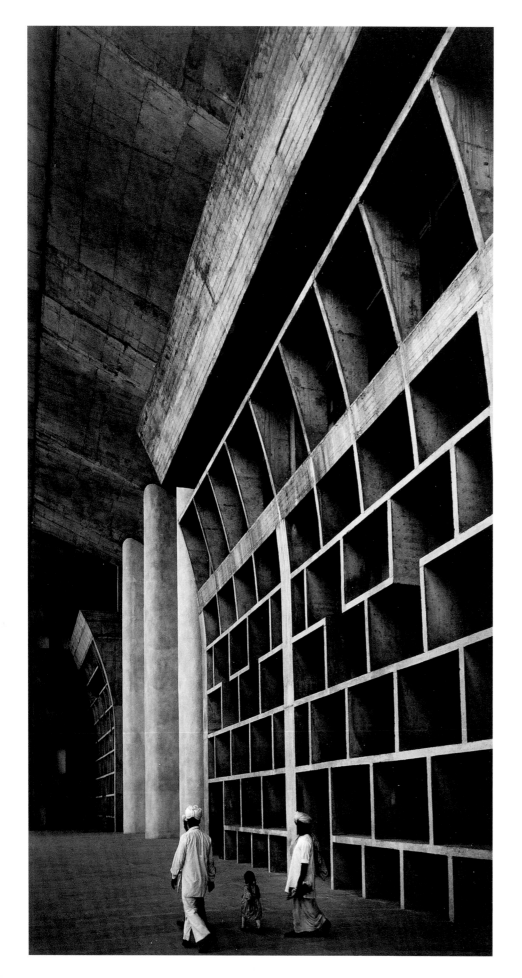

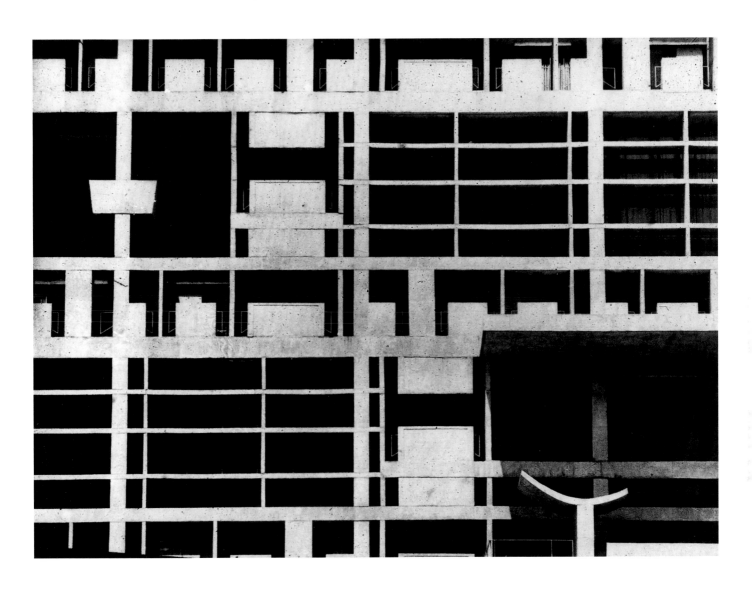

Left:
High Court of Justice, Chandigarh, India, 1955

Above:
Secretariat, Chandigarh, India, 1955

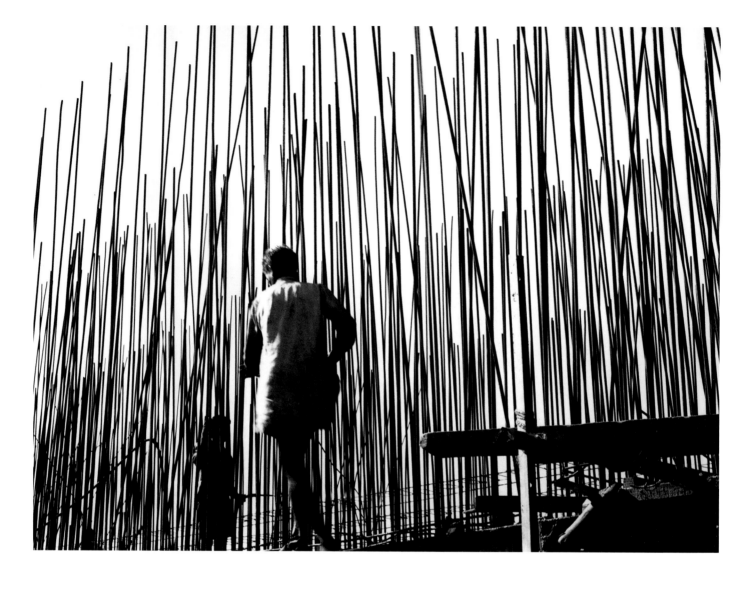

Above:
Secretariat, Chandigarh, India, 1955

Right:
High Court of Justice, Chandigarh, India, 1955

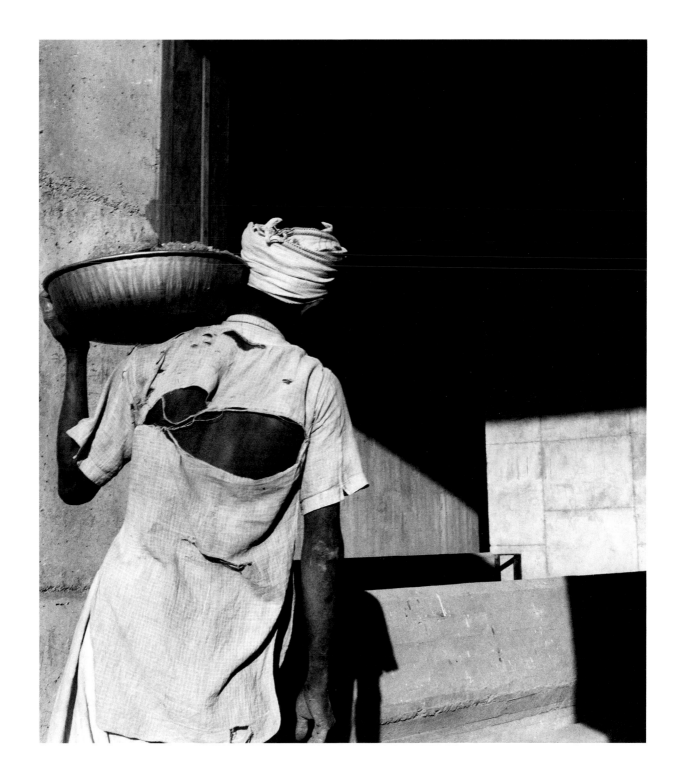

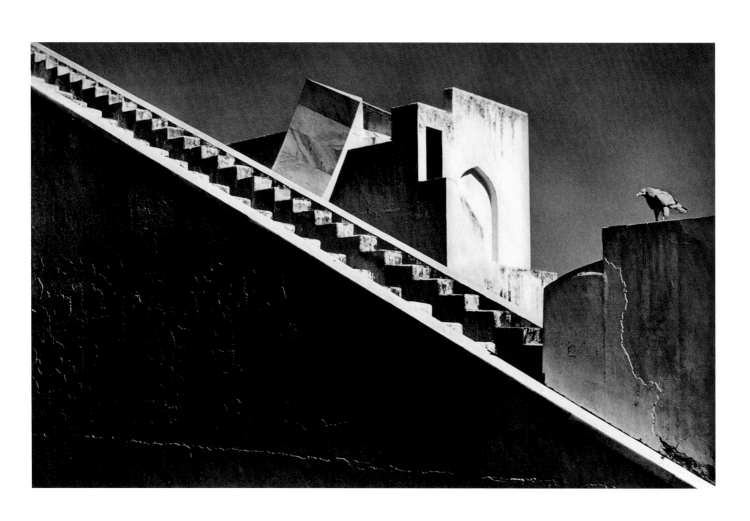

Observatory, Jaipur, India, 1955

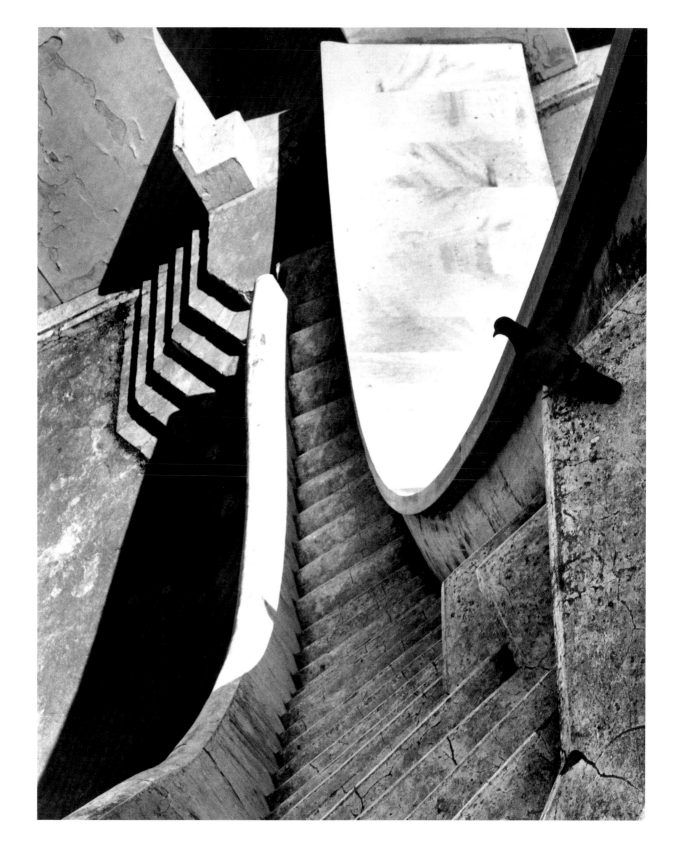

Observatory, Jaipur, India, 1955

ED RUSCHA

The photographs of Los Angeles in the 1960s, taken by **Ed Ruscha** (b. 1937, USA) are documents of the late-twentieth century's 'shock city'. If Manchester was the urban emblem of the Industrial Revolution and New York that of twentieth-century high modernity, then Los Angeles was and is the dramatically alien, confusing, inexplicable metropolis of late capitalism, the inadvertent and usually unacknowledged model for almost everything that came in its wake, at least in the USA and Europe. Not only in being a city largely powered by media and consumption — albeit with a considerable and usually overlooked sideline in logistics and petroleum — but mainly in its complete absence of what were hitherto considered 'city-like' qualities, it is the ultimate confirmation of Gertrude Stein's observation that 'there is no there there'.

Partly this was a consequence of the dangers in building skyscrapers on this unstable territory, which meant that until relatively recently LA lacked a 'skyline' in the manner either of a medieval city or an American metropolis, making it hard to identify visually. Yet the main reason for the baffled reaction of many East Coast and European observers came as a result of it being arguably the first city to be totally planned for the private motorcar. It meant that it could spread out in a way no city had done before, more so even than previous sprawling, suburban cities such as London. Lacking railway or underground stations, the city appeared to have no 'hubs', no local centres.

As baffled English youths looking at the size of people's houses and gardens in *Boyz n the Hood* could attest, even its ghettoes looked completely unlike those of older cities. What it did have was an enormous road network, a concrete web that provided the state-sponsored public sector glue that kept this vast ultra-capitalist metropolis together. These are, as a rule, the 'architectural' images of Los Angeles, which however strange they must first have appeared, can be apprehended as three-dimensional objects, to be welcomed or rejected aesthetically according to taste. Ed Ruscha's photographic works on Los Angeles's motor infrastructure sidestep the potential spectacle of vaulting flyovers-upon-flyovers entirely, and give instead an unromantic, abstract vision of what this actually meant in terms of urban space, on the ground.

Ruscha's paintings often give a dramatic picture of Los Angeles and its combination of Utopia and stark spatial segregation — the glossy image of official culture and unrest in *The Los Angeles County Museum on Fire* (1965–68), for instance, or the famous image of *Standard Station* (1966), where the forms of the new petrol-driven exurbia surge forward with a confident, Modernist drama. *Thirtyfour Parking Lots in Los Angeles* (1967) slows all of this down, removes all the excitement, and shifts into a forensic aerial view of what the abundance of car parking does to the cityscape. Each one of them depicts a parking lot, with its precise address serving as the title, taken from the air so that it becomes abstract, diagrammatic: abstract, but not illegible. In *5000 W. Carling Way*, the size of the parking lot, the allotted spaces etched on to them geometrically, contrasts with the tiny houses around, each with their suddenly puny patch of garden out front and at back.

Or they may be pulled into dialogue with equally abstracted, equally mundane forms. In *Pierce College, Woodland Hills*, the parking lot runs alongside a freeway, next to a stadium, with the topographic outline of the hills just behind. In *Gilmore Drive-in Theatre, 6201 W. 3rd St.* the spreading forms of the parking lot are immediately legible once you read the title, designed like a traditional theatre to offer everyone a view of the 'stage'; while in *Dodgers Stadium, 1000 Elysian Park Ave.*, the object around which everything revolves is right in the centre, a host organism in an immense circular nest. The extreme of abstraction is reached in *Good Year Tires, 6610 Laurel Canyon, North Hollywood*, where more than two-thirds of the frame is taken up with parking lots the size of entire districts, with the houses straggling in the other third.

It is telling that one of Ruscha's most tireless promoters was the novelist JG Ballard, given that these images inhabit the same world as his stories *The Terminal Beach* and *The Atrocity Exhibition* — an uncanny confusion of scales, in which the body, the city, the car and technology are alternately reduced and amplified by magnification, reproduction and mental illness. On the street, of course, you'd see a whole lot of nothing.

OH

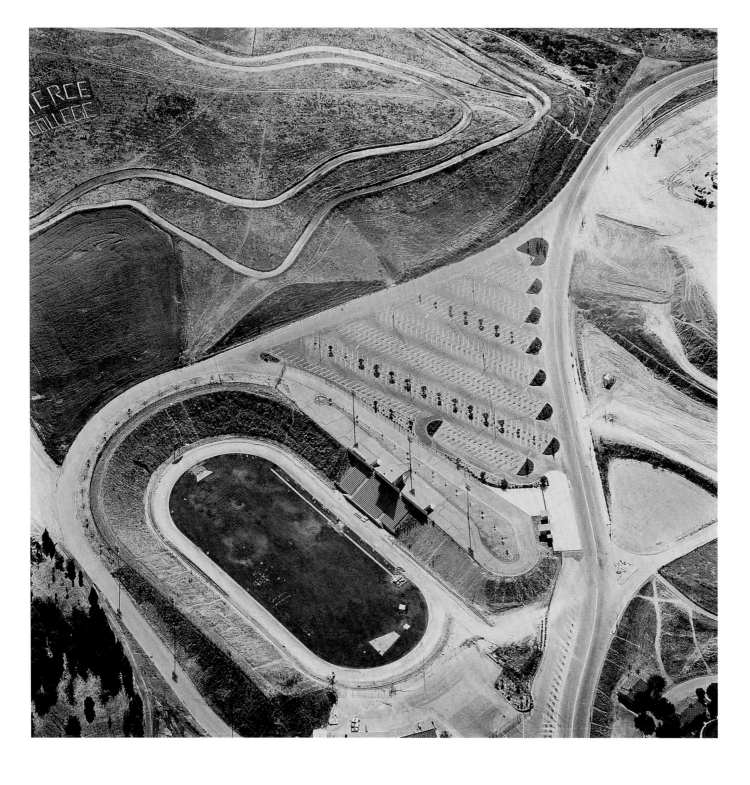

Parking Lots: Pierce College, Woodland Hills, 1967/99

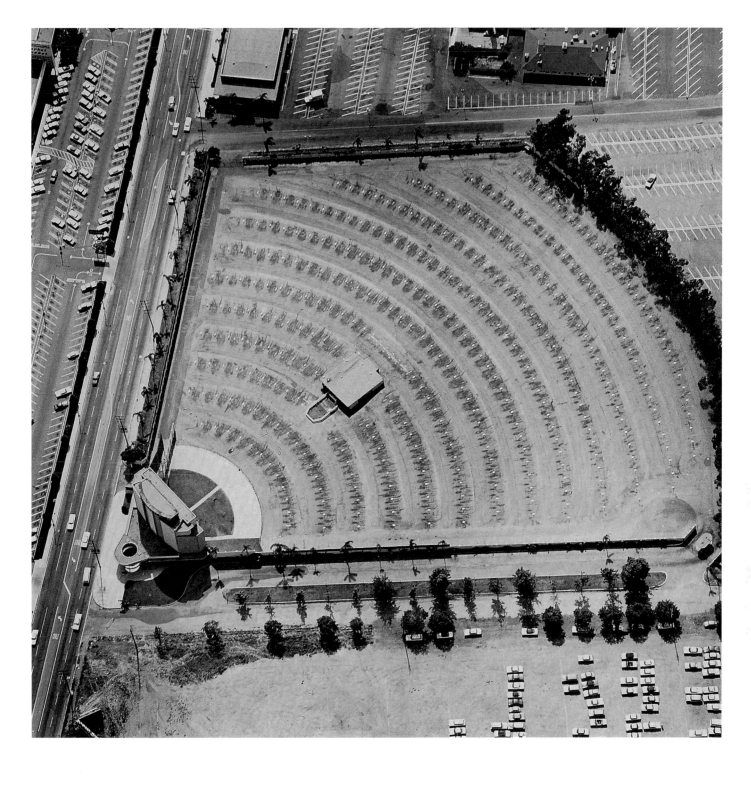

Parking Lots: Gilmore Drive-in Theatre, 6201 W. 3rd St., 1967/99

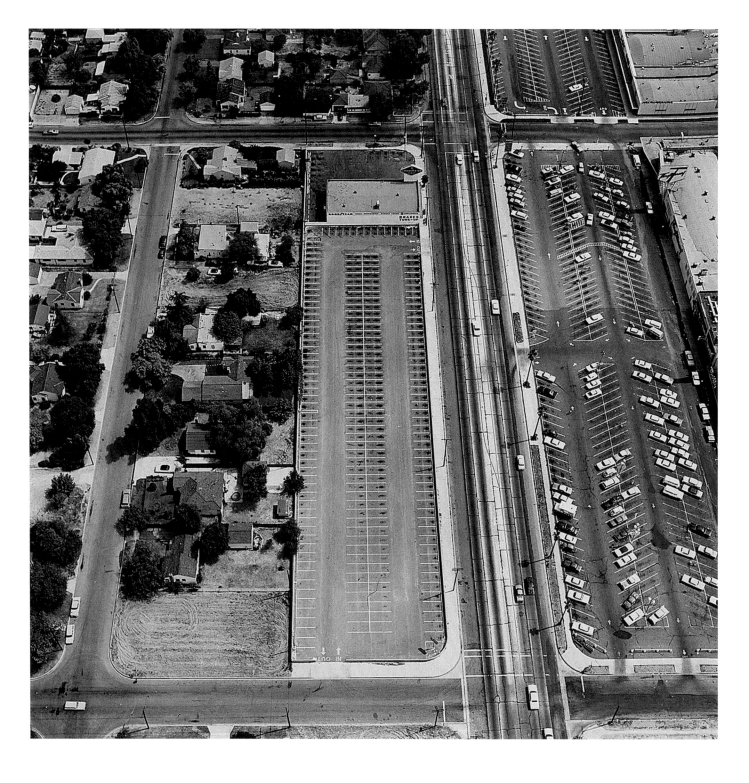

Parking Lots: Good Year Tires, 6610 Laurel Canyon, North Hollywood, 1967/99

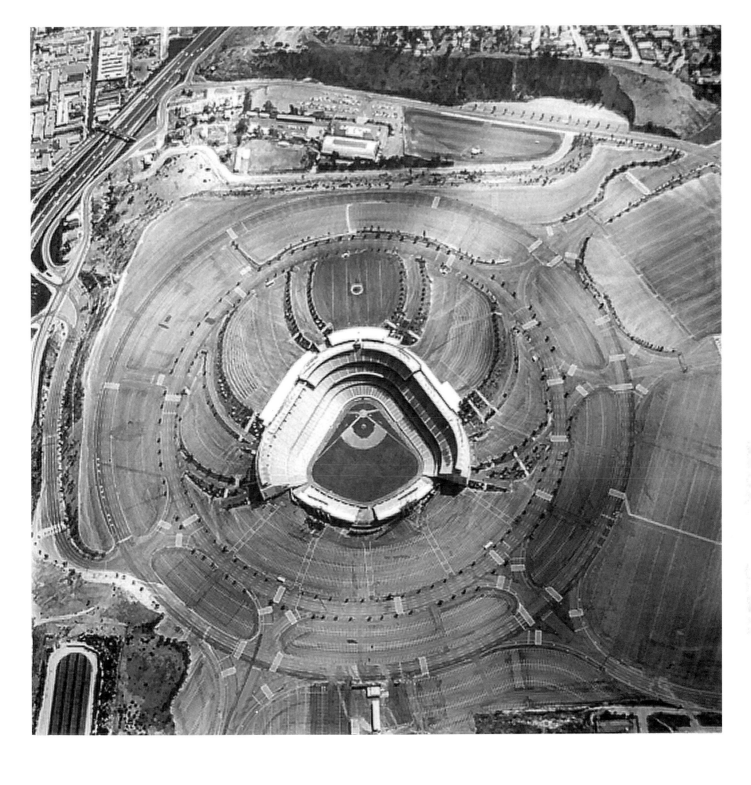

Parking Lots: Dodgers Stadium, 1000 Elysian Park Ave., 1967/99

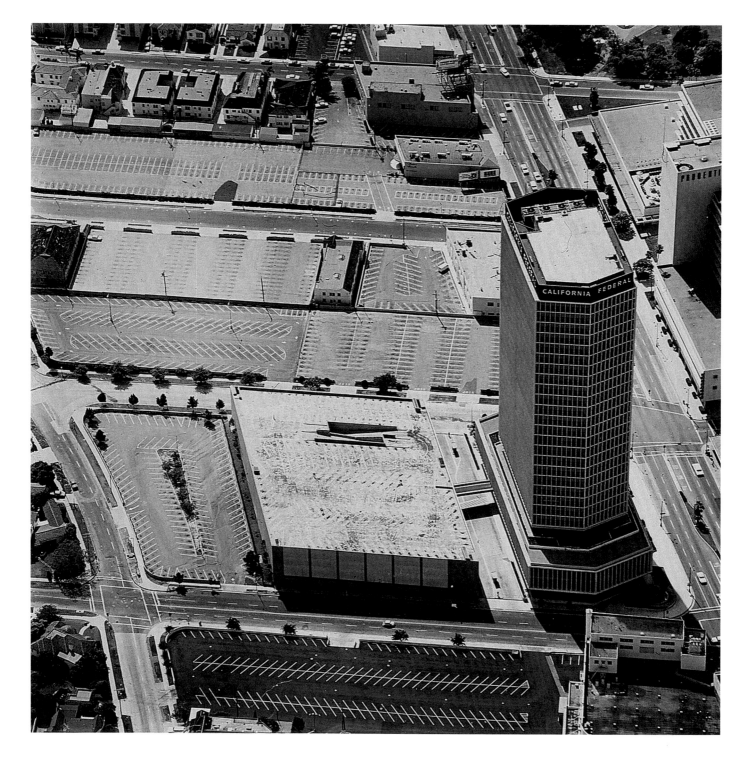

Parking Lots: 5600–5700 Blocks of Wilshire Blvd., 1967/99

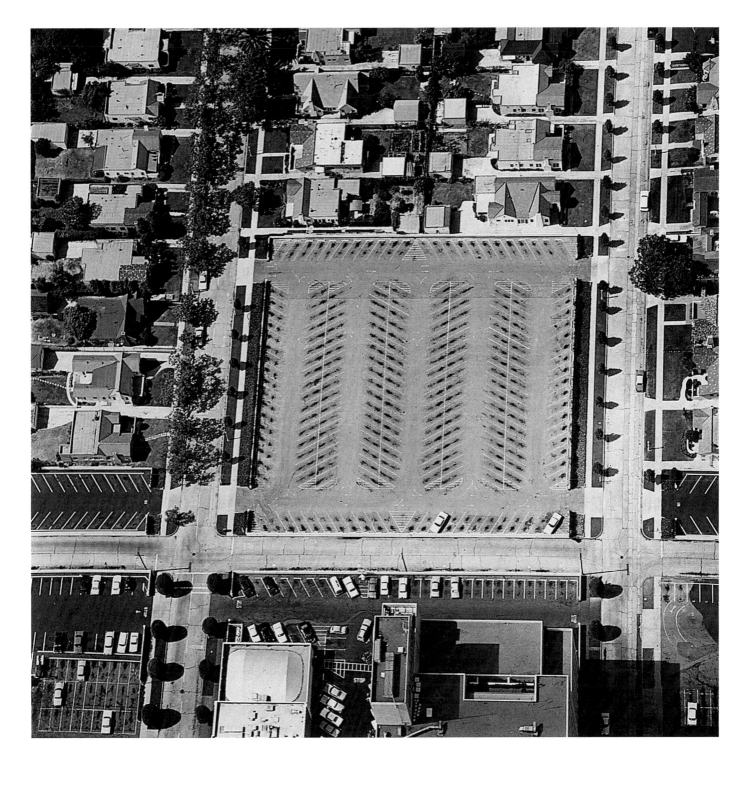

Parking Lots: 5000 W. Carling Way, 1967/99

SOME

LOS ANGELES

APARTMENTS

1555 ARTESIA BLVD.

6565 FOUNTAIN AVE.

PARKLABREA TOWERS, 360 S. BURNSIDE AVE.

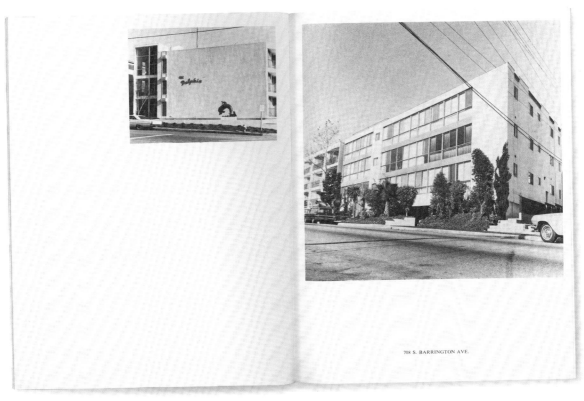

708 S. BARRINGTON AVE.

Cover and spreads from Some Los Angeles Apartments, 1965

BERND
AND HILLA
BECHER

————In 1989, **Hilla Becher** (b. 1934, Germany) claimed that 'we want to change nothing about the objects we photograph'.[1] This might have been an unusual, even amoral thing to say, given that their subject matter was industry, industrial landscapes and industrial towns. Generally, those photographing industry did want to change it in some way. At one extreme — the commissioned end of industrial 'art' photography — Albert Renger-Patzsch, the German figurehead of the New Objectivity, shooting at AEG or Fagus, and Charles Sheeler, the American painter/photographer at Ford, aimed to show the factories they were depicting as exemplars. They took different approaches in doing so. Renger-Patzsch favoured a blank, lustrous concentration on industry's surfaces and spaces, while Sheeler opted for a Constructivist melodrama of epic, clashing forms. Both edited out references to labour, workers and social relations — unsurprisingly perhaps, given how close their work was to advertising. Both changed what they photographed.

Renger-Patzsch was harshly criticised by Bertolt Brecht and Walter Benjamin for images that declared the factory beautiful in a time of Taylorism, industrial turmoil and class conflict. The alternative preferred by Brecht and Benjamin was 'worker photography' — a Weimar-era movement in which the workers themselves, as far as possible, took the pictures. The resulting images document social minutiae and political struggle.

Unlike Renger-Patzsch or Sheeler, Bernd (b. 1931, Germany; d. 2007) and Hilla Becher were not photographing brand new factories, so they could deflect accusations of industrial propaganda. They were, however, a very long way from worker photography. People are absent, as are any hints of industrial politics or conflict. But then how could such insights have been possible, given that so many of the factories they were recording had either closed or were on the verge of doing so?

In the same 1989 interview, Hilla Becher continued: 'only one artifice is always permissible, namely to strip the individual objects of their context, in other words to position them such that they fill the frame; now this does not concur with the facts, as on site they are usually in the midst of an architectural chaos or jungle.'[2] That chaos was what Sheeler and the Constructivists attempted to dramatise and what Renger-Patzsch edited out. The Bechers merely cropped it, in order to produce a series of typologies.

Given their background in the Rhine-Ruhr region, West Germany's coal and steel heartland, the pair were in a position to observe the imminent disappearance of these types — the thrilling, bulging tangles of blast furnaces, the latticework circuses of gasometers, the grim gable ends of workers' tenements, the filigree work of the iron-and-glass machine halls — and to catalogue them before they disappeared. In this they were pioneers, with all that that implied, both in the sense of discovery and the way in which they isolated the buildings from the 'jungle' of competing forms. These forms were then catalogued and codified, regarded with a quasi-scientific detachment, like fauna in a natural history textbook.

That did not mean that the Bechers romanticised the buildings they photographed: on the contrary. Eschewing fine weather, for which most architectural photographers habitually wait, the Bechers' skies are typically Germanic (or English or Midwestern): overcast and unflattering. Apart from the artifice of the radical cropping, the fascination is not in the presentation but in the forms themselves. The images fall somewhere between archaeology and aesthetic history and the viewer is encouraged to study these apparently banal typologies as if for the first time. Tellingly, the Bechers found Britain, with its tradition of industrial archaeology, a congenial place to work.

There is often a remarkable tension and interest in these industrial forms. To some degree, that is the point. It is never truer than in the Bechers' series of water towers, which present some of the most whimsical, unusual and attractive of these cropped typologies. From harsh cage frames to bulbous alien spacecraft, from conical trophies to fluted plinths, the water towers provide a rich index of formal experiment. And unlike many of the objects the Bechers catalogued, water towers had not died out as forms, had not become merely a subject for archaeology. Here there are Brutalist water towers, Expressionist ones, and many where the hand of an architect as much as an engineer is obviously in evidence. While few of them are decorative as such, they are notable in that although their fascinating forms are dictated by function, they were designed to be understood and enjoyed as aesthetic objects.

OH

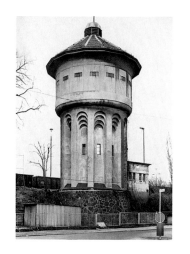 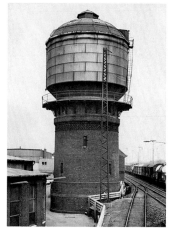 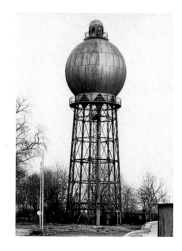

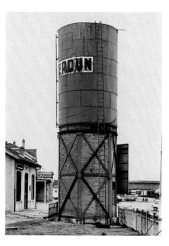 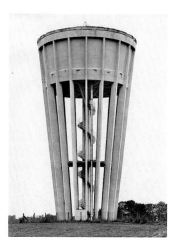 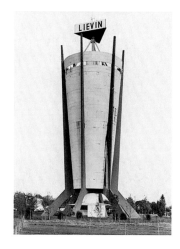

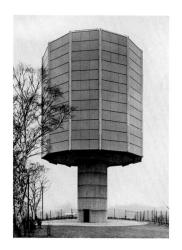 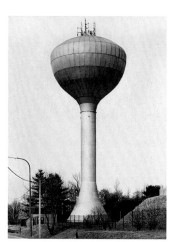 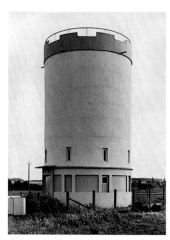

Top row, from left:
Görlitz, Germany, 1995
Oberhausen-Osterfeld, Germany, 1977
Gelsenkirchen-Bismarck, Germany, 1970
La Combelle near Brassac Les Mines, France, 1981
Singen am Hohentwiel, Germany, 1978
Kornwestheim, Germany, 1980
Crusnes, Meurthe-et-Moselle, France, 1984

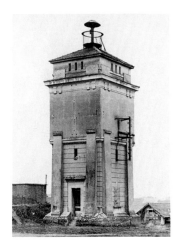
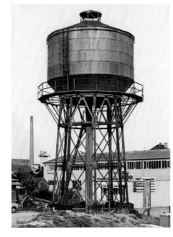
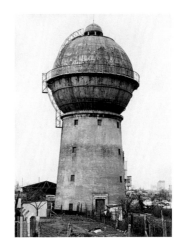
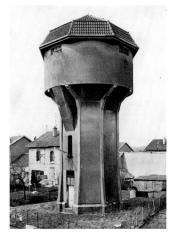

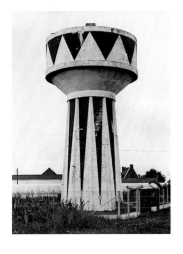
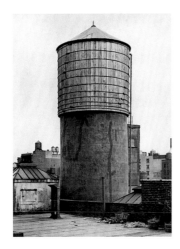
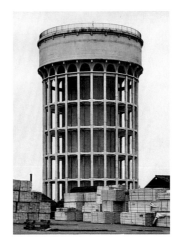
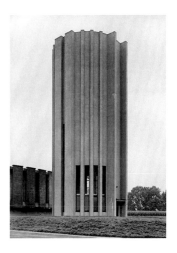

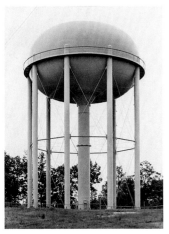
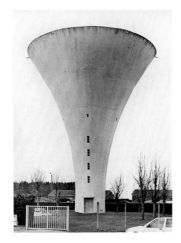
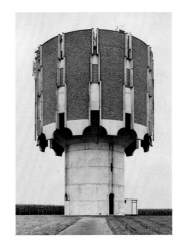
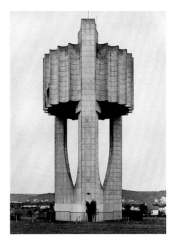

Middle row, from left:
Verdun, France, 1974
Autretot, France, 2012
Liévin, France, 2012
Marquion near Cambrai, France, 2010
New York City, 155 Wooster St., USA, 1978
Goole, Great Britain, 1997
Brakel, Belgium, 2010

Bottom row, from left:
Essen-Werden, Germany, 1980
Manage, Belgium, 2009
La Boulette near Cambrai, France, 2010
Gadsden, Alabama, USA, 1983
Bois Bernard, France, 2009
Lessines, Belgium, 2010
Saint-Aubin-lès-Elbeuf, France, 2012

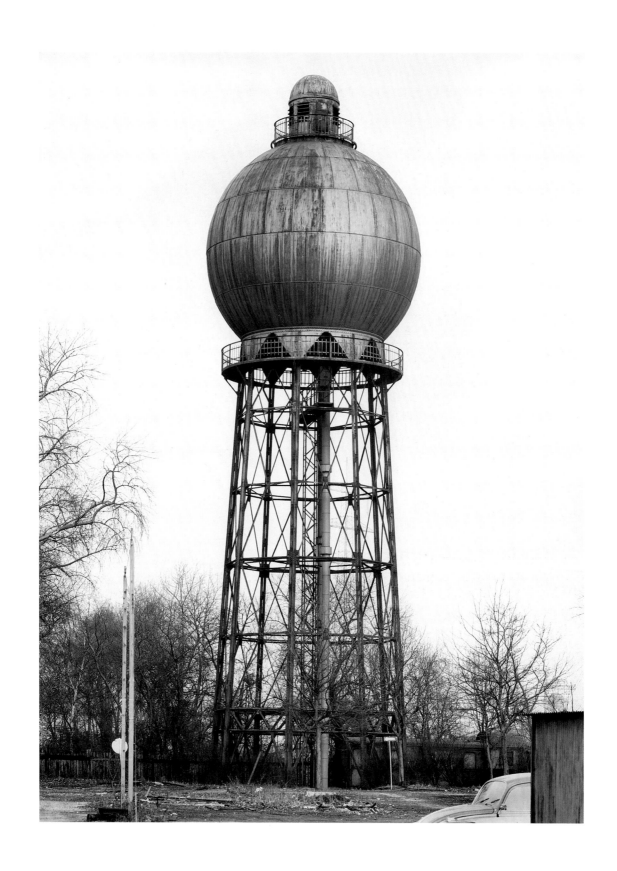

Gelsenkirchen-Bismarck, Germany, 1970

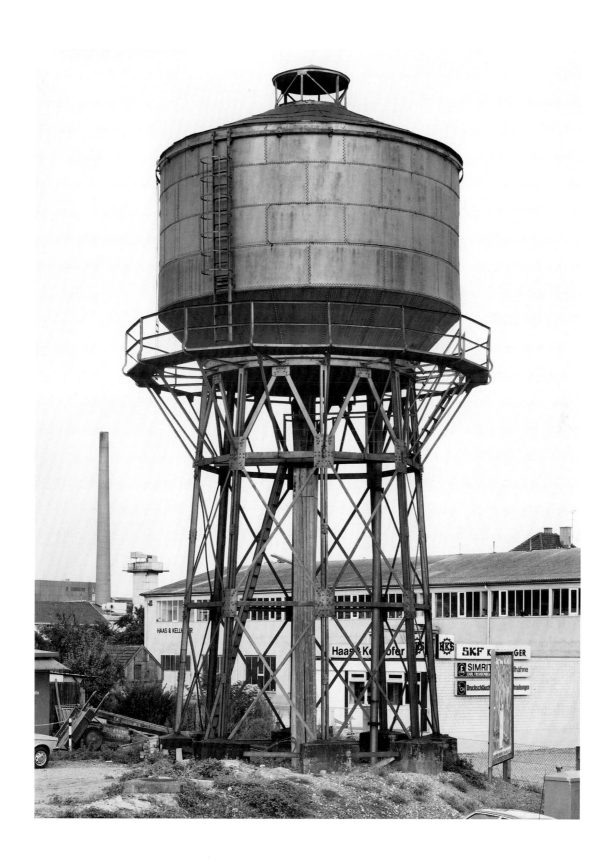

Singen am Hohentwiel, Germany, 1978

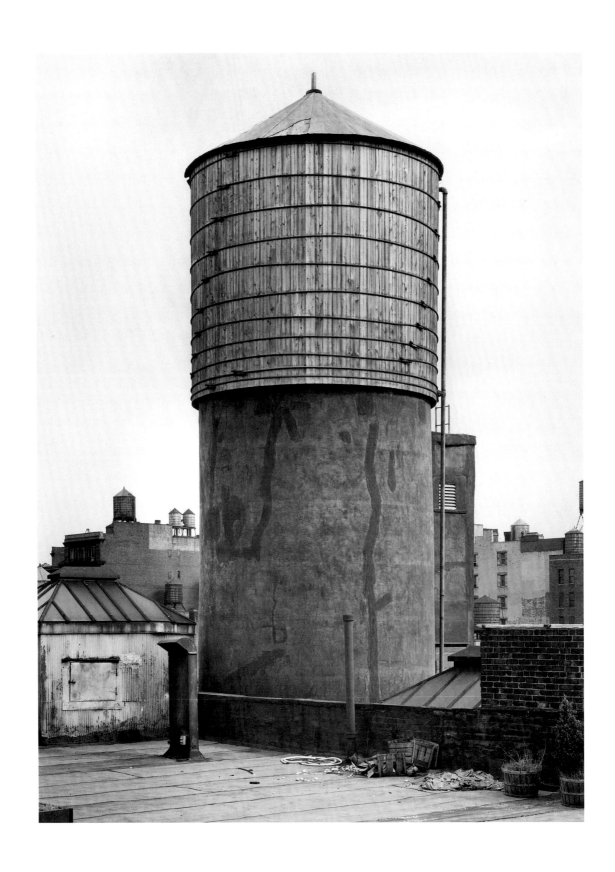

New York City, 155 Wooster St., USA, 1978

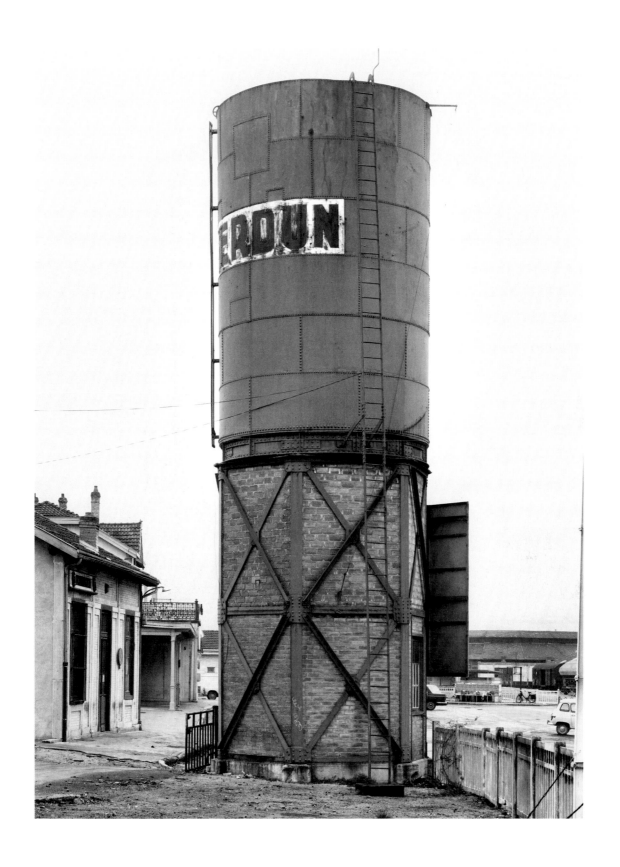

Verdun, France, 1974

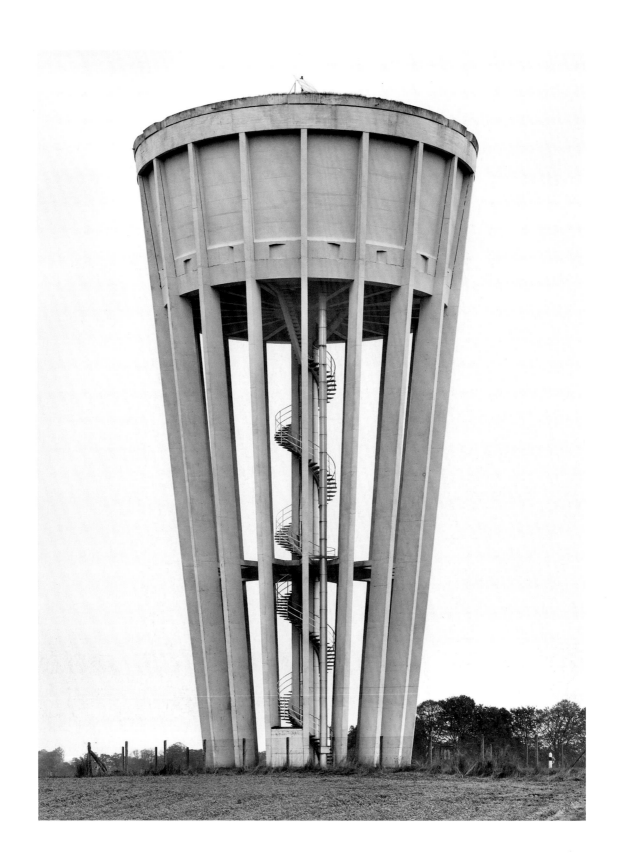

Autretot, France, 2012

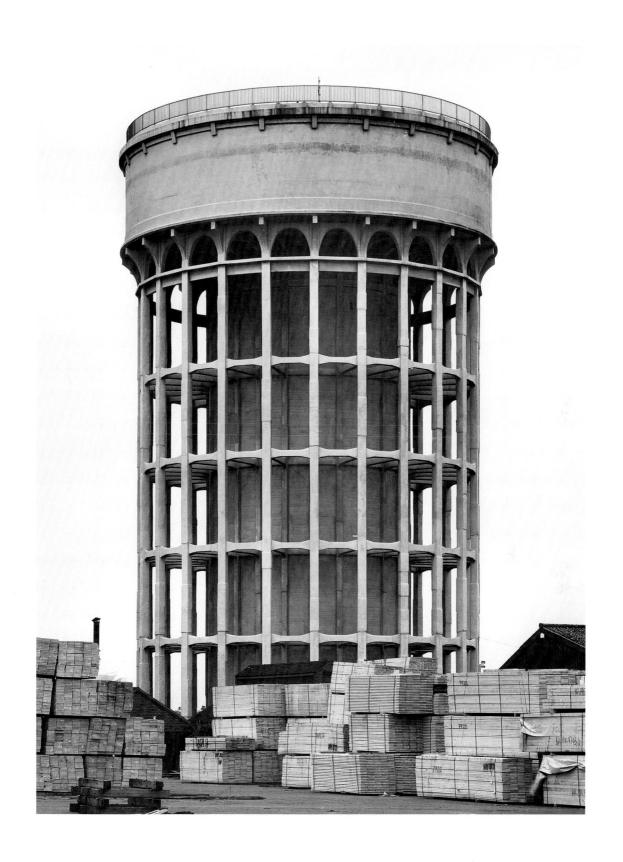

Goole, Great Britain, 1997

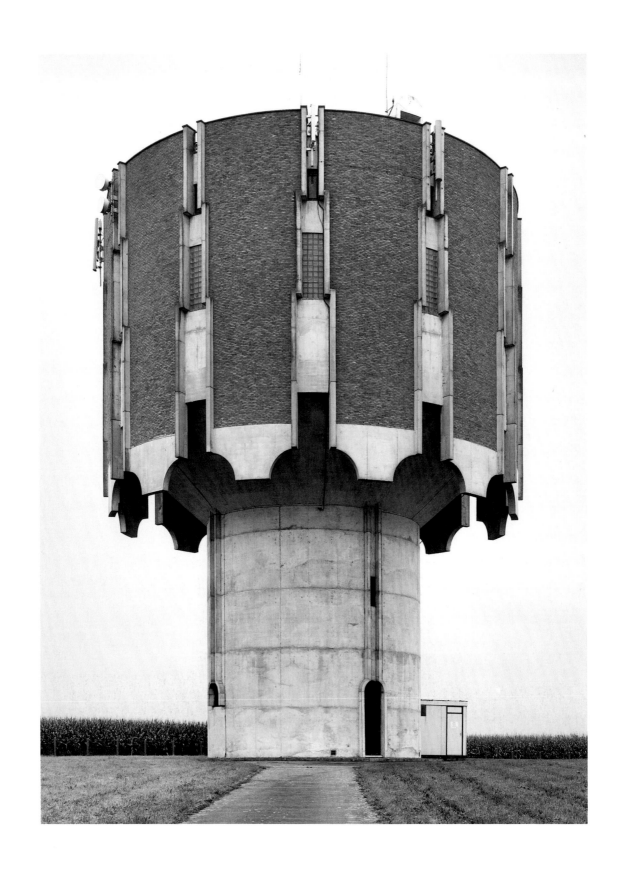

Lessines, Belgium, 2010

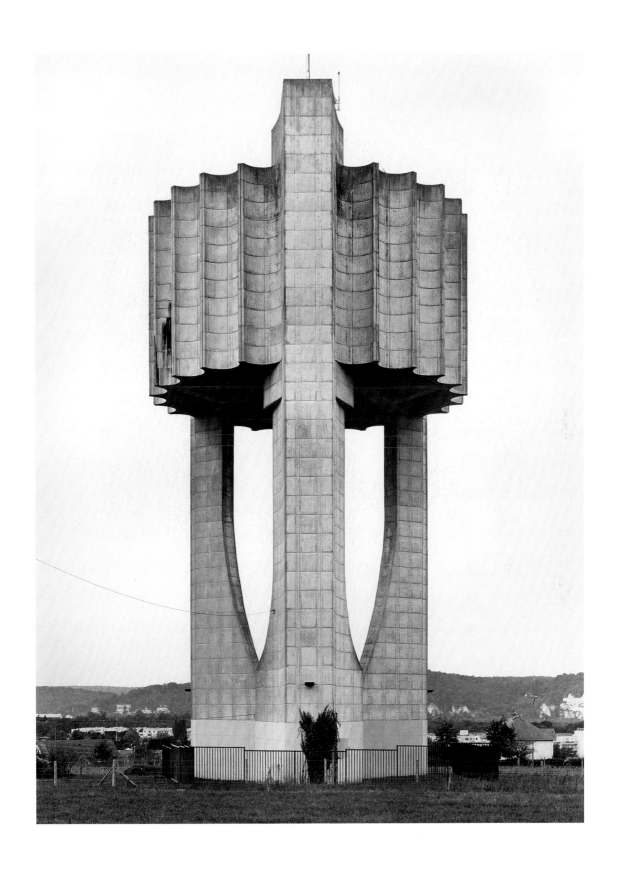

Saint-Aubin-lès-Elbeuf, France, 2012

STEPHEN SHORE

———The series *Greetings from Amarillo, "Tall in Texas"* (1971) by **Stephen Shore** (b. 1947, USA) was not only inspired by picture postcards, but was conceived as such. Assuming that these ten photographs of mundane street scenes would be a hit with the New York conceptual crowd, Shore printed a total of 56,000. The cards did not sell in New York and so he took them to the sort of non-metropolitan, unfashionable places he was photographing — petrol stations and tourist shops — and surreptitiously stuffed them into the postcard racks. He went back later to find that the cards had been purchased, although presumably not by the same people that would now spend thousands of dollars on one of them. So these postcards — taken and intended seriously — pivot on an uneasy line between metropolitan appreciation of the 'mundane' and the question of how ordinary spaces are perceived by those who live in them.

Christy Lange compares them to the genre of 'Boring Postcards',[1] implicitly referring to Martin Parr's collection of mostly post-war postcards of Modernist structures — airports, Arndale Centres and council estates, re-contextualised many years later as glorious follies or ironic statements of hubristic or merely shabby banality. Shore's images, unlike those rainy vistas of poignantly optimistic concrete, are of a landscape that was in its time increasingly successful, as the industrial urban areas of the north-eastern United States began to be supplanted by the un-unionised suburban sprawls of the south and west — the 'sunbelt' at the expense of the soon-to-be 'rust belt'.

This was an America uncharted by East Coast aesthetes, with certain exceptions — most obviously Walker Evans, whose influence on *Greetings from Amarillo, "Tall in Texas"* is obvious and acknowledged, particularly through the preference for the framed view, for closed worlds over the continuum of reality visible in the work of a photographer like Robert Frank. Peculiarly, given the economic growth in the south at the time, affluence is not always conspicuous in the postcards/ photographs, although the bright colour created by southern weather and glossy printing certainly is. There are images of imposing, shiny new mirror-glass office blocks, of rainbows arching behind a motel, of clapboard houses painted with a blue sky and clouds; but they are also documents of a messy, chaotic, unplanned landscape.

Perhaps because of this, the photographs have an anticipatory nostalgia. Lange claims that this comes from Shore's ability to spot the sort of pop-cultural or consumerist minutiae that will later be the object of nostalgia.[2] It was a trick that he learned in his years documenting the Warhol factory, the result of 'the same intuitive sense that there would be a use for photos of a young band called the Velvet Underground or a taste for pictures of Formica tabletops and peeling facades of run-down stores.'[3] In that sense, the shabbier aspects of *Greetings from Amarillo, "Tall in Texas"* can be imagined as a pre-emptive recording of townscapes that would, sooner or later, be destroyed — perhaps by the march of mirror glass and the expansion of the parking lots, which are visible in some of the images. In this Shore was proven right. The antiquated world of Googie signs, leatherette booths full of loneliness or intrigue, or even Miesian office blocks being supplanted by the more rhetorical architecture of Postmodernism, all now inescapably summon a nostalgia for the 'real America', perhaps particularly in the circles that originally spurned Shore's postcards.

These ten postcards are also an architectural project, of a sort. They document the built environment in a way that sidesteps explicit criticism, but also avoids the celebration of the sunbelt that was rife in the early 1970s, in books such as Venturi, Scott-Brown and Izenour's *Learning from Las Vegas*, or Reyner Banham's *Los Angeles: The Architecture of Four Ecologies*. They have instead a rather quizzical, deliberately uneasy perspective. Shore has written of the difference in architectural photography between photographing places because of their 'architectural interest' or those that are about the 'built environment ... photographed as a record of what a place looked like', where 'architecture [is] a visible face of forces shaping a culture.'[4] If Banham and Venturi/Scott-Brown/ Izenour confronted the old idea that there was no architecture in LA or Vegas by finding some, albeit of an unexpected kind, and praising it, Shore took a different approach, adopting an ambiguous view of townscape that neither praised nor blamed. At the same time, the obsessive, almost tangible richness of the photographs speaks of a particularly consumerist nostalgia.

OH

Badlands National Monument, South Dakota, July 14, 1973

Bellevue, Alberta, August 21, 1974

Taylor Street and West Fifth Street, Fort Worth, Texas, June 13, 1976

West Fourth Street, Fort Worth, Texas, June 18, 1976

Beverly Boulevard and La Brea Avenue, Los Angeles,
California, June 21, 1975

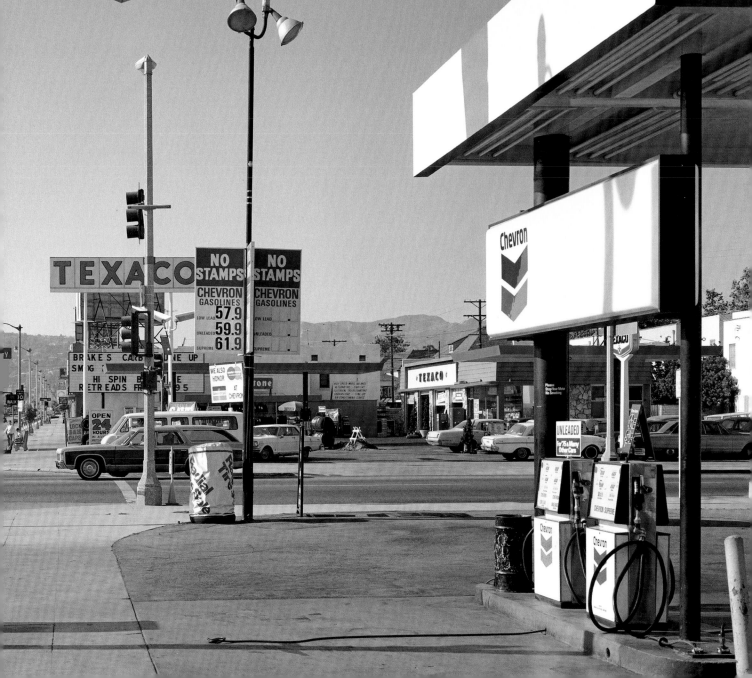

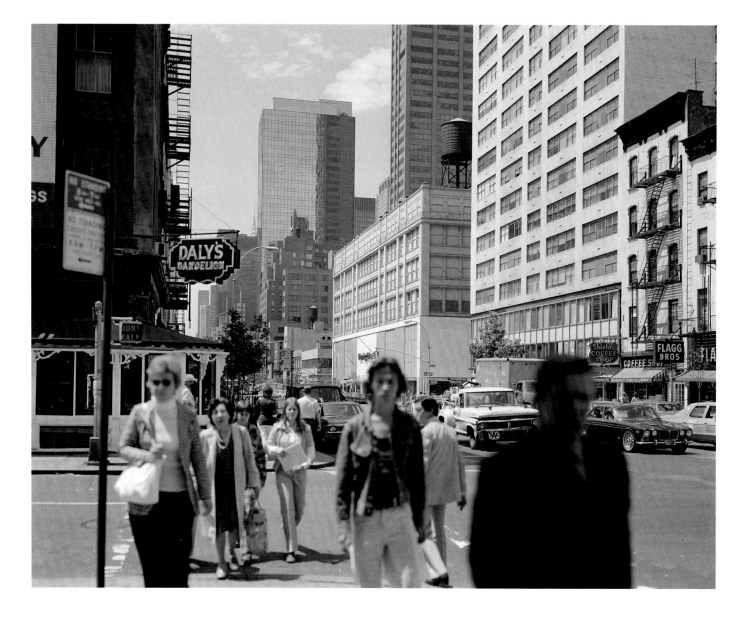

Third Avenue, New York, New York, June 23, 1974

Lexington Avenue and Sixty-Fifth Street, New York, New York, June 23, 1974

Holden Street, North Adams, Massachusetts,
July 13, 1974

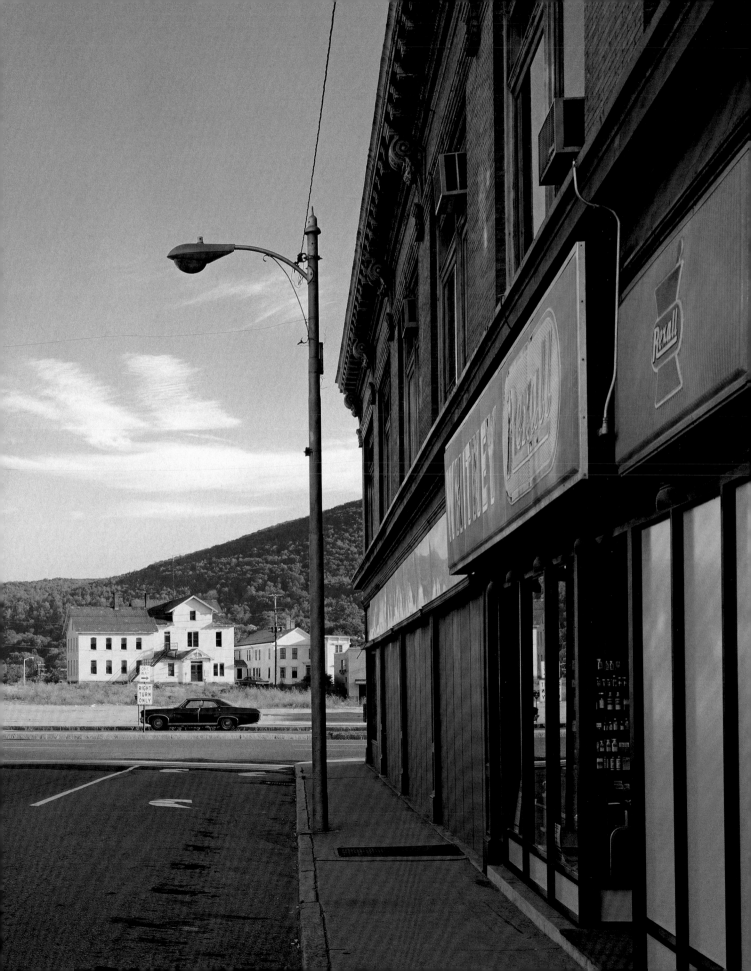

Double Dip
1323 S. Polk

Pub. by S. Shore - T. Wagner

Post Card

PLACE
STAMP
HERE

82812-C

dp MADE BY
DEXTER PRESS, INC.
WEST NYACK, NEW YORK

Postcards from Greetings from Amarillo, "Tall in Texas", 1971

THOMAS
STRUTH

————**Thomas Struth** (b. 1954, Germany) began his series of street scenes, *Unconscious Places*, in the late 1970s. At that time, the street was making a comeback in architectural and town planning circles after decades of criticism and obliteration. Le Corbusier's oft-quoted dictum 'we must kill the street' can be related to two preoccupations. On one level, Le Corbusier wanted to eradicate the dense, noisy, treeless and chaotic urban artery, because he thought he had something better to offer in the form of the Ville Radieuse, where high-rise apartment blocks would be set within parkland. Less attractively, his campaign against the street can be related to a political project, which was to convince the authorities that his reforms, like those of Haussmann in nineteenth-century Paris, were essential to avoid revolution. The street was where the dangerous classes congregated: if they were tamed — by wide streets in the nineteenth century, by no streets at all in the twentieth — a potentially restive urban population might be pacified. It was never quite clear whether the obliteration of streets was intended as an act of liberation or suppression.

Even among architects in the 1920s and 1930s, Le Corbusier's campaign was not widely accepted. Designers such as Bruno Taut, Michel de Klerk and especially Erich Mendelsohn excelled in the creation of streets, emphasising their dramatic effects through corners, entrances and other features to lead and please the eye. The resurrection of the street came with the success in the early 1960s of Jane Jacobs' book, *The Death and Life of Great American Cities*, in which all the things that once signified 'slum' — such as high density, short blocks, 'mom and pop stores', lack of greenery, multiple uses and lack of zoning — were completely revalued. Twenty years later, the street in turn had become the new orthodoxy. Towers in parkland, desolate open spaces and a lack of corner shops came to signify urban impoverishment. What is remarkable in the first run of Struth's *Unconscious Places* is how, while the spaces themselves are impeccably Jane Jacobs-like — dense, treeless, unashamedly urban — all the 'vibrancy' and mix of uses, all the inherent 'fun', has been stripped out to leave places both full (of buildings and development) and empty (of people, largely, and something less tangible, rather harder to pinpoint). Perhaps that is because so many of Struth's early studies were of cityscapes in West Germany. Having been bombed by the Allies, cities such as Cologne or Düsseldorf were not usually reconstructed on radical Corbusian terms. What happened instead can be seen in *Düsselstrasse, Düsseldorf* (1979) or *Sommersstrasse, Düsseldorf* (1980) where the late-nineteenth-century street pattern remains, but the buildings have been reconstructed in a semi-modern style, devoid of Wilhelmine frippery. These rushed cityscapes can be found in abundance in the films of Rainer Werner Fassbinder, the peculiarly amnesiac modernity of the old West Germany resulting, in urban terms, in an apparently blank canvas that nonetheless retains the shape of the old city. The only dash is offered by the *gemütlichkeit/* Modernist hybrid of the sign on the Hotel Boersen, in *Kreuzstrasse, Düsseldorf* (1977). Although they are presented with extreme objectivity, these are streets with something to hide.

London, meanwhile, as seen in *Clinton Road, London* (1977) is bleaker still. The street is Victorian, but it looks as if the war has only just ended. Other photographs capture urban conflicts between the 'street' and 'anti-street' factions. In *115th Street at 2nd Avenue, Harlem, New York* (1978), a shabby nineteenth-century street front faces widely spaced modern housing blocks, while a classical portico marks the end of the disrupted axis. The later subjects of *Unconscious Places*, particularly the megacities of East Asia, shift the emphasis again. Here the 'street' has sometimes disappeared entirely, leaving only a concrete pathway with a view of dramatic but empty-looking skyscrapers. *Buksoe Dong, Pyöngyang* (2007), is an image of overdevelopment masking urban failure; while in *Shinju-ku, Tokyo* (1986), the city is just towers, linked by elevated roads. However, to read into the photographs of those two cities a critique of the apparently successful killing of the street would be strange — are they really any less disconsolate and depressing than the 'real' streets of 1970s London or Düsseldorf?

OH

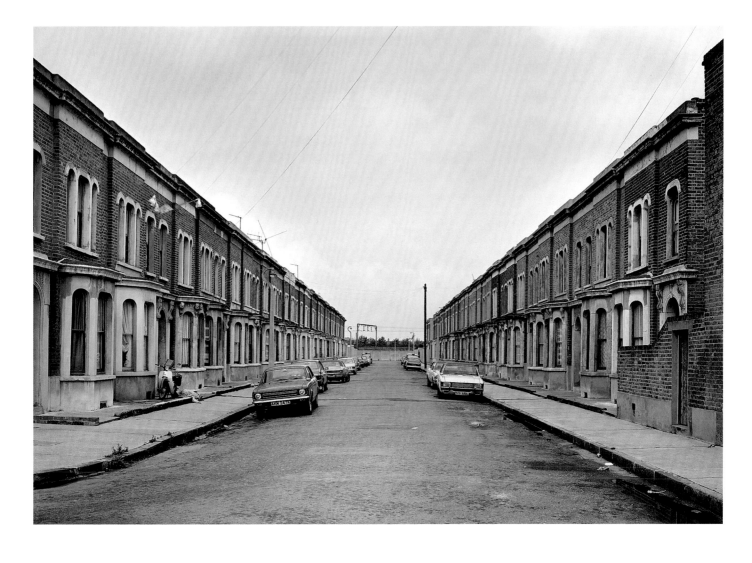

Clinton Road, London, 1977

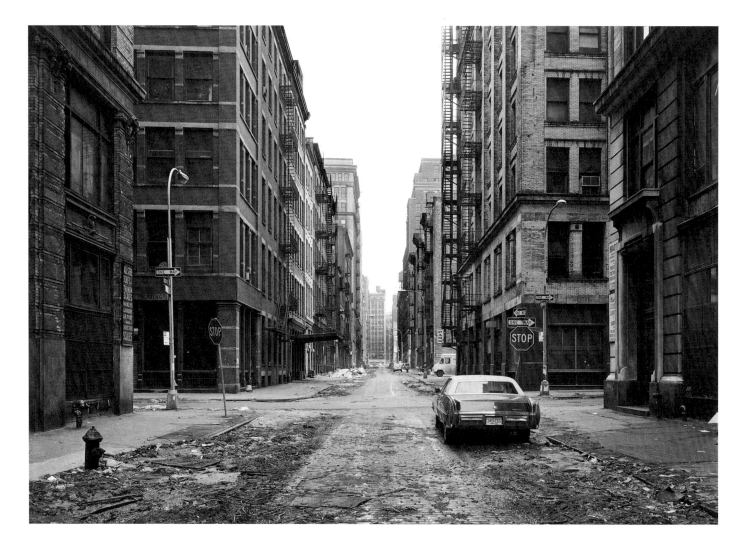

Crosby Street, New York, Soho, 1978

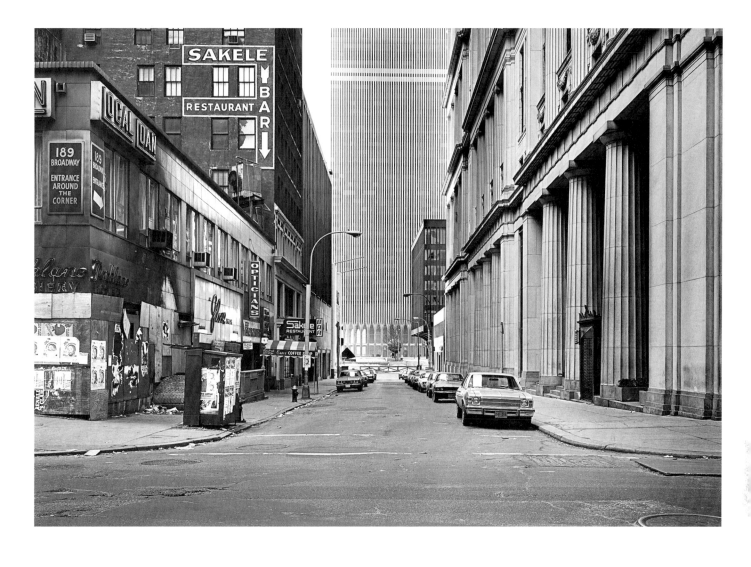

Dey Street, New York, Wall Street, 1978

Buksoe Dong, Pyöngyang, 2007

Le Lignon (Horizontal), Geneva, 1989

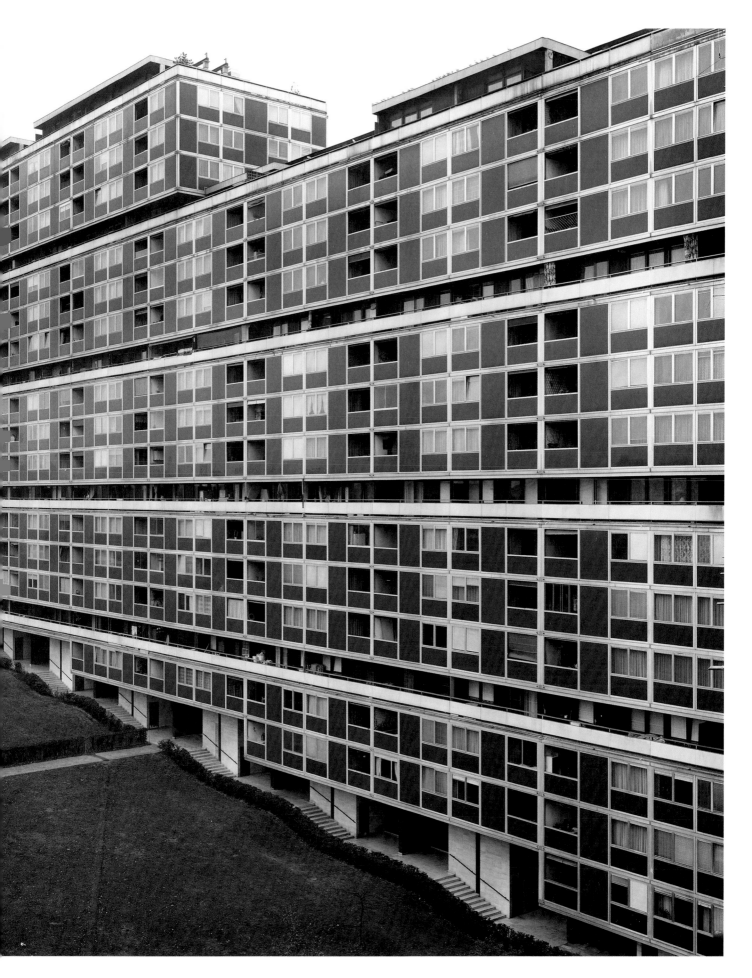

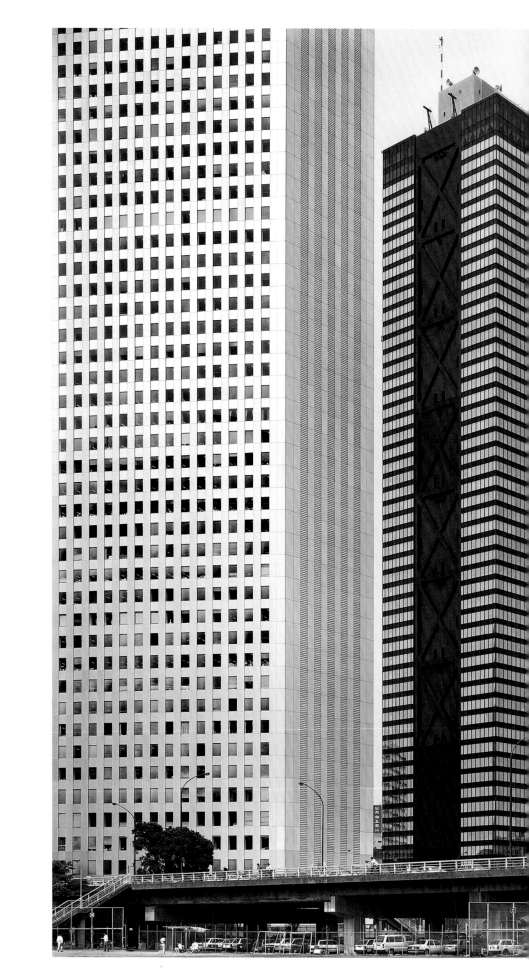

Shinju-ku, Tokyo, 1986

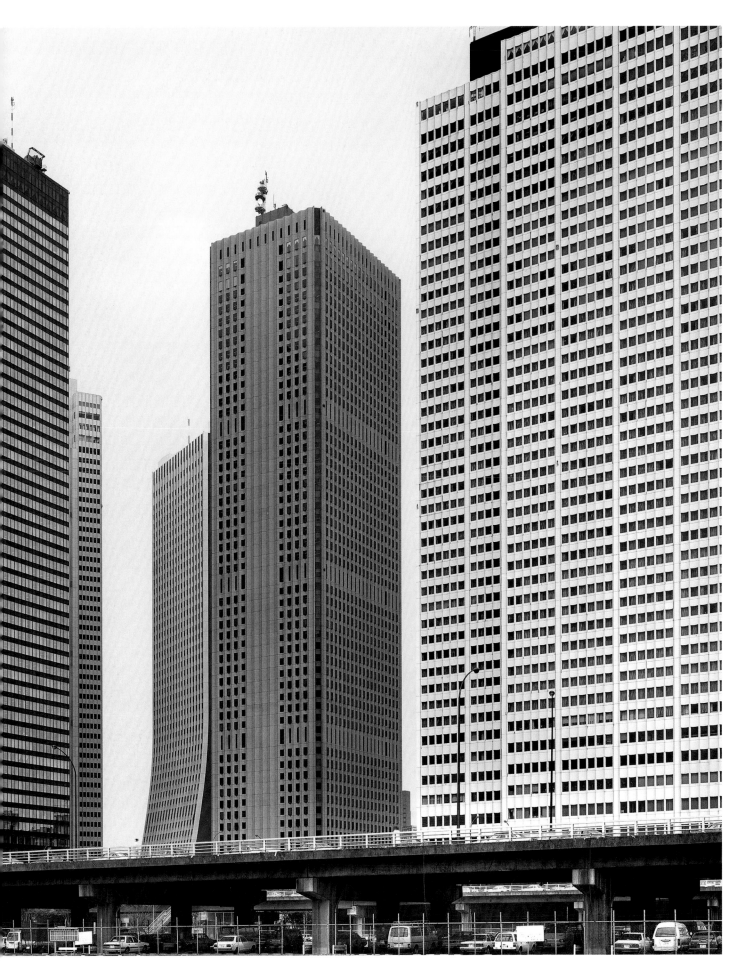

LUIGI
GHIRRI

'As we know, a route exists that begins with conceptual design, passes through well-established design phases, and culminates in the construction of the building. The completed project is then authenticated by photography. At the end of this route we have a kind of stereotype of the architectural image, very similar to a "still life" but executed out-of-doors. Although these still lives often seize and hold attention, through their singular and dizzying precision, they remind me of photographs of architectural models rather than of realised buildings. The skies are almost always clear and unchanging; the camera is centred on the axis and equipped with a decentring lens, so as to avoid distortions; the focus is exact, to obtain maximum clarity. This is the functional if fascinating ritual through which architecture is translated into something for the archive or the museum … I thought of all this again as I searched for a new way of describing architecture.'[1]
Luigi Ghirri

'Ghirri's photographs of my work as well as my studio are that "something new" that only an artist recognizes. And I see in them something I was looking for but never found.'[2]
Aldo Rossi

——A lauded pioneer of colour photography as an art form, from the 1970s **Luigi Ghirri** (b. 1943, Italy; d. 1992) approached the medium as 'a large magical toy that succeeds in bringing together the large and the small, illusions and reality, our adult awareness and the fairy-tale world of childhood.'[3] His work surveyed the world with a deceptive lightness of touch, packing a graphic and chromatic punch into a body of images that, with casual elegance, poetry and deadpan humour, created new narratives from the everyday. Ghirri is often celebrated as an unsung Italian peer of American contemporaries such as William Eggleston and the New Topographics[4]. Yet while he shared their fascination with the 'man-altered landscape' and the changing world around them, his own work offers a more elegiac take on the photographic form. Rooted in a meeting of the past with the present his work often uses melancholy and wit to question the very nature of representing the world at a time in which 'the only possible journey now seems to be within the sphere of signs and images.'[5]

It perhaps comes as a surprise that such an open and endlessly roving anthropological eye would settle upon an extended 'strange collaboration', in Ghirri's words, with the work of Aldo Rossi.[6] Beginning in 1983 as a commission from the Italian architecture magazine *Lotus International* to document Rossi's San Cataldo Cemetery, in Modena, over the years Ghirri shot numerous Rossi projects, including an exploration of the Veneto for the architect's 1985 submission to the Venice Biennale, photography for two monographs on Rossi's work, and ——in one of the artist's final projects — a portrait of the architect through the ephemera and 'interior landscape' of his studio; a portfolio which was executed in parallel with Ghirri's shooting of the atelier of the painter Giorgio Morandi (1890 –1964).

Early in his career Ghirri worked as a surveyor, learning 'many things about space, the landscape, the stone-by-stone construction of a space, beginning with a plan', training his eye to the creation of the built environment.[7] His early work would employ this eye to map the world around him, in particular his home region of the Po Valley, in Northern Italy, which he personified as 'my room.' This formerly agrarian region underwent rapid industrialisation in the twentieth century, offering a case study in the changing nature of contemporary space. Neorealist filmmakers such as Fellini and Antonioni would explore the terrain; Ghirri would document it though a postmodern lens, attuned to estranging the familiar.

Rossi's Modena Cemetery arrived in the midst of this landscape, designed in the architect's signature use of reduced geometric forms and urban quotations. 'Works like this, so simple and linear — a pierced red cube and, a little farther away, the long extended line of pink and azure building — show themselves full of an unpredictable vitality', Ghirri commented.[8] Rossi's archetypal and symbolic forms — circles, squares and triangles — share conceptual ground with Ghirri's own exploration of 'the borderline between cliché and reality'[9] and his ability to make the generic unique, whilst proving a fertile subject for a photographer whose own precise work could sometimes be seen 'as line drawings laid out on a computer … extracting two-dimensional sculptures from the man-made land.'[10]

Ghirri was also a writer, teacher, curator and publisher. Despite most of their collaboration being conducted at a distance, he found in Rossi a polymathic spiritual and professional counterpart: 'a poet who happened to be an architect'.[11] Throughout his life Rossi kept diaries he referred to as 'autobiographies', 'repetitive fragmentary texts between memoir and meditation',[12] which append the 'subjective nostalgia'[13] of his work and his theorisation of the city as a 'collective memory'.[14] Rossi stated: 'I believe that today we live in a world that cannot be repaired, a world of psychological and human fragments … I always say that our true invention as architects is to determine how to connect all these fragments together.'[15]

A parallel search for choreographing meanings, memories and connections through fragmented form is found at the heart of photography itself, and acutely so in Ghirri's work. The artist professed a desire to document '"zones of memory", localities that demonstrate more than others that reality is transformed into a grand story.' Despite Ghirri's aversion to the genre of architectural photography, which he perceived as typically transforming living reality into an ascetic 'still life', so began a dialogue with Aldo Rossi that would continue until the photographer's death; refining the vision of both towards their own work, and educating the quest of each to imbue form with narrative.

Upon Rossi's winning of the Pritzker Prize in 1990, the jury praised his work as 'at once bold and ordinary, original without being novel, refreshingly simple in appearance but extremely complex in content and meaning.' They could have been talking about Luigi Ghirri.

JJ

Cemetery of San Cataldo, Modena; the Ossuary in Winter, 1985

Above:
Cemetery of San Cataldo, Modena, 1983

Right:
Cemetery of San Cataldo, Modena; 'The Blue of the Sky', 1983

Above:
Elementary School, Fagnano Olona; library interior
and view of the chimney, 1987

Left:
Elementary School, Fagnano Olona; the interior courtyard
seen from the stairway facing the library, 1987

Elementary School, Fagnano Olona, 1987

Elementary School, Fagnano Olona; pergola and chimney, 1987

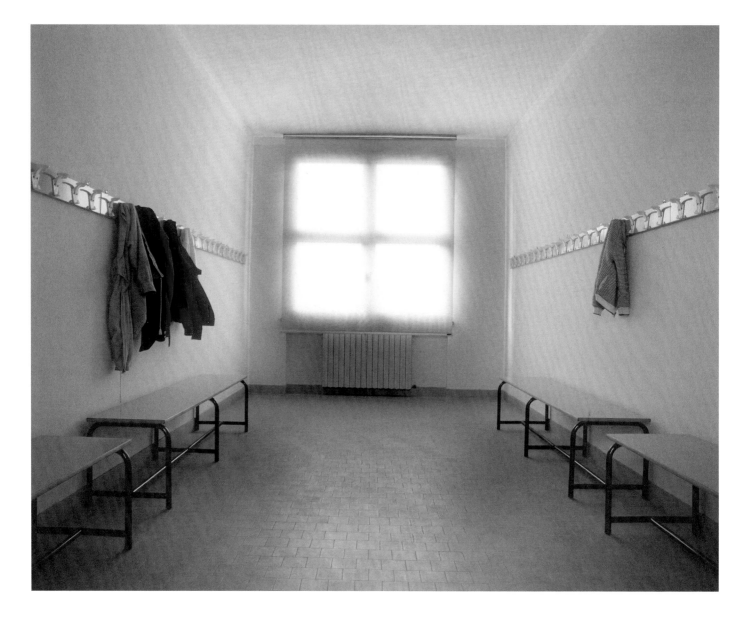

Secondary School, Broni; interior, 1987

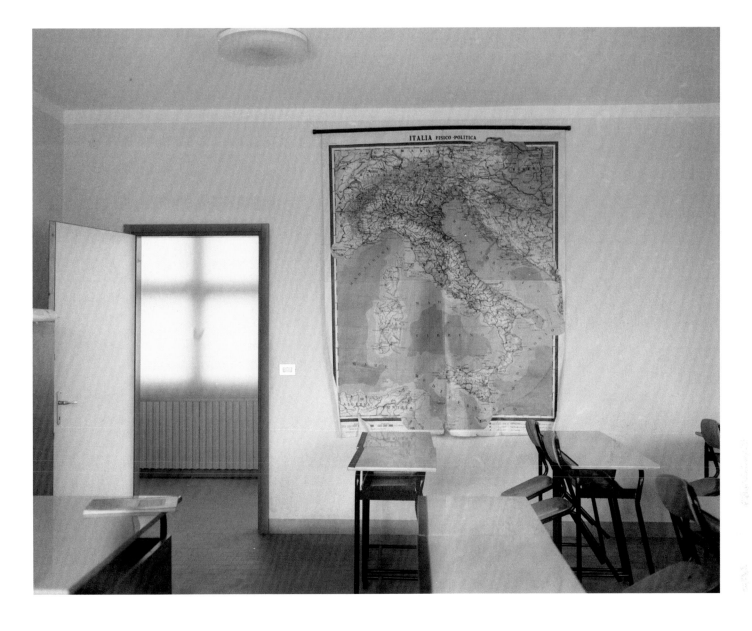

Secondary School, Broni; interior, 1987

HÉLÈNE BINET

———Hélène Binet (b. 1959, Switzerland) is a conductor of fragments, a composer of space, and a director of light and shadow. She works predominantly in black and white, and is a vocal advocate of film, the large-format camera and visual reduction. Her architectural photography is chiefly the result of direct commissions from her architect clients, a product of close confidence from the profession in her ability to respect and elucidate the specific story and concept of an individual building, and testimony to the discipline's need for strong images to mediate its built work. Her ongoing relationships with architects including Peter Zumthor, Zaha Hadid, David Chipperfield, Caruso St John, Daniel Libeskind and, more recently, with Studio Mumbai attest to a nuanced collaboration and trust between designer and photographer — and a deep mutual respect for each other's vision.

Born into a family of musicians, Binet studied photography at Istituto Europeo di Design in Rome and cut her professional teeth as photographer for the Grand Théâtre de Genève before her journey into architecture began as the result of a re-kindled friendship in the mid-1980s with architect Raoul Bunschoten — whom she would later marry. Through Bunschoten she met Libeskind and discovered the vibrant scene around the Architectural Association (AA) in London (then under the chairmanship of Alvin Boyarsky) becoming the visual conduit and a nuanced reflector of an emergent generation's architectural concepts and form.

Such beginnings help to contextualise Binet's singular output. Her body of work is typified by a deeply personal and sympathetic engagement with architecture and its protagonists, a focus upon fragmentation and form-making which could be viewed as a quiet product of the legacy of Deconstructivist tendencies nurtured by the AA school and, moreover, a theatrical sensibility born of her experience of photographing opera and ballet. This grounding in the documentation of performance would lead her to envision buildings as stage sets, often shrouded in darkness and pierced by light, inviting or waiting for the viewer's entrance and the act of occupation.

Binet's images create a depth of space that both belies and utilises the photograph's two-dimensional form. Walls and planes emulate the perspective conjured by theatrical stage flats, and the photographic frame renders volume as a backdrop. Yet her images are not illusory, but instead concerned with form making as a compositional exercise enabled by the technological apparatus of her medium. Acutely aware of the impossibility of capturing the phenomenological experience of being in a building, Binet revels in the photograph's ability to re-vision in order to create a powerful, independent image from the materials of volume and light — to say more, by saying less, through focusing upon the silent spaces within the complexity of built form. She fixes upon fragments so as not to compete with the totality of a structure, not to act as a stand in for the experience of truly being there. Instead she offers an empathetic distillation of the essence of an architect's vision. 'I often compare my position with a musician and a score. There is a score, there is a spirit, and I have to follow that. I am not an independent artist that completely moves away alone with my own individual interest. I have to follow what the style is — and in that case, I stay very neutral.'[1] In architect John Hejduk's words, Binet creates 'photographs of the dreams of the architect of the building'.[2]

This empathic attempt to co-exist with her subject is present in Binet's photographs of Daniel Libeskind's Jewish Museum Berlin. Photographed during the building's construction, before doors or exhibits would functionalise the formal qualities of the space, Binet created a series of images that capture the drama of the building and the piercing voids, or scars, of Libeskind's monumental design. 'I was playing with this very strange sensation that my camera — a film camera … a box that collects light and that light is going to enter through the lens and just touch the surface of the film — and the building in front of me was like a box with openings, and the light was touching the floor of the building and scratching it. So it was almost a dialogue between those two boxes.'[3]

In Binet's work, she and her camera become the protagonists of a silent dialogue between space and lens, as she acts within the building's scenario and interprets the architect's script. 'You could compare it to the pas de deux in ballet,' Binet has stated. 'The total image is made out of two bodies; you can't separate them. For me, that is photography of architecture: one final new shape is made out of the interaction between camera and building.'[4] The word 'camera' is etymologically descended from the Latin for 'room', its modern usage a shortening of 'camera obscura' — the darkened room that gave rise to lens-based image-making. In Binet's photography, the darkened room reappears as the matter of the photograph itself.

JJ

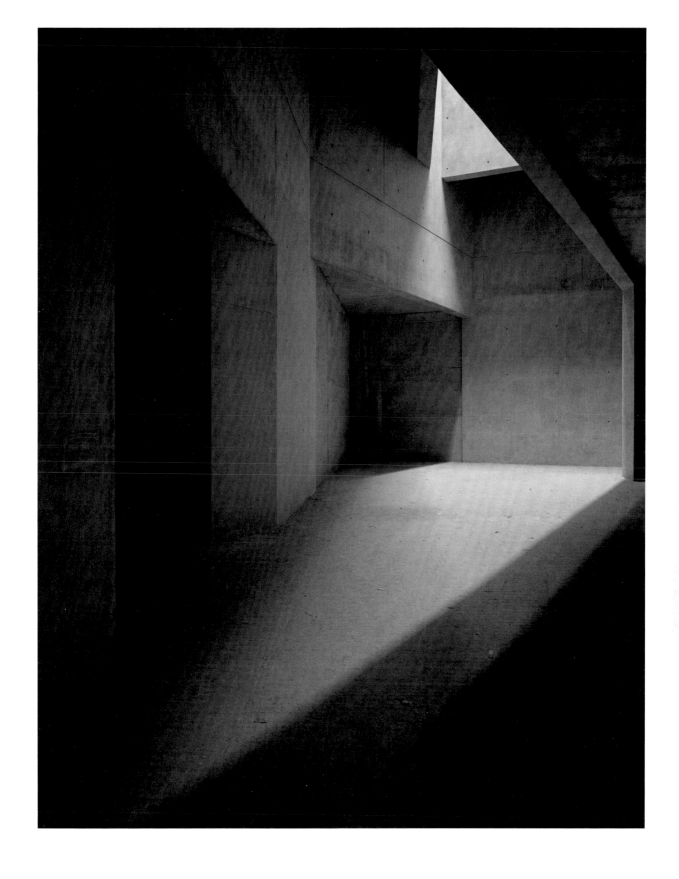

Jewish Museum Berlin, Daniel Libeskind, Untitled 2, July 1997

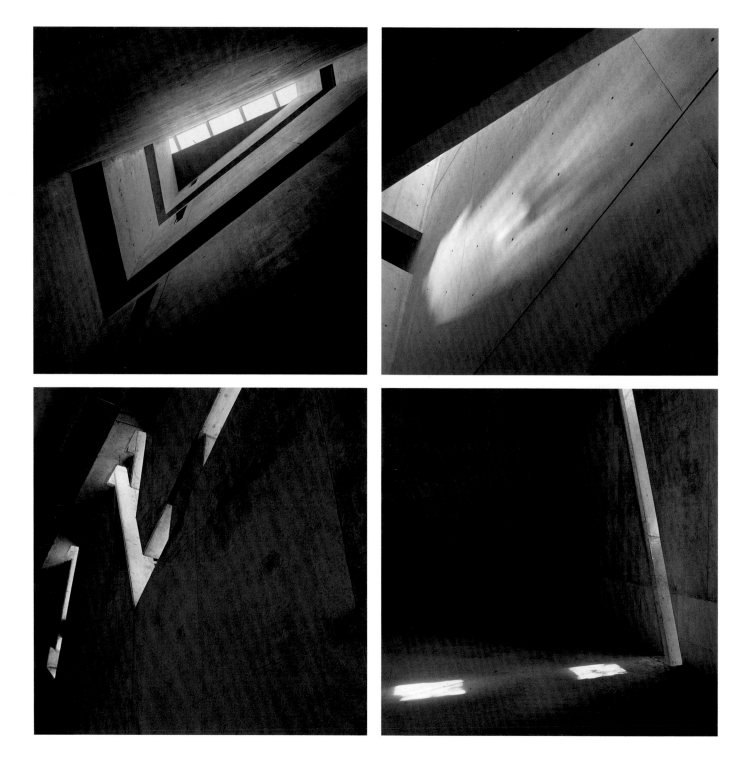

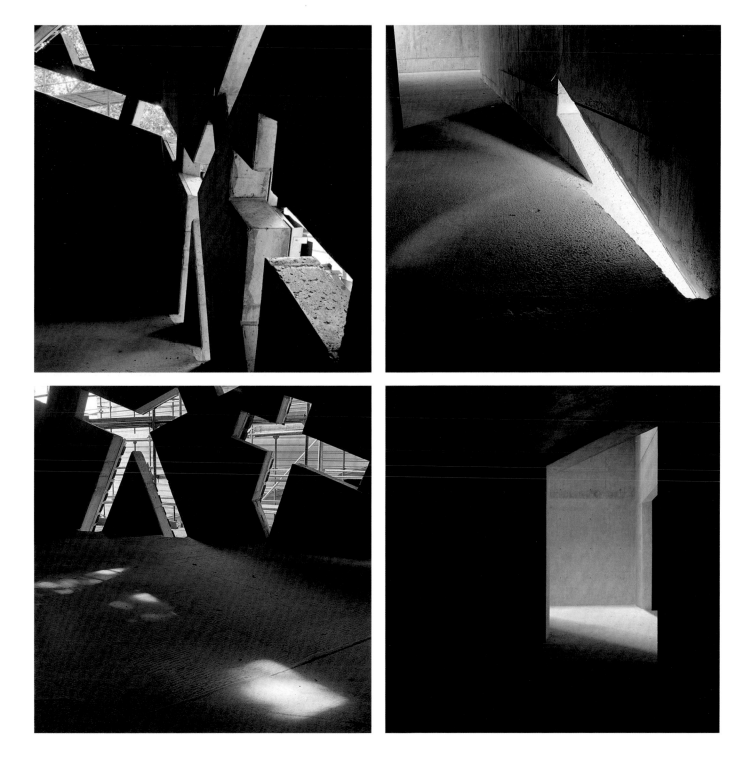

Jewish Museum Berlin, Daniel Libeskind, Untitled 3 – 10, July 1997

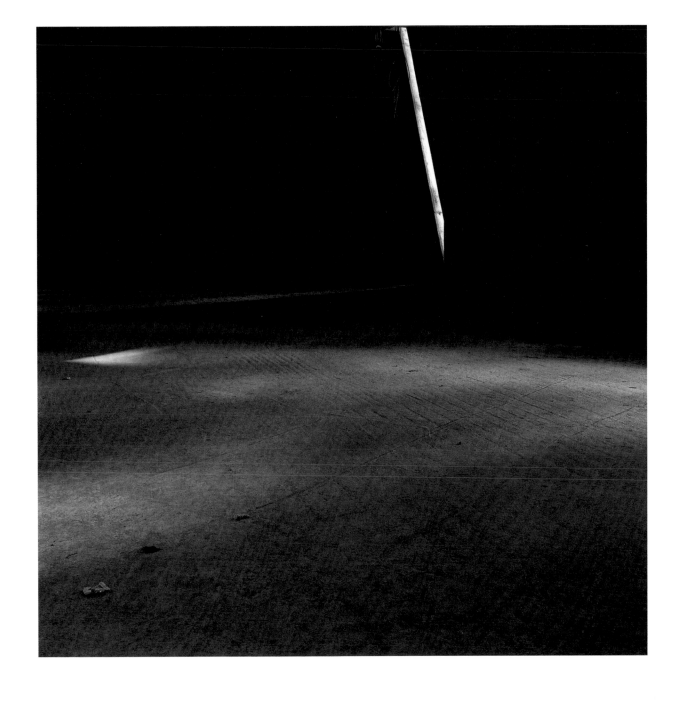

Jewish Museum Berlin, Daniel Libeskind, Untitled 1, July 1997

HIROSHI
SUGIMOTO

——Using minerals and chemistry to address questions of the hereafter, **Hiroshi Sugimoto** (b. 1948, Japan) is a modern day alchemist, as well as a scholar of history, science, religion, art and architecture. Through the lens of his late-nineteenth-century camera he fixes light in the manner of photography's pioneers and renders it visible through the medium of silver gelatin prints. He follows in the historical tradition of William Henry Fox Talbot[1], whose negatives he has both collected and transformed in the series *Photogenic Drawings* (from 2007); and invokes the technical secrets of Ansel Adams — Sugimoto's 'technical master'.[2]

An avid collector of ancient art, with a keen interest in the rituals and talismans evoked over the ages by humanity's contemplation of notions of life, death and eternity, his photographs seek to encapsulate such philosophies by acting as artifacts and engagements with photographic and historical time. Working always in series, he has transformed waxworks from Madame Tussaud's into historical portraits, lit as if painted by Hans Holbein (*Portraits*, 1999), practiced nature photography on stuffed animals in the darkened spaces of museum habitats (*Dioramas*, 1976), created hazily primal, meditative abstract images through the elements of water, air and the horizon line (*Seascapes*, 1980); and, in his breakthrough series, he shot entire movies on a single frame of film, rendering them glowing rectangles of light amongst an invisible audience in cinema auditoria (*Theaters*, 1978).

In 1997 Sugimoto began his *Architecture* series, creating an extensive personal taxonomy of some of the twentieth century's most notable architectural landmarks, such as Le Corbusier's Chapelle Notre-Dame-du-Haut de Ronchamp (completed in 1954), Tadao Ando's Church of the Light (1989) and Frank Gehry's Guggenheim Museum, Bilbao (1997). Shooting these buildings out of focus, adjusting his lens to what he has referred to as 'twice infinity', he softens Modernism's hard lines and makes the monumentally static appear to wobble and dissolve. His ethereal photographs present themselves as images of memories and disobey the more graphic conventions of architectural photography. 'Most of [the buildings are] in very bad condition', Sugimoto has commented. 'To make them an out-of-focus picture, all the wrinkles disappeared.'[3] The work seeks both 'to trace the beginnings of our age via architecture',[4] and to envision these buildings as ideological apparatuses. 'A finished building is a product of negotiation; I used an out-of-focus technique in an effort to regain a sense of the architect's core idealist vision for the building',[5] he has stated. 'I am trying to go backwards in time as a concept ... to capture the architect's image of the building, before they built [it].'[6] Yet, while he conjures these buildings into a dreamlike state of becoming, the photographs also have a sense of the gothic about them. Elsewhere, he has described this body of work as depicting 'architecture after the end of the world'.[7] Looming, depopulated, in a noir-ish light, the grain of the images seems to suggest the fragility and entropy to which they and we will inevitably succumb.

One of the icons Sugimoto photographed in 1997, at the beginning of this series, was the Empire State Building: the building Andy Warhol filmed for eight consecutive hours as the star of a 16mm moving-image portrait in *Empire* (1964). Where for Warhol the Empire State was a confident screen icon, lights coquettishly flickering on and off before bed in a durational epic, in Sugimoto's image the building appears to tremble with nervous uncertainty, fixed for the brief period of a single exposed frame. 'Life is a movie. Death is a photograph', wrote Susan Sontag.[8] 'The human eye, devoid of the shutter, is essentially a camera with long exposure', says Sugimoto.[9] In the *Architecture* photographs, the camera that lingered over the movie in Sugimoto's *Theaters* series instead transforms monuments into memorials in the blink of an eye — a sentiment literally embodied in his images of the now vanished World Trade Center (1971).

Both architecture and photography attempt to withstand time; the architect and photographer both articulate a vision for posterity. It is of consequence that in recent years Sugimoto has turned to the practice of architecture itself. In 2002 as an artist/designer he renovated and transformed the Go'o Shrine for the Benesse Art Site Naoshima. In 2008 he founded the New Material Research Laboratory (with architect Tomoyuki Sakakida), a practice (playfully and ironically) devoted to the resuscitation of traditional Japanese building techniques — a further agent of the artist's ongoing reflection upon history and time. Following a range of recent architectural commissions, he is currently designing his own museum — the Odawara Art Foundation. Fittingly, an element of the project involves an extended box that will end in a picture window pointing towards the Pacific Ocean, enabling Sugimoto to use architecture itself to create an endlessly changing version of one of his signature photographic works: a seascape.

JJ

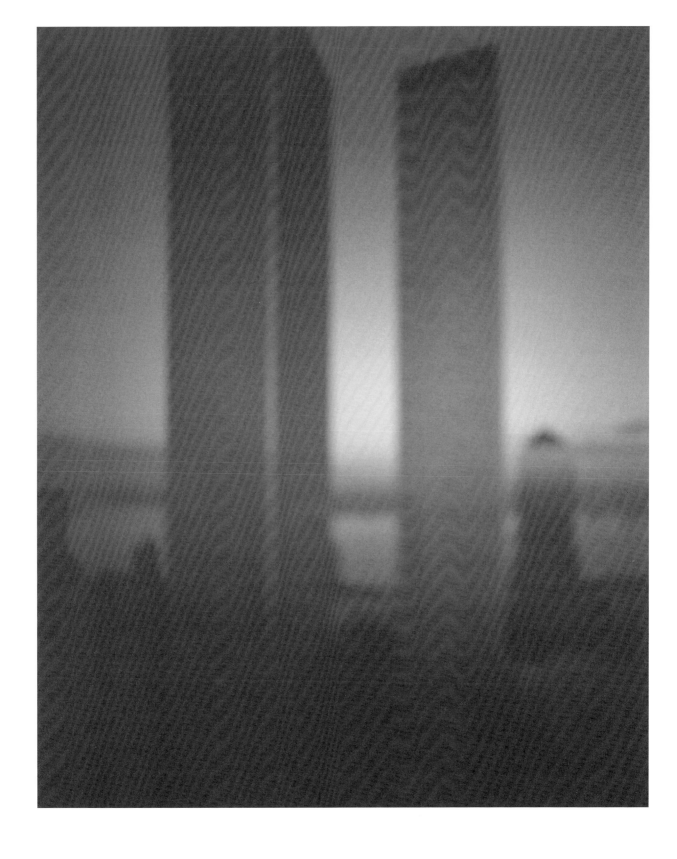

World Trade Center (Minoru Yamazaki), 1997

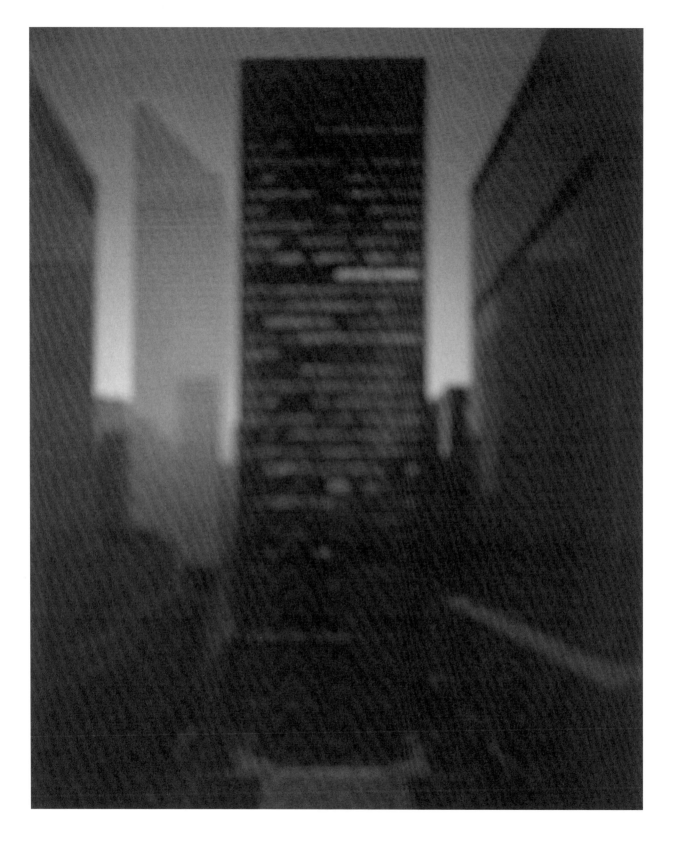

Seagram Building (Mies van der Rohe), 1997

Marina City (Goldberg Associates), 2001

Barragán House (Luis Barragán), 2002

Chapel Notre Dame du Haut (Le Corbusier), 1998

LUISA
LAMBRI

'It is quite frustrating, because in a way my work is not really about photography, nor is it about architecture, yet I always return to the camera and to the interiors. After all, I don't think of myself as a photographer, and most of the time for me, architecture is just a dream.'[1]
Luisa Lambri

——**Luisa Lambri** (b. 1969, Italy) was raised in Como. The Italy of her youth was a country at the peak of a radical design revival. Throughout the 1970s figures such as Ettore Sottsass, Superstudio, Aldo Rossi and Paolo Portoghesi contributed a polemical discourse to both the architectural scene and Italy's national identity, while influential magazines such as *Casabella*, *Domus* and *Lotus International* brought the writings and vibrant imagery of this group before an international audience. Lambri's work, it would appear, exists in response to such bombast; a détournement from the legacies of Modernism, masculinity and the grid; a domestication of architecture's big ideas about itself. Lambri voyages to, and catalogues, iconic Modernist architecture. She names her images after the places she visits, yet situates the work's content outside of those walls. However, as Roland Barthes has written, 'every exploration is an appropriation'.[2] Through her interactions with these sites Lambri attempts to repossess the weight of architectural history: a legacy forever present in her work, despite her disavowal of it.

Taking private residencies as her material, Lambri's photography focuses upon interior details of houses designed by some of the twentieth century's most celebrated architects, including Frank Lloyd Wright, Le Corbusier, Luis Barragán and Oscar Niemeyer. Working in sequential sets of images, Lambri focuses upon subtle shifts of perspective and changing light to portray the passing of time and the movement of her own body and gaze around a space. Taking as examples two photographs of an Oscar Niemeyer building — *Untitled (Casa de Baile, #01)* and *Untitled (Casa de Baile, #02)*, both dating from 2003 — one can see the subtlety that plays out across these photographic series. There is a slight change of density cast by the shadow of a pergola, a small step to the left, and an attempt through these tactics to render visible and capture a moment in the inhabitation of a specific site.

Lambri's interiors are both architectural and psychological; the interiority of her work's subject is both within the building and within the artist. Acknowledging the influence of Francesca Woodman's performative self-portraits in domestic space,[3] Lambri has elsewhere stated that in her own work she is 'trying to capture the shadow of my own presence as it is reflected on the architecture' to create self-portraits of absence through the sharing of her intuiting eye. This eye, Lambri says, 'arises from the condition of being a female in a male-created world'. She seeks to 'achieve personal distance from the dominance of Modernism in the architecture and aesthetic of twentieth-century Western culture' by injecting 'a female point of view into my photographs of buildings designed mainly by men.'[5]

Lambri's gaze often falls upon emptiness and details of buildings that lack specificity in relation to the totality of their design. It is an approach that could be seen to be making non-spaces from iconic places — of celebrating the limits of an architect's control. Vegetation is often found in her images, glimpsed through a skylight or window, portraying the encounter of nature with rational human order and the limits of a Modernist aesthetic. Transforming the casualness of the snapshot into a crafted artifact, Lambri searches for common colours, lines and shapes to unify her oeuvre in the creation of an endless house. 'Even though I have been taking photographs of many different houses and buildings, they are somehow the same house, and the same building,' she has said.[6] 'In a sense, I am building my own house from these details: the search for the ideal home in my pictures can actually be taken quite literally.'[7]

Windows, doors, thresholds and corridors form prominent motifs in Lambri's work, as if the artist is trying to escape from the architecture itself (and perhaps the strictures of its conceptual rigour). It is difficult not to correlate the camera's aperture with these architectural openings. For example, the shutters of the Barragán House she studies in her photographs (dating from 2005), read as metaphors for the camera shutter, as Lambri maps the encounter between enclosed architectural space and the world outside. In *Untitled (Barragán House, #04)*, the cross of light framed by the shutters gives Lambri's photograph a votive, sacral quality that reminds us of the pilgrimage she has taken to the site. Lambri's work is born of such pilgrimages, the product of a traveller's sensibility and an archi-touristic bent that searches for access to these private icons of architectural history and documents her inhabitation of them.

JJ

Untitled (Darwin D. Martin House, #02), 2007

Untitled (Darwin D. Martin House, #03), 2007

Untitled (Darwin D. Martin House, #05), 2007

Untitled (Darwin D. Martin House, #06), 2007

Untitled (Hollyhock House, #03), 2007

ANDREAS GURSKY

——With his signature detached and elevated 'god-like' eye, **Andreas Gursky** (b. 1955, Germany) has achieved stratospheric heights. Through epic visual parables, he has sought, in his own words, to create 'an encyclopedia of life'. Holding the record for the most expensive photograph ever sold,[1] his large-format renderings of contemporary reality have conquered the market and the public imagination through their skillful flattening of the modern world and the artist's seductive ability to update classical form and composition for the twenty-first century. Like history paintings for Francis Fukuyama's 'End of History',[2] his images have transformed stock exchanges and racetracks, landscapes and crowds, 99-cent shops and Prada products, buildings and cities into a richly composed catalogue of the human species and its environment.

A student of Bernd and Hilla Becher, Gursky entered the Kunstakademie Düsseldorf shortly after the graduation of Thomas Struth (who remained tightly in its orbit), and studied alongside Candida Höfer and Thomas Ruff. Together, the Düsseldorf School would have a hugely influential impact upon contemporary art photography, inheriting a new objectivity influenced by the Bechers' clinical exactitude in the serial documentation of industrial structures and typologies. While strong resonances within the group's formal and conceptual approaches are notable, Gursky's work has taken a singular path. He has introduced a romantic and spectacular subjectivity into this objective aesthetic, alongside a willingness to transform and alter reality — to manipulate facts in order to tell a greater truth and communicate his vision. It is a vision that sees with physical and emotional distance, and that seeks to map order on to complexity.

In his Renaissance treatise *On Painting* (1435) Leon Battista Alberti described the newly adopted science of perspectival painting as offering '*una finestra aperta sul mondo*' (a window onto the world). Gursky's photography, behind its Plexiglas surface mounted flush to the gallery wall, operates in the same continuum for a global era. However, Gursky's windows relinquish the traditional vanishing point in favour of an anti-hierarchal all-over flatness, swapping Renaissance perspective for the Modernist grid. Like a Jackson Pollock painting — one of which, *One: Number 31,* (1950), was the subject of a Gursky photograph, *Untitled VI* (1997) — this flatness privileges the image's surface, giving each detail the same focus and the same significance as an element in the choreography of the overall image. In so doing Gursky's photographs encourage dual modes of viewing, as the initial moment of dazzling submersion in the totality of the image gives way to a close examination of its details, conceptually and physically putting the viewer into a state of empathy with the artist's concerns for the macroscopic and the microscopic, the mass and the individual.

Gursky has often taken architecture as his subject matter, perhaps seeing it as an analogue of his own formal and conceptual concerns. As he has stated, 'My preference for clear structures is the result of my desire — perhaps illusory — to keep track of things and maintain my grip on the world.'[3] Within architectural form — from Norman Foster's Hongkong and Shanghai Bank building, in Hong Kong, to Oscar Niemeyer's residential Edifício Copan in São Paulo — Gursky finds parallel ordering structures and principles, which similarly attempt to choreograph and control lived experience through the medium of design.

In *São Paulo, Sé* (2002) we are immersed within a metro station in urban Brazil. The photograph is titled after the name of the station, christened Sé ('cathedral' in Portuguese) due to its location beside the city's Catedral Metropolitana. But one can also interpret the title and chosen site as a metaphorical nudge towards an understanding of the image as a depiction of a shrine to speed and modernity, to being elsewhere. The grandeur of Gursky's treatment of the building further attests to such a reading, as a nave emerges from the station's void. The photograph creates a subtly impossible perspective from the station's concrete floors, through Gursky's postproduction of the architecture through digital collage. He transforms the structure into a pattern, whilst the building he depicts simultaneously orders the movement of its users, who wait within the photograph, fixed for eternity. Separate yet together, teetering on the precipice, ordered by forces of which they are not conscious, the image concretises Gursky's concerns.

In *Paris, Montparnasse* (1993) — a very early example of Gursky's adoption of digital compositing (here necessary to avoid perspectival distortion of the graphically linear building) — Gursky contends with architect Jean Dubuisson's Mouchotte building. Conjuring an infinite geometric grid and abstract form from the building's facade, he creates an image that both talks to art-historical precedents such as Gerhard Richter's *Colour Chart* paintings (1966–74) and recalls Alfred Hitchcock's *Rear Window* (1954)[5] as a visual invitation to interrogate the residents for evidence. The photograph offers a monumental window on to the very framing of lived experience that is architecture's task, and moreover asserts Gursky's own role as an architect of reality.

JJ

São Paulo, Sé, 2002

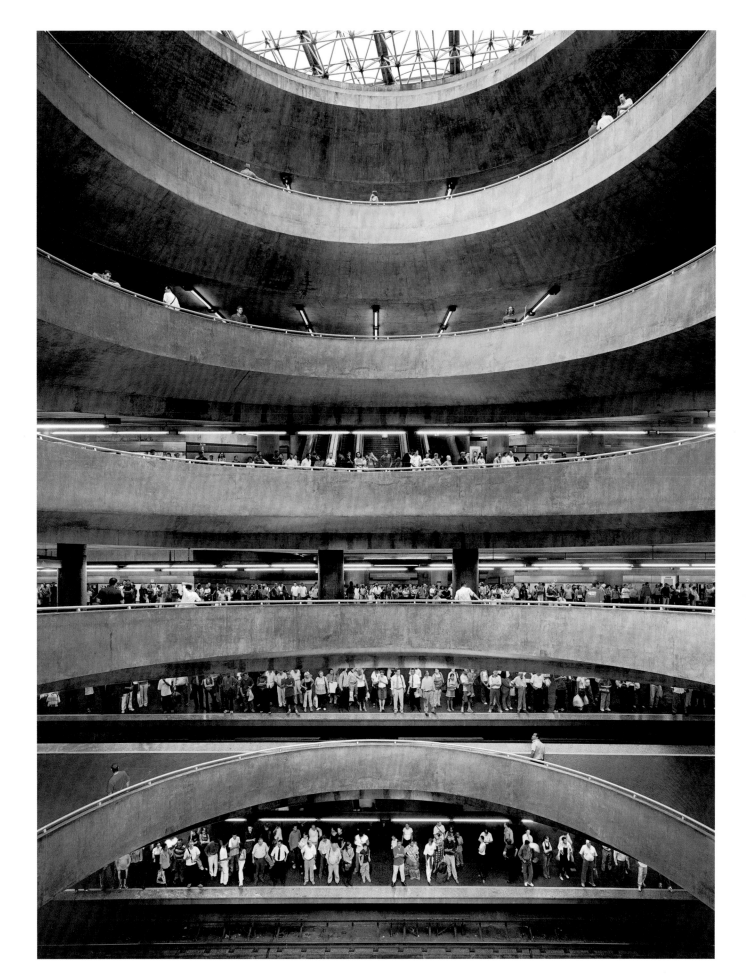

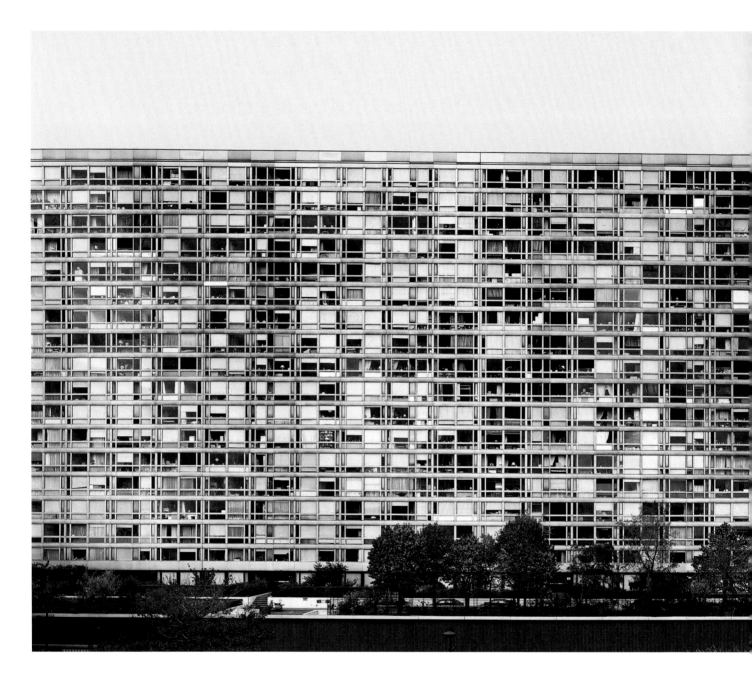

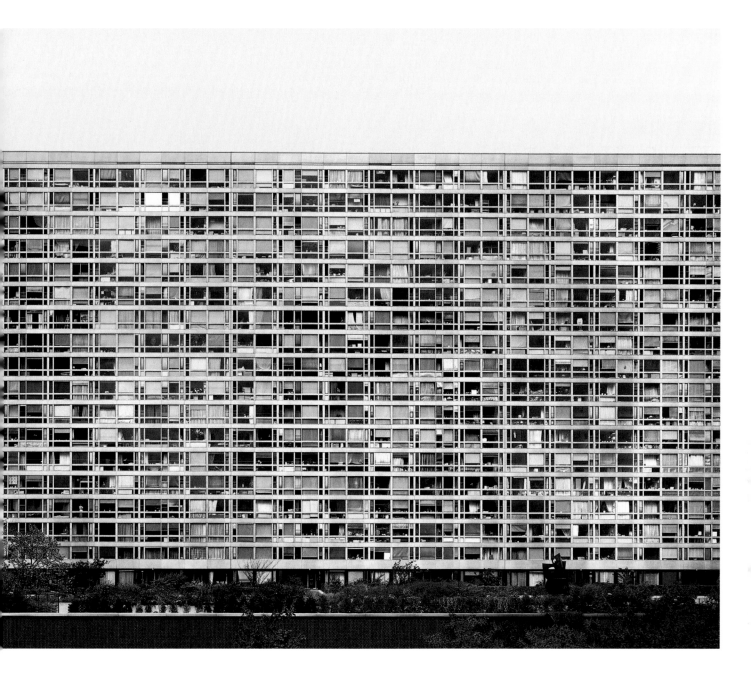

Paris, Montparnasse, 1993

Copan, 2002

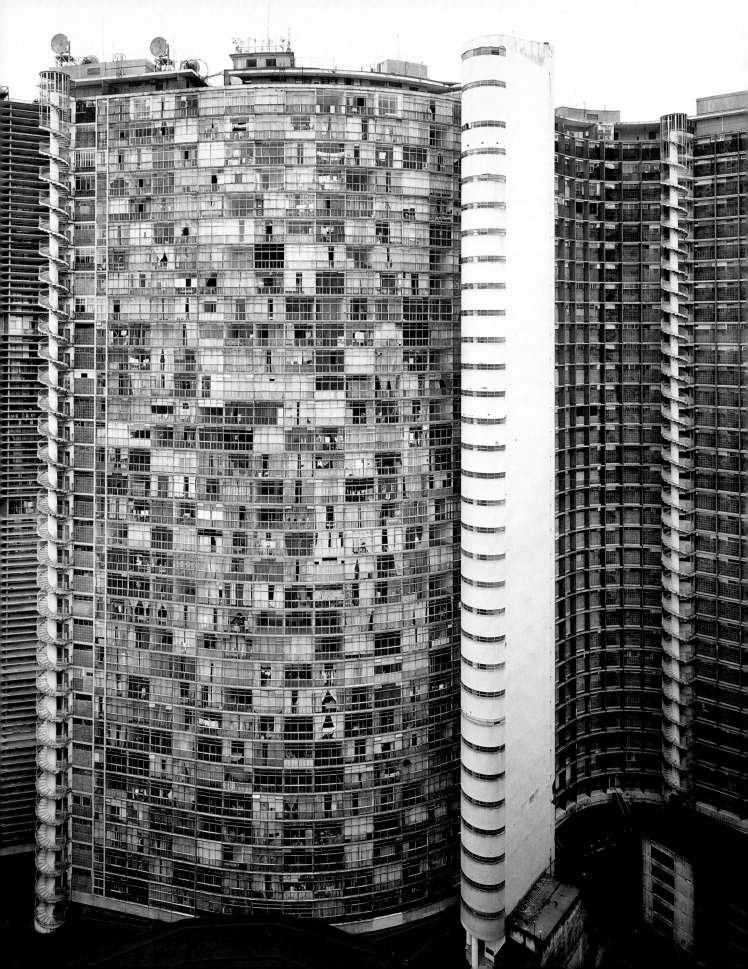

SIMON
NORFOLK

——Few of those who were present, in May 2011, will forget **Simon Norfolk**'s (b. 1963, Nigeria) talk at Tate Modern about his series of pictures from Afghanistan — *Burke + Norfolk*. The exhibition, which showed the work of the two photographers alongside each other — Burke's military, ethnographic and military photography from the 1870s and '80s, and Norfolk's contemporary reworkings — seemed restrained and ordered. The light falling on people, land and buildings is focused, ordered and governed by the geometry of the lens and the black box. The talk, by contrast, set out for those gathered in the gallery a dire and extended chronology of conquest, exploitation, oppression and racism. The 'heroes', as they are regularly described, of the British armed forces were revealed as an army of occupation, which had been in that land many times before to secure the Empire's strategic and material interests.

The juxtaposition of Burke and Norfolk pointed to a remarkable historical amnesia about imperial domination: as if the British had not merely lost their Empire but (largely) agreed to forget that they had once had it; certainly to forget that it was maintained with every weapon of war from aerial bombing (for example, of the 'restless natives' of Afghanistan between 1915 and 1919) to manufactured famine: the RAF bombed not just people but irrigation ditches to cause crop failure.[1] Forgotten, too, is how often that force was resisted.[2] As Norfolk has said in an interview, the current British intervention should be called the Fourth Anglo-Afghan War.[3] The Afghans, of course, like most populations subject to such attentions, have a clear and detailed historical memory of invasion, occupation and resistance.

There is a large contrast in subject matter and handling in Norfolk's two Afghan projects: the first, *Chronotopia*, undertaken as the Taliban fell in the face of Allied invasion in 2001, and the second, begun in 2010, when the country had been transformed by long-term occupation. In the first pictures, often taken in golden light at dawn, the history of the war against the Soviet Union and of the long years of sectarian violence are written picturesquely into the collapsed structures and pitted walls of apartment buildings, barracks and cultural monuments. It is as if a long and deadly storm has ceased and the sun rises on a world both old and new; it shines on fantastical ruins, as if in a perverted landscape by Claude Lorrain.

In the newer pictures, twilight predominates. Amid the ruins, the true shape of the new is revealed: the gaudy palaces of the drug traffickers and arms dealers; the bleak shanties in which live millions of people displaced by the violence (in shelters made from shipping containers, for instance); in alien infrastructure and buildings carelessly slapped over the old; and in the apparatus of security. It is this last that has had the greatest effect on urban life: the blast walls, checkpoints, vast military bases, and privileged enclaves for the rich and for foreign workers. As in Baghdad, constrained existences are lived in constant fear between looming concrete barriers. Utilitarian Modernism finds stark, ugly expression in the blast wall and the surveillance tower.

The Baghdad pictures, taken at the time of the invasion in 2003, play with the picturesque tradition, as did the *Chronotopia* series. In some photographs, the ruins of Saddam Hussein's confected monuments to the region's illustrious ancient history and his own power are shown, again in golden sunlight, alongside disturbing elements: the destroyed half-century-old Iraqi armour torn apart by modern munitions, or the boy scavenging for scrap metal, posing for Norfolk's large wooden camera in the ruins of an Air Force Headquarters.

Other images lead the viewer into darker regions. They show the unadorned ruination of the modern infrastructure of a state. The Ba'ath dictatorship had in part survived by ensuring good education and health care for the great majority of Iraqis, by bringing women into employment and limited political power, and by supporting the rise of a secular professional class.[4] Much of that was destroyed in the systematic attack on Iraqi infrastructure in the Gulf War, and then by the long years of punitive sanctions, which starved the population and allowed for little sustained repair work.[5] The coup de grace was delivered by the 2003 invasion, which once again targeted the structures of the Iraqi state. Occupying forces sat by as long-impoverished Iraqis stripped everything of value from the ruins of government buildings, from hospitals to museums.

Norfolk's images show the ruins of state power and wealth: at once the ruins of a brutal and criminal tyranny, and those of the support structures of everyday life. Although *Chronotopia* also showed the ruins of a dirigiste state, blasted into collapse by prolonged warfare, the Iraq images highlight the stark present of another destruction. Ironically, those images that were made in dialogue with Burke, and photographically look the most antiquated, show one enforced future: the twilight architecture of the minimal security state amidst the free play of criminal capitalism.

JS

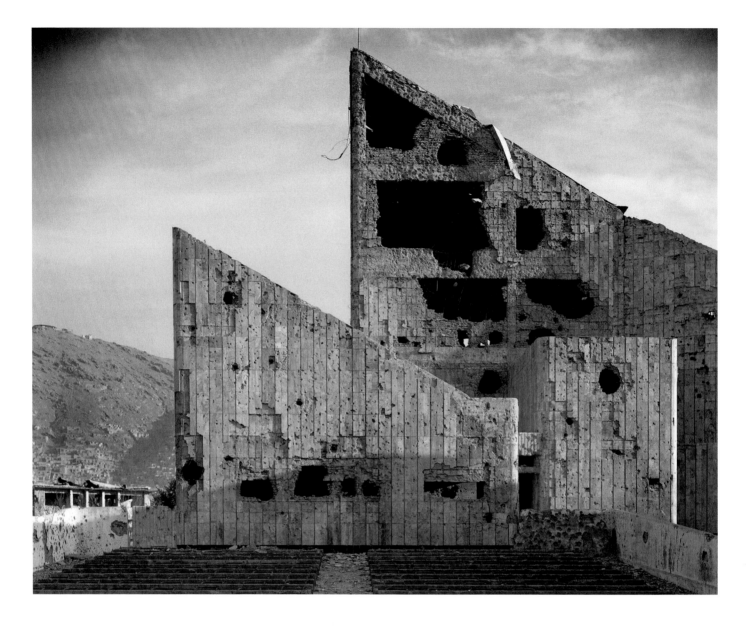

Former Soviet-era 'Palace of Culture', Kabul, 2001-02

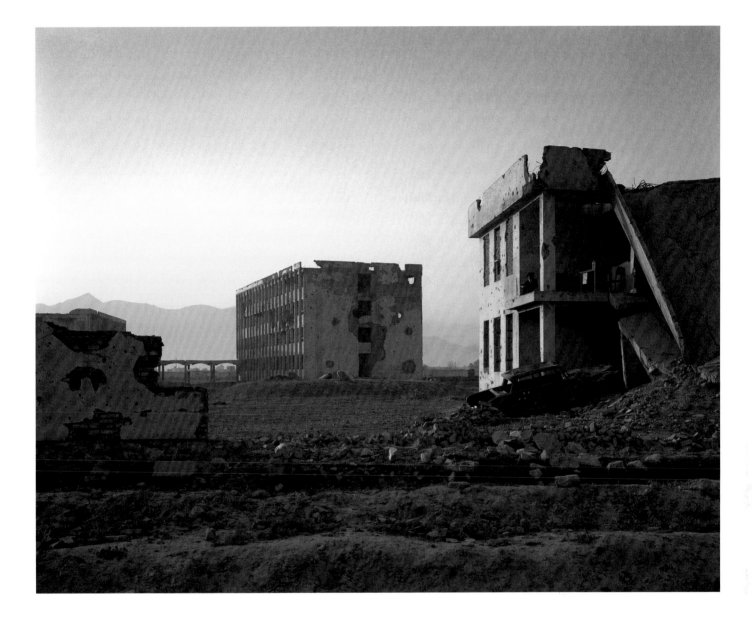

Caretaker in the remains of a military building on Jaday-e Darulaman, 2001-02

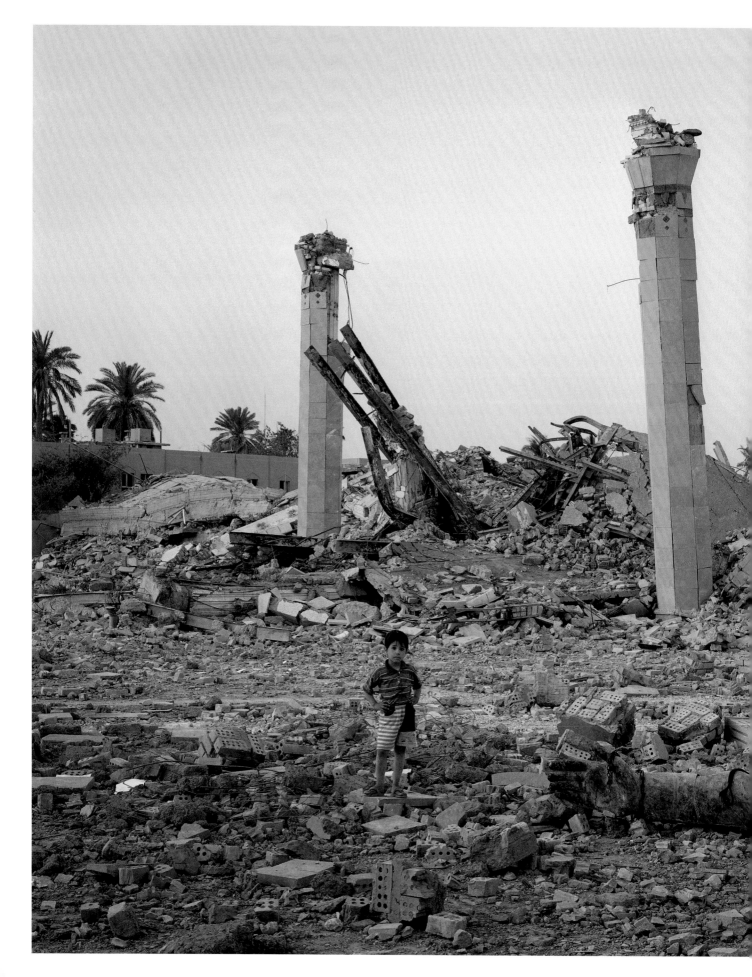

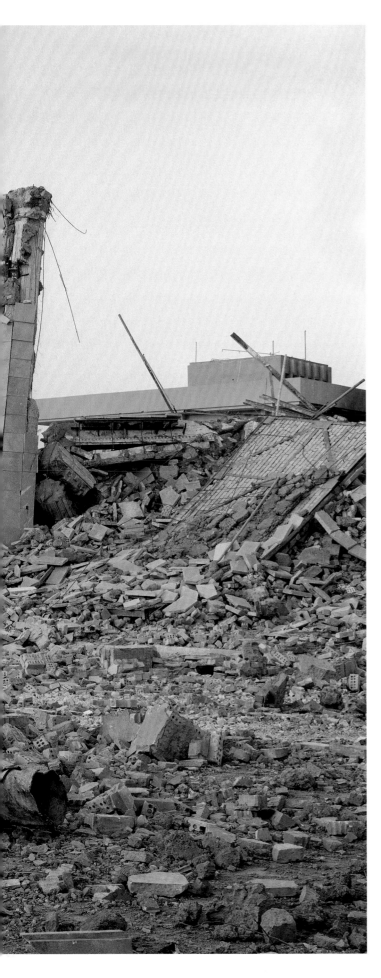

A looter and his family removing the arm of
Saddam's statue from the forecourt of the old
Air Force Headquarters, Baghdad, April 2003

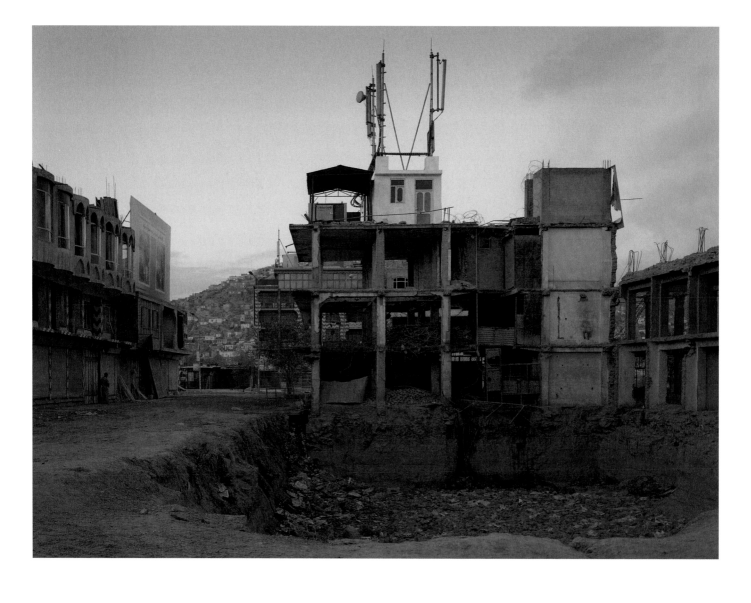

A cellphone booster-station built on the wreckage
of buildings that once housed a market, Kabul, 2010-11

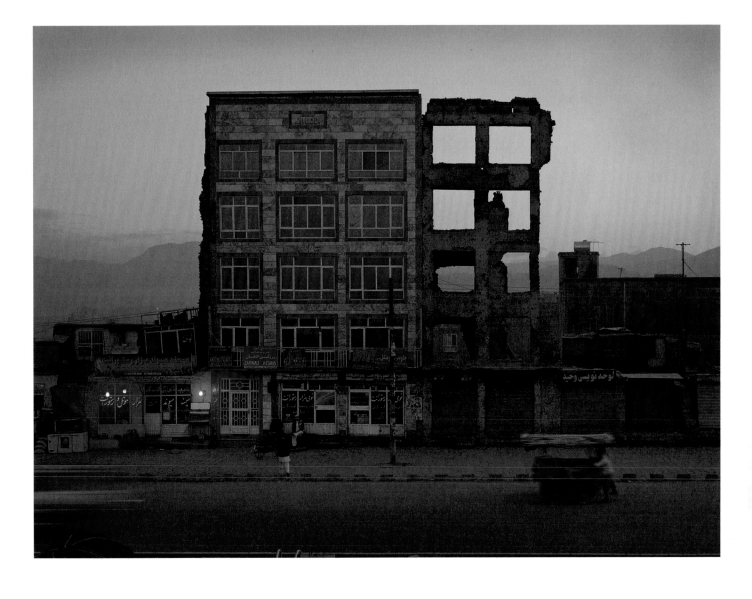

Some of the nonsensical property development taking place
in Kabul. The district of the city, Karte Char Chateh,
is remembered by Kabulis as that part of the Bazaar which
was burned by the British in 1842 as collective punishment
for the killing of the British Envoy, 2010-11

A security guard's booth at the newly restored
Ikhtiaruddin citadel, Herat, 2010-11

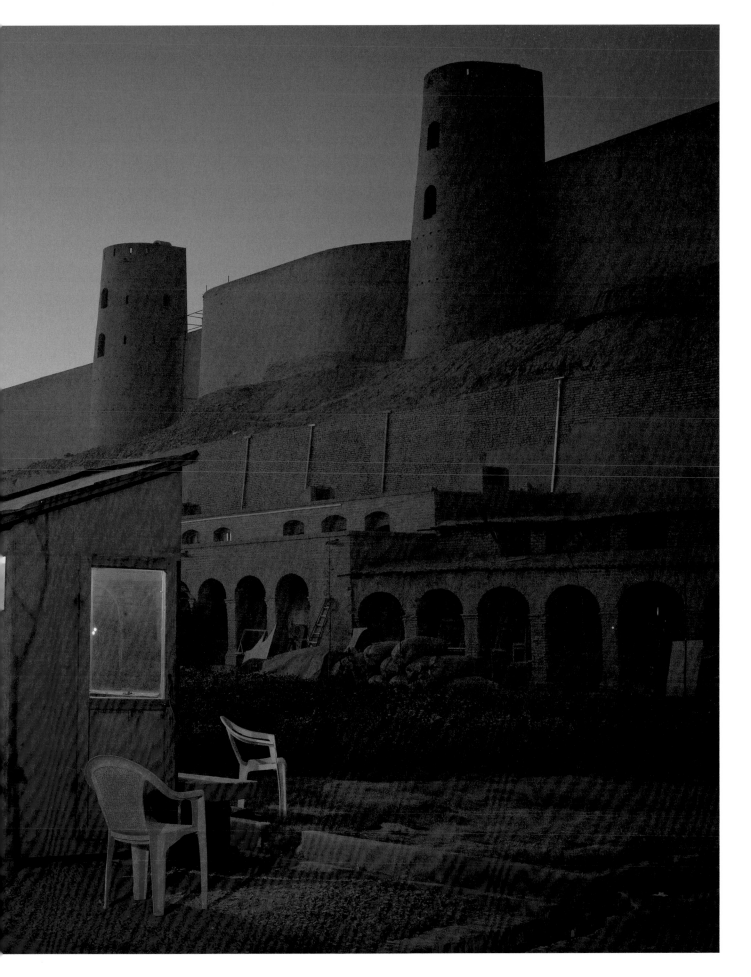

GUY
TILLIM

Guy Tillim: 'Avenue Patrice Lumumba'
Reprinted from *Portfolio* magazine (UK), issue no. 51 (May 2012)

——In this collection of topographical studies, **Guy Tillim** focuses on the architecture that took shape in the moment of decolonisation in Angola, the Congo, and Mozambique during the 1960s and 1970s. What comes into view across the fifty-seven photographs — of apartment blocks and administrative offices, schools and other public buildings — is a distinctly African variant of late-modern style. It has a ghostly familiarity, even though its strange ambience seems at first to stem from the 'alien-ness' of these architectural forms within the subtropical landscape. Beneath the harsh sunlight and the encroaching vegetation, the geometric planes of the high International Style give way to cross-cultural configurations that have an almost baroque complexity of shadow and light as they sculpt the living spaces of contemporary African cities.

> '"These buildings are very much inhabited but they are decaying", says Tillim, who draws attention to the way such architecture belongs simultaneously to the past and to the present — "There's a ten-year period in the late modernist world where there was this grand colonial architecture built in Francophone Africa and Lusophone Africa. It was this strange contemporary mythological time. These buildings are impressive, for all their inappropriateness they're nonetheless part of a contemporary African stage."'[1]

Evoking the independence era led by politicians such as Patrice Lumumba and Kwame Nkrumah over fifty years ago, the dilapidated state of the buildings bears witness to the unfulfilled hopes of post-colonial generations. But instead of signifying innate poverty or decline, along the lines of mere reportage, Tillim's strategy puts forward a contemplative option, which makes his photo-essay more akin to a novel or short story. His approach allows us to see the conflicting forces and desires that made the architecture of decolonisation meaningful for all sides. Whereas Africans appropriated late-modern style to articulate their visions of Afro-Modernity, the aim of the departing colonial powers — who commissioned grand architectural projects as symbols of European modernity — was to delay the moment of separation and prolong colonial dependency.

As historian Mark Crimson argues, prestige buildings from the period 1956 – 66 in British West Africa engendered a variety of 'tropical Modernism' that was presented as a 'gift' in exchange for continued cooperation after independence.[2] Whereas in Algeria the French built huge housing projects that introduced mass Modernism in contrast to the classical architecture of high empire, the Portuguese postponed the break considerably: Mozambique only became independent in 1977. Photographs from the Mozambican town of Beira, which feature prominently in Tillim's work, testify to this protracted struggle around the 'de-colonial' moment.

Poised between survival and disappearance, these decaying civic structures are relics of a future that never quite arrived. Tillim captures dialectics at a standstill, showing how competing visions of the post-colonial future were mutually forestalled. Crucial to this process are a range of quasi-pictorialist devices that engage with the iconography of ruins. Aware of the risks of romanticising Africa's cityscapes, Tillim says, 'the challenge was not to become a connoisseur of decay or come up with some Havana-esque vision'.[3] Nonetheless, it is fascinating to see how the imagery of architectural ruins is re-accentuated in the African setting. The solitary figure gazing out of the office window in Antsiranana, Madagascar, performs a picturesque role: his scenario seems haunted by [the German Romantic landscapist] Caspar David Friedrich. Far from aestheticising decay, the active presence of such figures serves to heighten the overlay between the ongoing usage of these late-Modernist structures and the unresolved political moment in which they were built.

In Romanticism, the ruin is an emblem of the impermanence and vulnerability of all human achievements in the face of time. The social theorist Georg Simmel pinpointed how ruins strike a precarious balance between 'the upward thrust … of human will' and 'the mechanical force of nature, whose power of decay draws things downwards'. Where architecture enacts human mastery over time, Tillim's catalogue of ruination certainly testifies to Nature's revenge upon culture in the African ecology, although his pictorialist devices also suggest that the contrapuntal tension between 'these two world potencies — the striking upward and the sinking downward' is a human-made product of historical conditions and not a fatalistic inevitability.[4]

Taking the notion of ruins a step further in his view that 'Allegories are in the realm of thoughts, what ruins are in the realm of things', Walter Benjamin saw art as a critical re-assembling of the fragments thrown up by the catastrophe of 'progress'.[5] Against the grain of the prevailing documentary tradition in Southern Africa, driven by a strong activist ethos, the contemplative melancholy solicited by 'Avenue Patrice Lumumba' may be easily misinterpreted as an indulgence. But once we understand these architectural ruins as allegories of Africa's post-colonial condition, we can see that Tillim has introduced far-reaching questions about the politics and aesthetics of the built environment as a produce of cultural practices. There is not only the question of what Africans feel about their city spaces, but also the parallel case of the post-Communist world where late-Modernism did not sink into architectural ruin but was preserved as monumentalism. Where dominant social forces often use architecture to create the illusion that their values are timeless and unchangeable, the subversive allegory of ruins suggests that the future is always waiting to be rebuilt.

KM

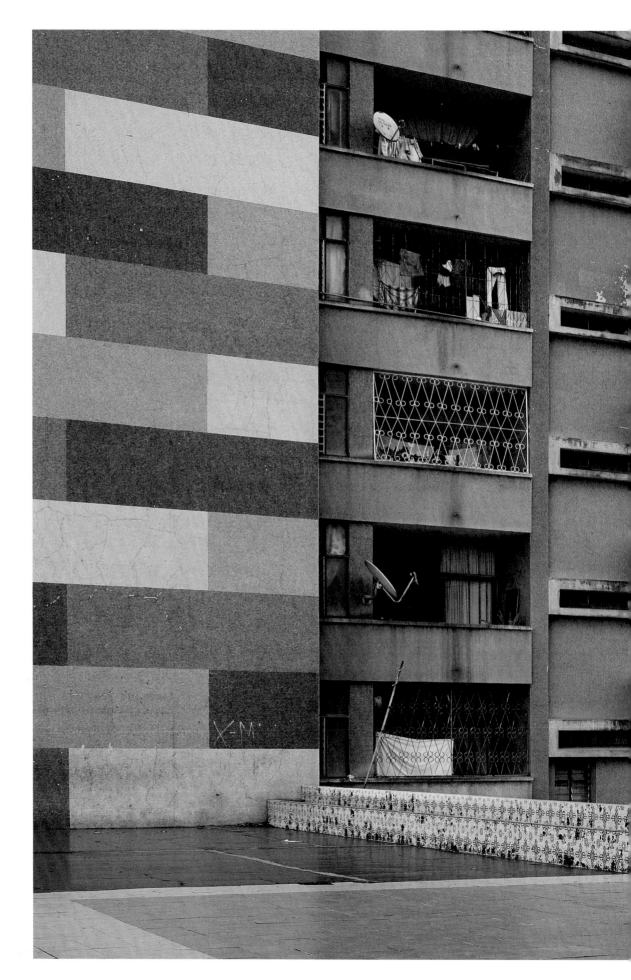

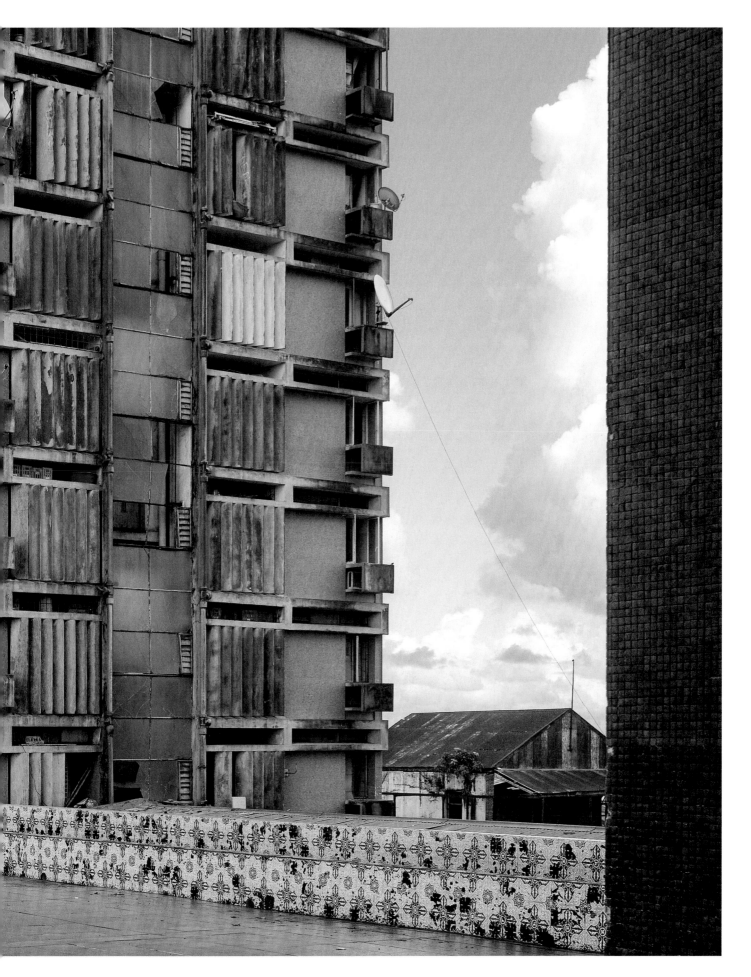

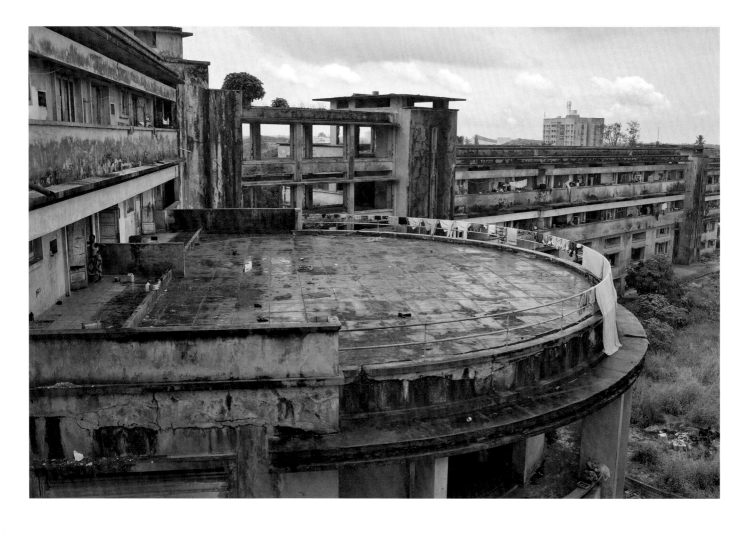

Previous pages:
Apartment Building, Beira, Mozambique, 2007

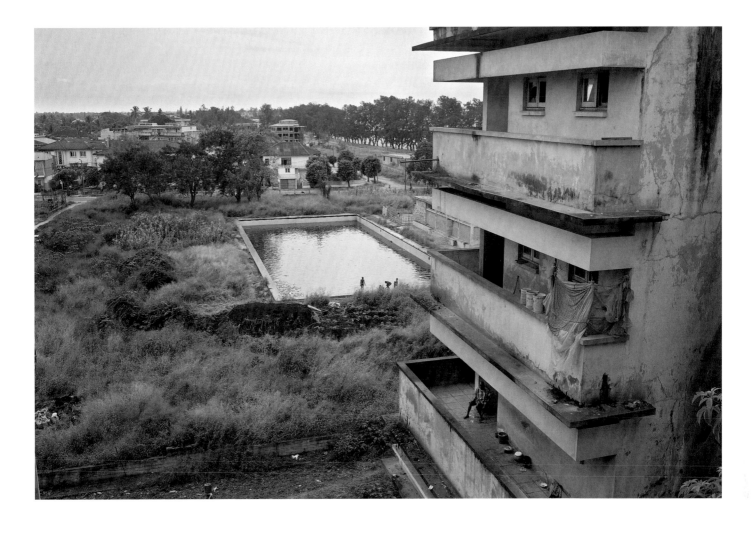

Left and above:
Grande Hotel, Beira, Mozambique, 2008

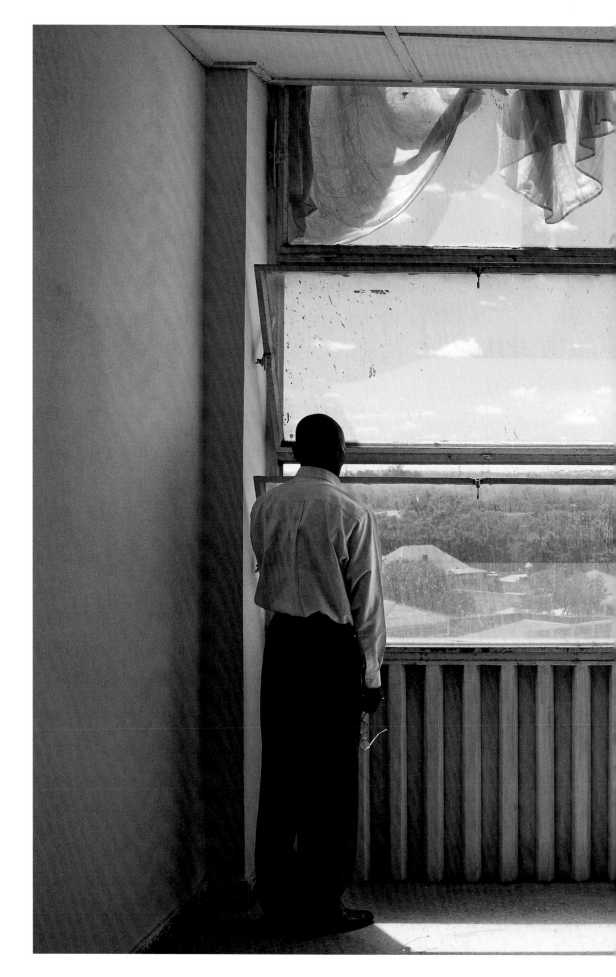

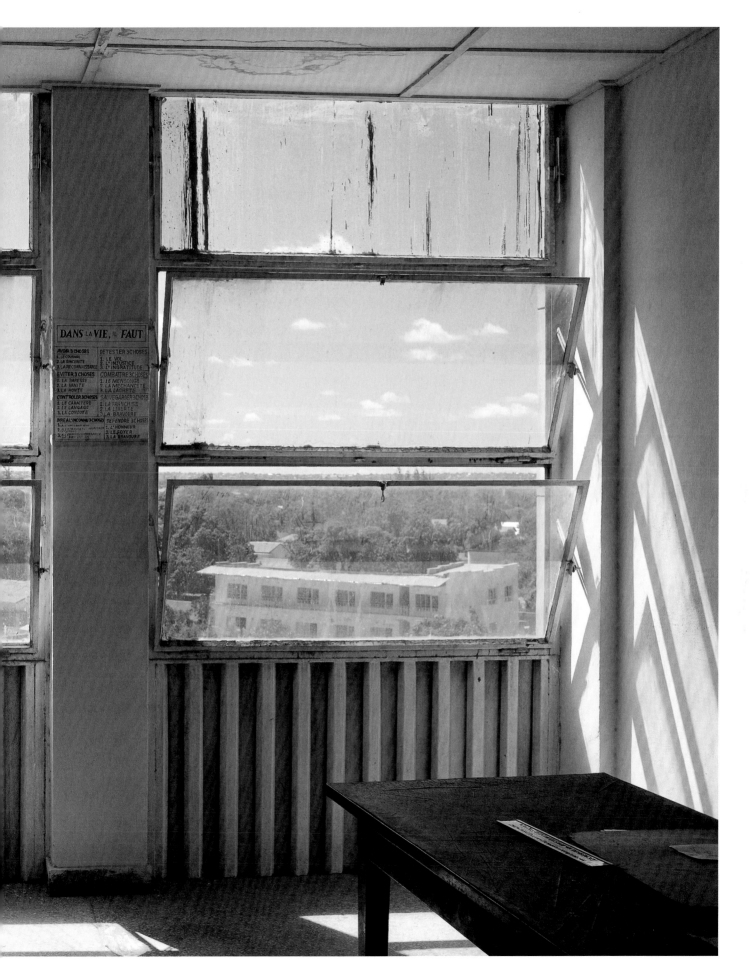

DANS LA VIE, IL FAUT

AVOIR 3 CHOSES
1. LE COURAGE
2. LA SINCÉRITÉ
3. LA RECONNAISSANCE

DÉTESTER 3 CHOSES
1. LE VOL
2. L'INJUSTICE
3. L'INGRATITUDE

ÉVITER 3 CHOSES
1. LA PARESSE
2. LA VANITÉ
3. LA MONTÉ

COMBATTRE 3 CHOSES
1. LE MENSONGE
2. LA MÉCHANCETÉ
3. LA LÂCHETÉ

CONTRÔLER 3 CHOSES
1. LE CARACTÈRE
2. LE LANGAGE
3. LA CONDUITE

SAUVEGARDER 3 CHOSES
1. LA FRANCHISE
2. LA LIBERTÉ
3. LA BRAVOURE

DIRE À L'INCONNU 3 CHOSES
1.
2.
3.

DÉFENDRE 3 CHOSES
1. L'HONNEUR
2. LE FOYER
3. LA BRAVOURE

Previous pages:
City Hall, Lubumbashi, DR Congo, 2007

Left:
Library, Sports Club, Kolwezi, DR Congo, 2007

Above:
Wires Linked to Private Generators, Apartment Block, Luanda, Angola, 2007

BAS
PRINCEN

'I try to show landscape in an uncertain state, where the transformation can be extreme — a colonisation — or it can also be stagnancy, a slow movement.'[1]
Bas Princen

——Many recent photographs of cities, particularly of megacities[2] in the rapidly urbanising regions of the world, depict scenes of hyper-density and intense activity, often accompanied by dramatic statistics about the speed and scale of change. In comparison, the work of **Bas Princen** (b. 1975, The Netherlands) depicts more obscure sites and subtler conditions, enhancing our comprehension of the ambiguities and paradoxes of contemporary urbanisation.

In its subject matter and approach, Princen's work has a clear precedent in that of the New Topographics, a photographic movement whose stark, rigorous images documented the widespread imprint of human activities on the American landscape. The movement took its name from the title of a 1975 group exhibition[3] now considered pivotal in validating as artistic subject material the deceptively dull types of suburban, residential or industrial landscapes that still fascinate Princen and his peers forty years on.

Princen is an artist of the Anthropocene age.[4] The ubiquity of human intervention in the natural landscape is a recurring theme in his photographs; manmade structures are depicted as integral parts of their environments, or more precisely, these elements are shown as continuous rather than distinct. The 'built' or 'new' figure and 'natural' or 'existing' ground merge so regularly in Princen's work that it seems clear he believes that a distinction between the categories is no longer particularly interesting or even possible to make. Originally trained as an architect at Rotterdam's prestigious Berlage Institute, Princen associates this acceptance of ambiguity in the landscape with the work of certain Dutch architects of the preceding generation — including MVRDV and West 8 — which challenged binary distinctions in the built environment, including those between the natural and the artificial.[5] Princen, who often consults archival images when preparing for shoots, has also credited Asahel Curtis's 1910 photograph *The Levelling of the Hills to Make Seattle*, which shows buildings perched precariously amidst a surreally scarred landscape, as a strong influence in this regard.[6]

Refuge, *Five Cities* is Princen's 2009 series of more than two-dozen photographs depicting scenes from peripheral and emerging zones of Istanbul, Cairo, Amman, Beirut and Dubai. The work was commissioned as part of an initiative that united artists with architectural and urban experts in order to generate critical discourse about the 'voluntary and involuntary forms of urban exclusion and urban practices that confront, subvert and transgress growing spatial and social polarization' in Turkey and the Middle East.[7]

Princen describes his approach to photography as 'making' rather than simply documenting.[8] As with his previous work, *Five Cities* formal minimisation of context and suppression of narrative seems calculated to demand,

or at least reward, active interrogation over passive consumption. In the series the tone of intentional ambiguity prevails, even at the most basic level: *where are we?* Princen says that his key objective for the project was to create images 'in which Amman, Beirut, Cairo, Dubai and Istanbul disappear as individual cities and as specific places, dissolving instead into a new kind of city, an imaginary urban entity in formation.'[9] The photographs, published and exhibited in a sequence that suggests thematic or formal resonances rather than geographic groupings, are shot and cropped so as to omit easily recognisable clues as to where they were taken. To Western viewers, even the relatively sophisticated ones who comprise Princen's primary audience,[10] the imagined environments of these regions might comprise a collage of stock images, none of which are evident within *Five Cities*.[11]

Most of the buildings depicted within the series, whether solitary or repetitively clustered, are set within barren desert terrain or eroded valley floors. Solid and inscrutable, they are often shot at an angle, so that their entries are obscured or peripheral. The majority of the photographs in the series depict residential structures — whether temporary housing for guest workers in the Dubai sand, or gated suburbs replacing former squatter settlements in the hills of Istanbul — but the images offer a sense of isolation and distance rather than respite or interiority. It is the buildings' structural relationships to their peri-urban settings, and the relationship between the photographs themselves — an imaginary city built of images — that seem of primary concern.

The photographs often reveal their objects' mode of construction over the nature of their inhabitation. The themes of making and unmaking, of environmental transformation, pervade the *Five Cities* series. The materials of construction and demolition are evident throughout: tidy stacks of breezeblock and wheelbarrows nestled alongside rubble in Beirut; in the outskirts of Cairo a horse-drawn cart sits alongside a forklift, a stack of steel rebar next to a goatherd and her flock; new buildings on a ridge in Amman overlook a waste tip.

In keeping with Princen's training, his photographs also often reference specific architectural precedents or concepts. Such examples in the *Five Cities* series include some that may be more recognisable to a general audience, such as the Ka'aba and the Tower of Babel, and others that are more obscure nods to the architectural fraternity, such as a visual reference to a construction method devised by Le Corbusier.[12]

Like their New Topographic precursors, the photographs are unpopulated. On the few occasions that people appear they do so as functional types (construction workers) or figures to convey scale. In this context one could interpret Princen's depiction of South Asian guest workers as a part of the infrastructure, as necessary to create a city in the desert as the massive cooling plant they rest beside. Despite depicting potentially controversial or emotional subjects such as these workers, from whose sweat Gulf cities are being constructed, or the district where Cairo's rubbish is processed as a cottage industry, the images are not traditional photojournalistic exposés. In addition to formal concerns, because Princen is himself a newcomer to these places, and because these social themes have been interrogated by others elsewhere, one should not fault him for maintaining a certain distance.

Sometimes beautiful, sometimes desolate, and most often both at once, the carefully constructed photographs of *Five Cities* invite us to look more closely at spatial conditions that are notable less because they are unique or spectacular, but rather because they are generic and pervasive. In other words: the world that is unfolding all around us.

SI

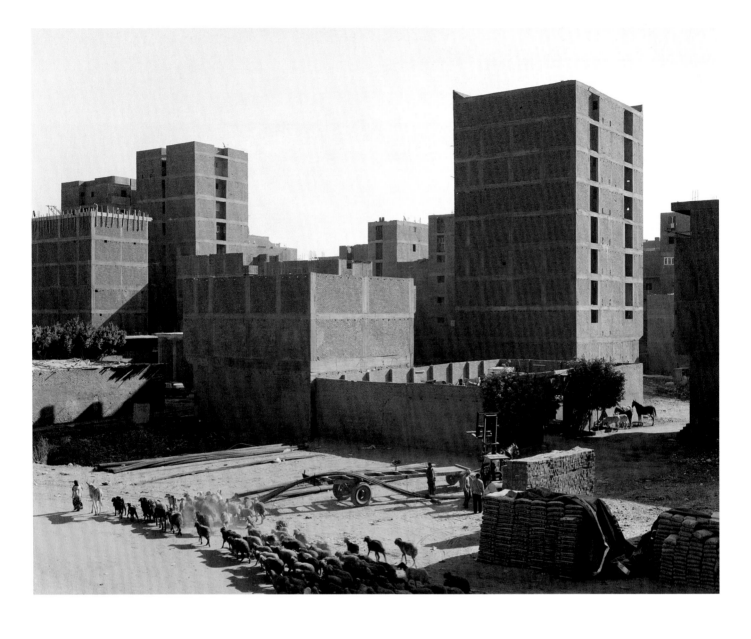

Ring Road, Cairo, 2009

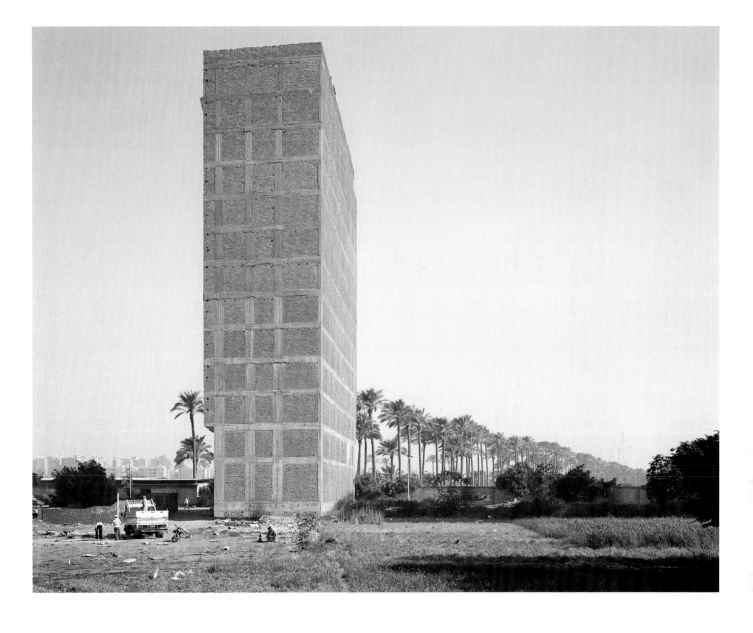

Former Sugarcane Fields, Cairo, 2009

Mokattam Ridge, (Garbage Recycling City), Cairo, 2009

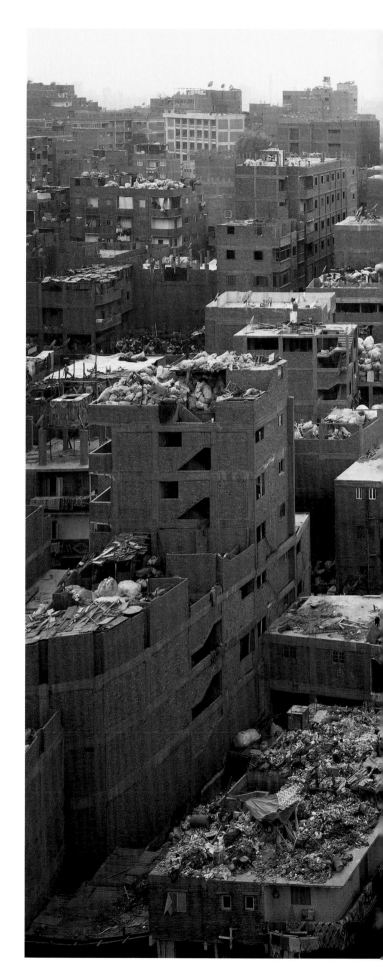

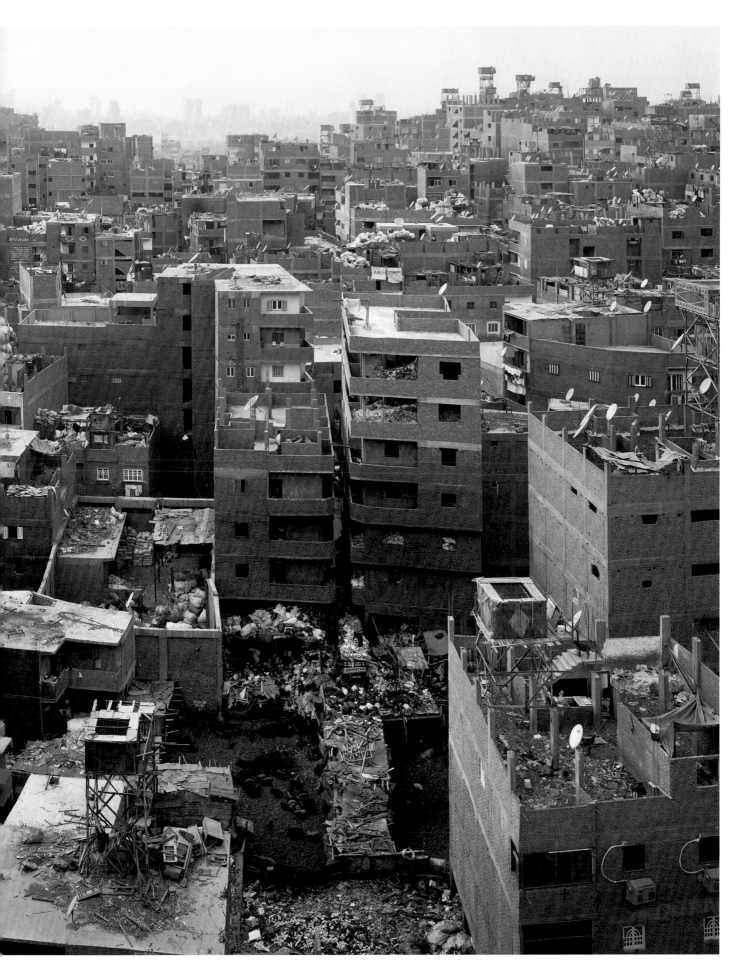

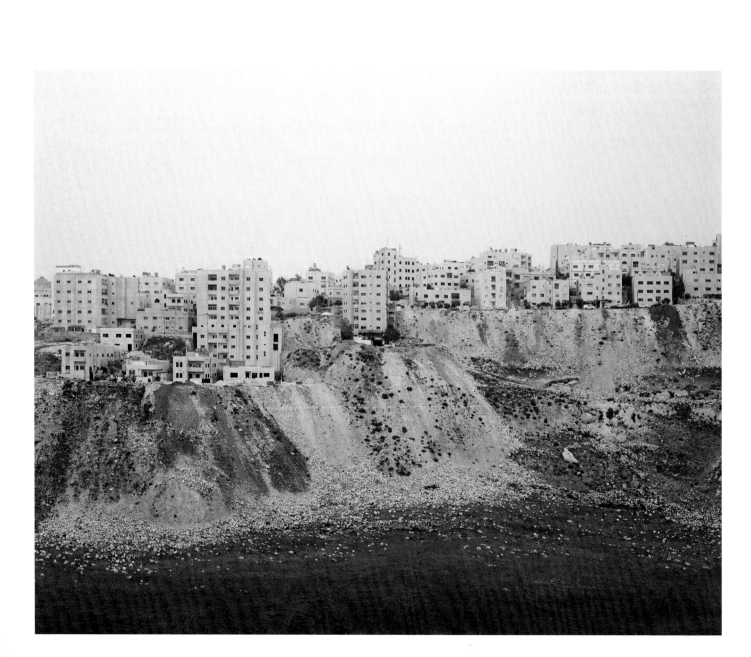

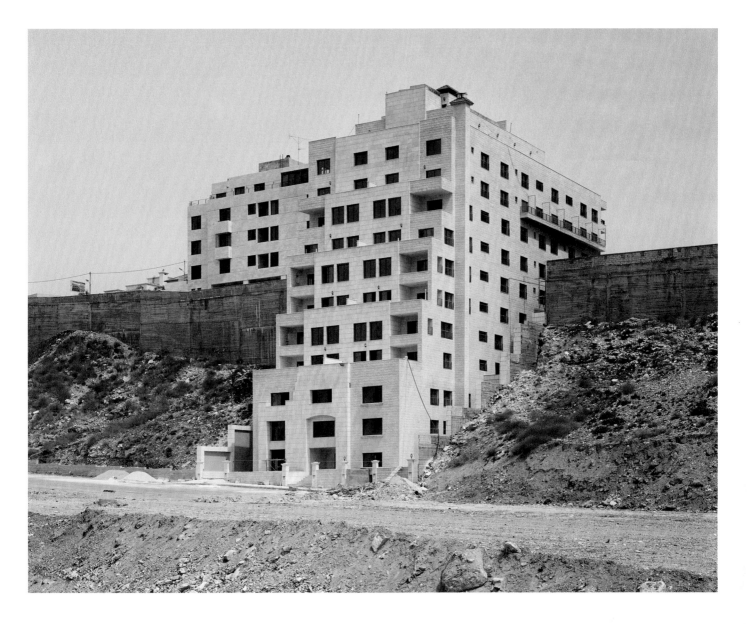

Left:
Valley II, Amman, 2009

Above:
Sand Ridge, Amman, 2009

Cooling Plant, Dubai, 2009

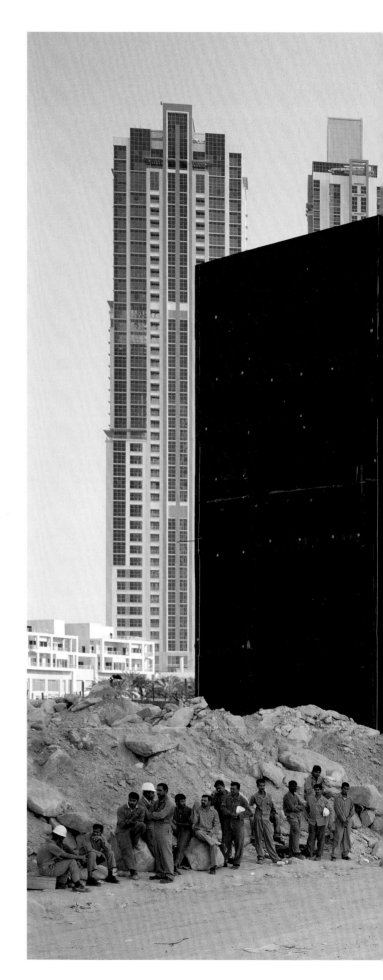

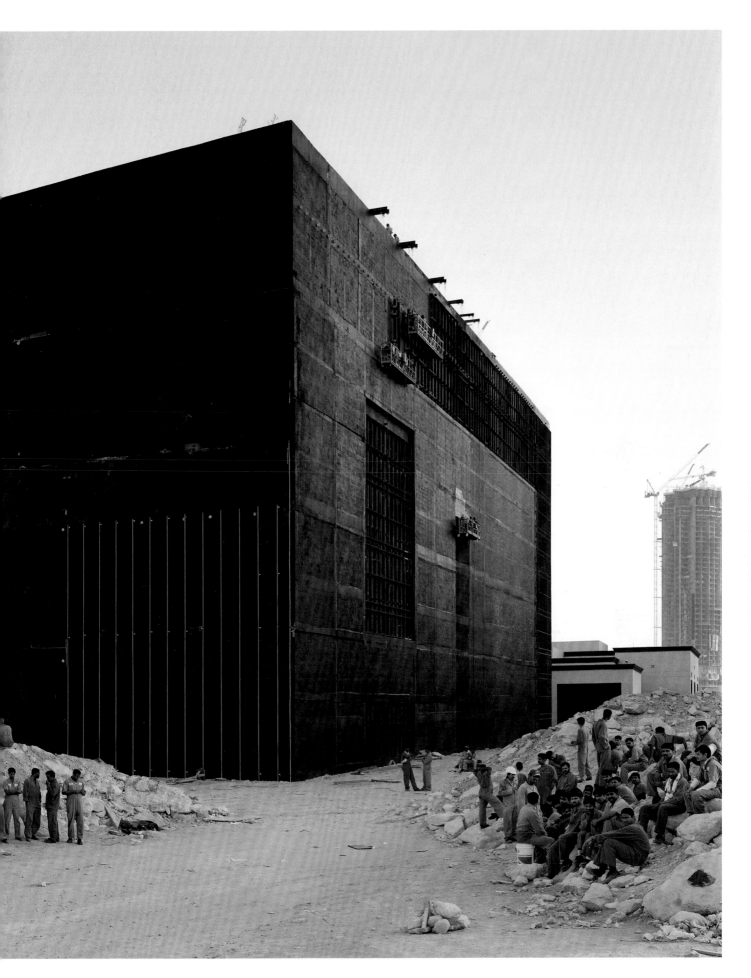

NADAV
KANDER

——The scale and speed of China's transformation is one of the greatest historical developments of our time. Millions have uprooted themselves from agrarian life to join a vast industrial and commercial urban workforce. Wealth, inequality, consumerism, social fragmentation and pollution have sprinted ahead, hand in hand. The air in many major cities is so dense with smog that it blocks photosynthesis. Rapidly and inexorably, it seems, China's GDP closes in on, and threatens to overtake, the colossus of the old century — the USA.[1] The intense energy and brutality of the Industrial Revolution are writ large here, with truly global consequences. So **Nadav Kander** (b. 1961, Israel) is right to say of his photographic series made along the Yangtze River, that it is not just about China but about all of us.[2]

Kander's project tracks a part of this vast change along the course of the great river; he travelled upstream from Shanghai, where the Yangtze meets the sea to its source in a remote area of Tibet. Many of his photographs show massive new developments, including the Three Gorges Dam, which involved the displacement of over a million people, the remoulding of an entire region's environment and destruction of historical sites. The scale of these recent interventions is hard to grasp: Kander photographs Chongqing, a city of 27 million inhabitants — over three times the size of London. In all, some 500 million people have moved into sprawling concrete cities, heavily reliant on motor transport. They are sharply divided between those with decent jobs and enough income to be able to buy consumer goods, and a huge underclass of casual migrant labourers who are denied basic public services.[3]

The photographs deploy a particular and familiar mode: well-composed, large landscapes decorated with a few small-scale figures. By their actions, these figures — like those in paintings by Nicolas Poussin or Claude Lorrain — hint at unfolding stories, while the grandeur of the surroundings that dwarf them gestures towards the significance of the drama and the larger forces at work that make puppets of the apparent protagonists. Kander's figures, and a few older elements, are set against massive new structures: bridges, container-lifting cranes, apartment blocks and flyovers. The colours are subdued, almost bleached in some pictures, the light white and even; and distance dissolves forms with a haze (much of it doubtless pollution). Often the eye is led into these distances where architectural form softens and disappears, implying the endlessness of concrete construction.

In a gesture towards the past, the new forms of architecture and infrastructure are loaded into an ancient pictorial genre. People engage in traditional riverbank activities — picnicking, bathing and fishing — but do so in alien and dramatically polluted environments. Kander's muted pictures are not of the activist sort, which are used by environmental organisations: they only hint at the chemical factories that line the river, and the vast quantities of sewage, industrial and agricultural waste that are emptied into it. The Yangtze and its banks, once fertile and rich in wildlife, are close to ecological collapse.

In Kander's series, the mathematical sublime (of expanse) is shown calmly and without drama, as if it speaks for itself. The dynamic sublime (of speed) is implied, as different timeframes are juxtaposed, and the ruination and active destruction of the old is glimpsed amid new concrete frames.[4] Memory often inheres in particular places, and tends to be eroded with the environment of its creation — here in favour of the functional (block housing for the masses) and the cosmopolitan: we see a replica Empire State Building in Chongqing, and the absurd and rootless stylistic eclecticism of housing for the newly wealthy.

Kander writes of his attachment to the paintings of Caspar David Friedrich, JMW Turner and John Martin, explicitly invoking the sublime.[5] The feeling is of danger held at a distance — the storm seen from the lighthouse, the battle viewed on screen, the thrill of acceleration and falling on a roller coaster. It has often been turned to conservative ends, as the elite quivers at the spectacle of the labouring masses it hopes will not rise against them, however desperate their situation becomes. Yet the danger indicated in Kander's photographs is not distant, though it is neatly framed and held in measured compositions: it is a present and profound threat. As more and more of the world's population is drawn into energy-intensive living and fashion-driven disposable consumerism, biodiversity will further crash (the Anthropocene mass-extinction event has long been unfolding), basic ecological functions (photosynthesis and insect pollination) will falter, and global warming will enter an unstoppable feedback loop.

Kander's images are calm, melancholy and even nostalgic. Things in China change so fast, he says, that even these pictures, which focus on new structures, can never be taken again. They pull from a degraded, often desolate environment, an order and pictorial beauty at disturbing odds with what they depict.

JS

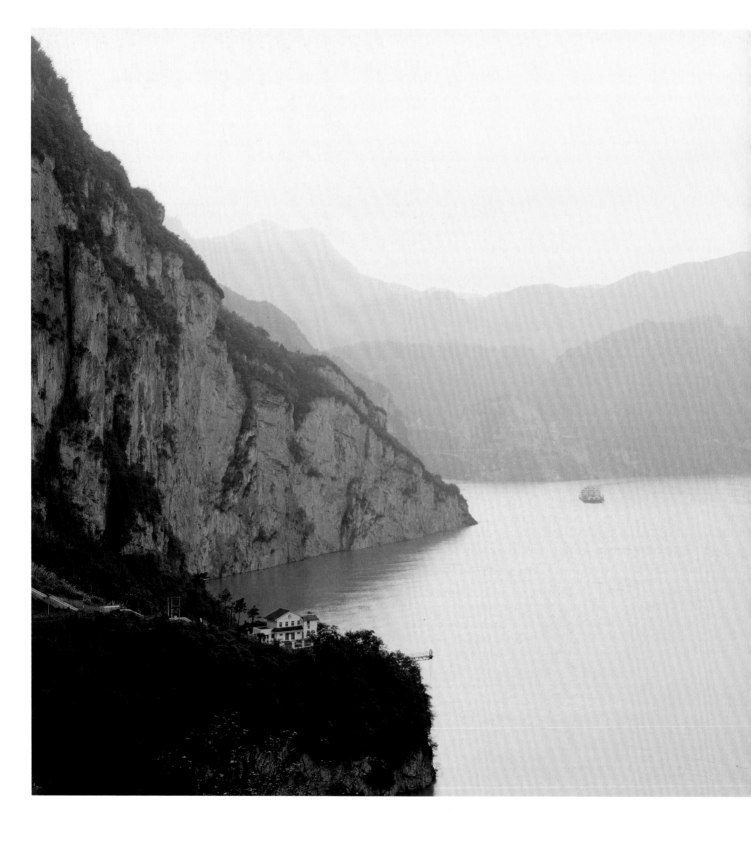

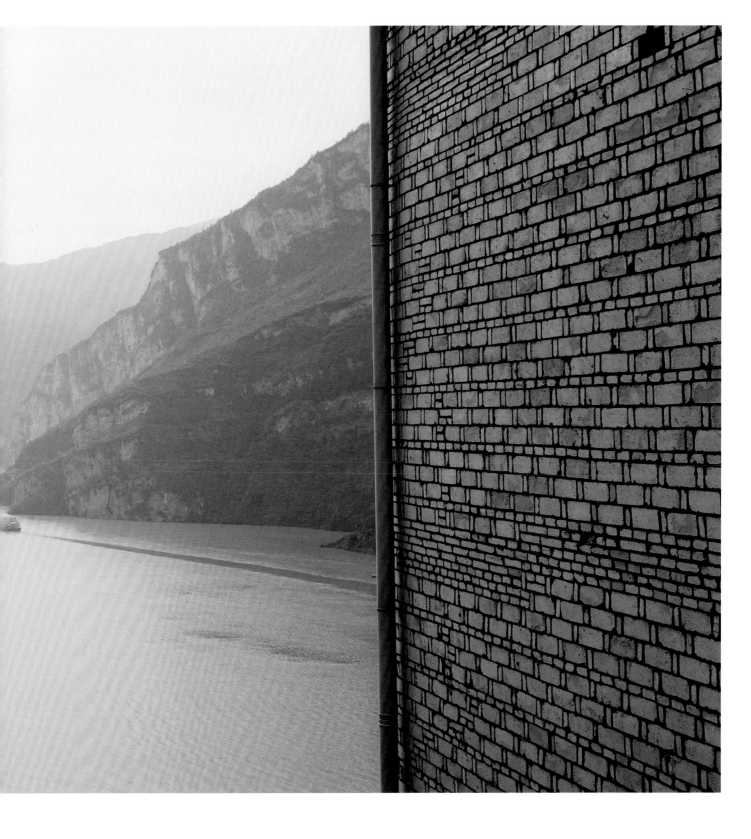

Xiling Gorge I, Hubei Province, 2007

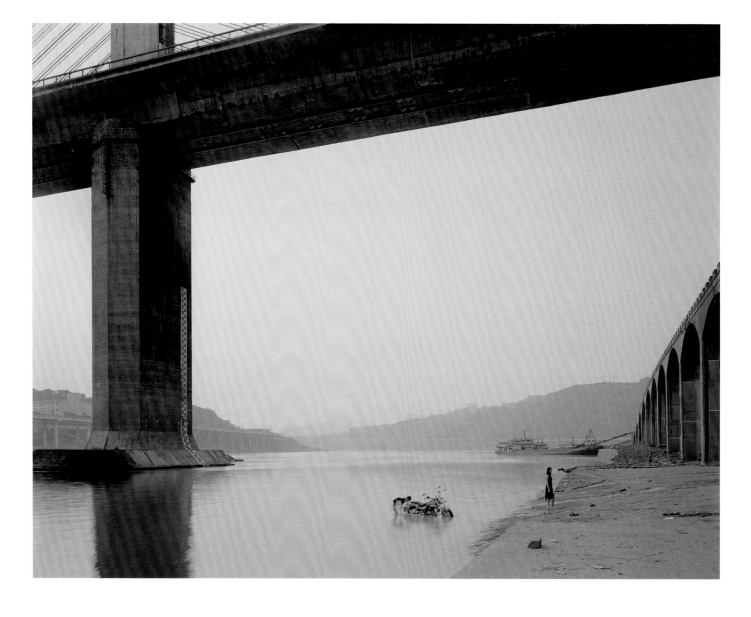

Chongqing VII (Washing Bike), Chongqing Municipality, 2006

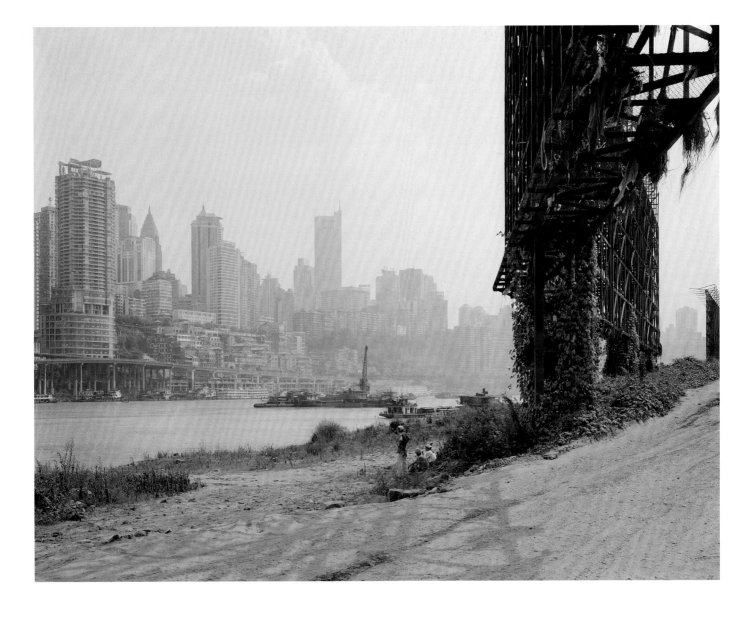

Chongqing II, Chongqing Municipality,2006

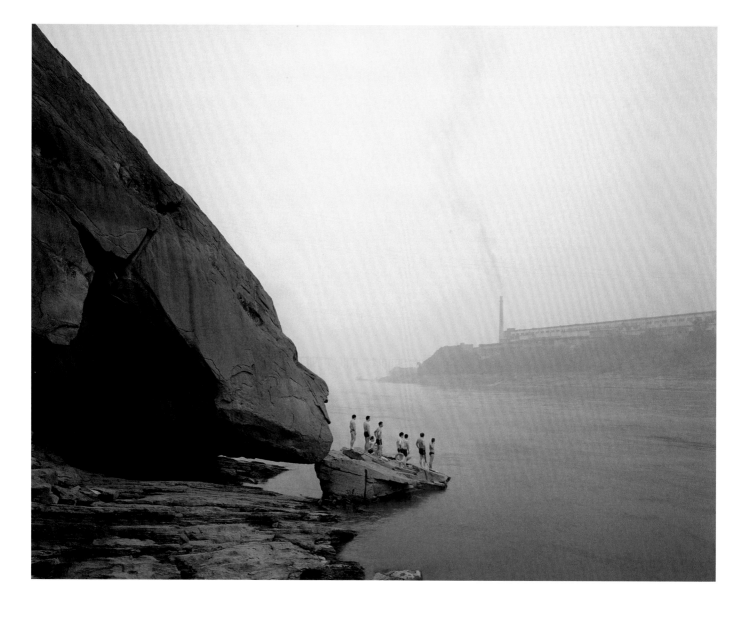

Yibin I (Bathers), Sichuan Province, 2007

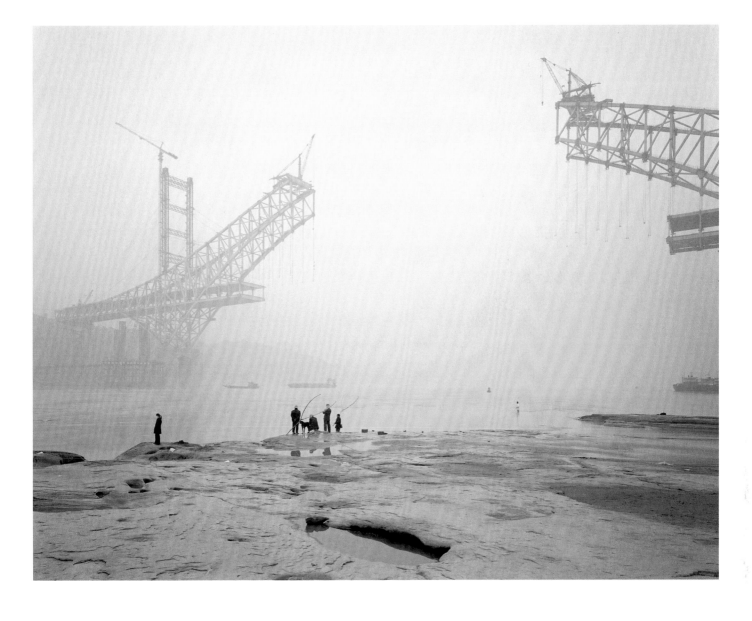

Chongqing XI, Chongqing Municipality, 2007

Fengjie III (Monument to Progress and Prosperity),
Chongqing Municipality, 2007

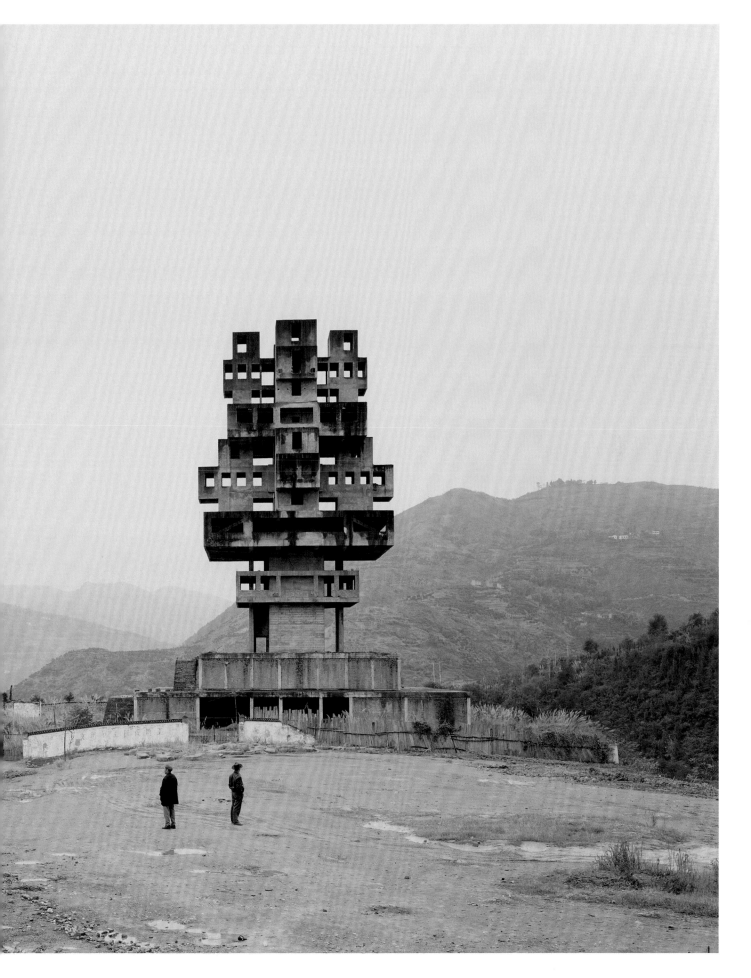

IWAN
BAAN

———Some photojournalists excel at making distant subjects appear immediately accessible; others' skills lie in providing fresh perspectives on seemingly familiar subjects. With his series of photographs of the Centro Financiero Confinanzas, a high-rise office and hotel complex in downtown Caracas which — stalled and abandoned in the mid-1990s — has been colonised by informal means into a thriving vertical neighbourhood, **Iwan Baan** (b. 1975, The Netherlands), achieves both of these things.

Baan's photographs provide sensitive alternatives to multiple visual clichés of informal settlements in Latin American cities. Contradicting, or at least counterbalancing, the 'endless city' trope — images in which agglomerations of repetitive structures stretch to the horizon — his photographs depict a specific place that has evolved at a human pace and is inhabited on a human scale. As locally embedded architects and researchers, Urban-Think Tank, observe: 'many Caraqueños' perceptions of Torre David are based solely on their views of its exterior'[1]; as such perhaps the most significant aspect of Baan's photographs are the way they make visible, and reveal as 'normal', the Torre's residents and the lives they lead within it.

The place commonly called the 'Torre David' as shorthand for both the five-building Confinanzas complex and for its most visible element — a forty-five-storey concrete, steel and glass tower, parts of its facade now patterned with the irregular brick balustrades, curtains and drying laundry of its 3,000-odd residents — is a compelling subject for research and reporting.[2]

The Torre's evolution parallels shifts in its nation's circumstances over the past two decades. Planned during Venezuela's final period of relative economic and political stability, after the oil boom of the 1970s and before the dramatic political upheavals of the 1990s, the complex was intended as an aspirational symbol for Caracas's thriving central business district. However, following the untimely death in 1993 of the project's chief proponent, the developer David Brillembourg (after whom it is named), and the collapse of its backing company in the wake of Venezuela's 1994 banking crisis, construction was abandoned. The building became the property of the state and sat vacant for twelve years, attracting the depredation of looters.

In 2007, a group of squatters, many of whom had lost their homes to eviction or flooding, invaded the vacant Torre David. As word spread, a growing group came together to clean the space, divide it amongst families, and introduce the services and safety features necessary to make it habitable. Gradually colonised, and still in the process of incremental development, the complex currently shelters some 750 households.[3]

The Confinanzas complex, designed by distinguished Venezuelan architect Enrique Gómez, was always intended to be iconic architecture. Interestingly, Iwan

Baan's first professional engagement with architecture was with a steel-and-glass building of similar scale, in another ascendant country seeking to project its ambitions through architecture — Office of Metropolitan Architecture's CCTV building in Beijing.

Baan is frequently commissioned to document projects by 'starchitects', who must appreciate how his photographs appear to allow new icons to integrate perfectly within their surroundings. His experience as a documentary photographer helps to set him apart from the bulk of commercial architectural photographers and those who commission them, whose preferred view of buildings is a pristine state, unmarred by the inconveniences of human activity. Instead, Baan's work captures the disorder of real places and people's appropriation of buildings for everyday life.

With architectural rigour, Baan documents the form of the original Torre David complex without romanticising it as a ruin or demonising its Modernist aspirations. His photographs provide evidence of how the building was constructed and — more interestingly — how it has been modified by its residents, how it is managed and navigated.

In some ways, the Torre David is typical of contemporary Caracas, where high levels of immigration, post-1950, have produced a housing shortage. Approximately 60% of Caraqueños live in barrios, and squatters are estimated to occupy over 150 'formal' buildings across the city, including shopping malls and government offices.[4] It certainly isn't the first office tower in the world to be squatted.[5] Nevertheless, in addition to its inventive and evolving fusion of formal and informal architectures, the Torre is remarkable for its highly organised systems of governance, management and servicing, including the limited provision of electricity and water to most units, and well-maintained common spaces.

There is a straightforward and upbeat tone to Baan's portraits of the Torre community. In contrast with many popular images of informal settlements, which describe conditions of squalor and menace, chaos and degradation,[6] Baan's photographs convey scenes of quotidian normality, some almost Rockwellian: a barber at work; teenagers goofing around on the basketball court. While most of the subjects are clearly aware of the photographer's presence, they seem at ease with him: he is more curious neighbour than scrutinising sociologist. The accomplishment of his high level of access to the guarded building and its wary residents should not be downplayed.

Baan's work blurs the familiar visual juxtaposition of the informal and formal as distinctive and contrasting components of the developing city.[7] These photographs — most strikingly those of confident young men pumping iron on one of the Torre's upper floors — invert the trope of the upper classes in their modern, guarded towers, looking down upon the irregular settlements of the poor.[8] Despite uncertainties about the squatters' legal status, and the very real dangers and inconveniences of life in a high-rise with holes in its floors and no elevators, Urban-Think Tank have noted the Torre's house-proud residents' evident aspirations to middle-class modes of dwelling.

Like Baan's broader portfolio, his photographs of the Torre David have reached a diverse audience. In 2012, the images were exhibited at the Venice Architecture Biennale in an installation that attracted both ire and praise. The installation included printouts of furious Venezuelan op-eds and emails debating the validity of exhibiting the Torre at the Biennale, but it also won the Golden Lion.

The previous year, the photographs were published in the glossy magazine *New York*.[9] Although parallels with Manhattan weren't mentioned explicitly in the article that accompanied Baan's photo essay, it could be read as a cautionary tale to the citizens of any metropolis that erects aspirational skyscrapers during boom times. Why might Baan's images incense the Venezuelan architectural establishment and make Manhattan socialites uneasy? Perhaps because they raise difficult questions about what constitutes a valid community, and what role architects might play in relation to the worldwide rise of informal urbanism.

Does Iwan Baan's work paint the Torre David in a naively optimistic light? Or does it reveal an inspiring example of the collective power of disenfranchised people to overcome the odds and create a functional, aspirational community, building lean yet healthy new muscles on the bones of capitalist Modernism?

SI

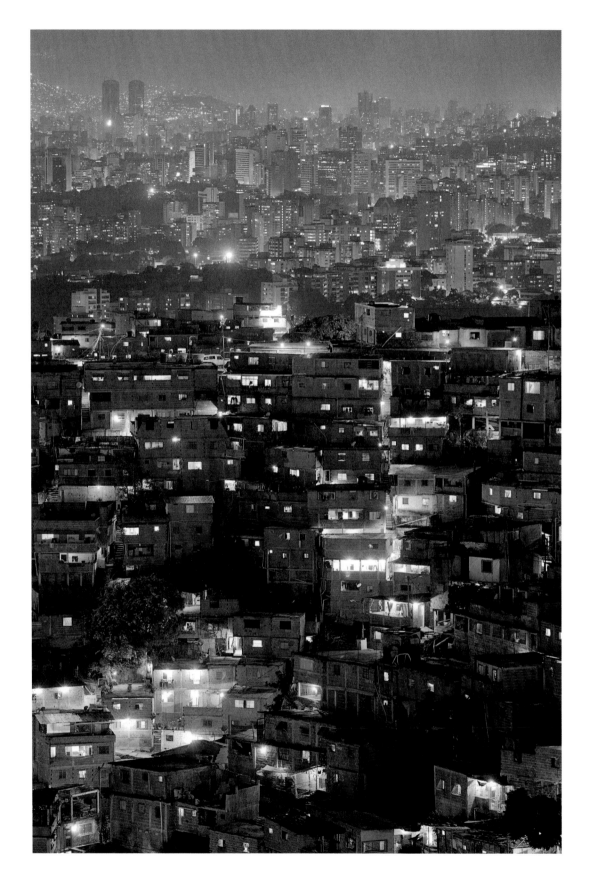

Caracas city view: favelas merging towards the city
centre, with Torre David on the horizon, 2011

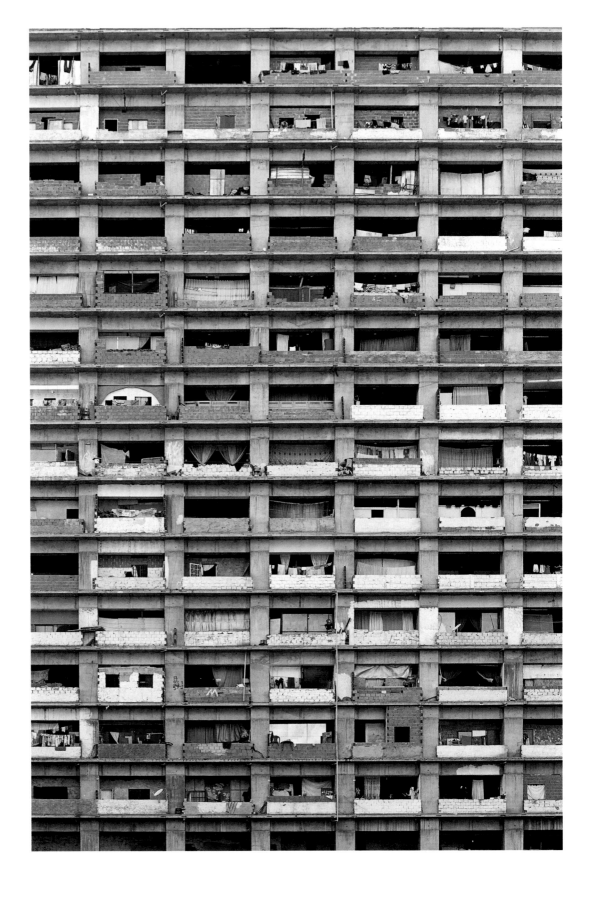

Torre David facade, 2011

Top:
Layers of coloured paint and planted tress
transform the raw unfinished entrance into a
welcoming environment, 2011

Bottom:
Left over construction materials are used in
new ways, 2011

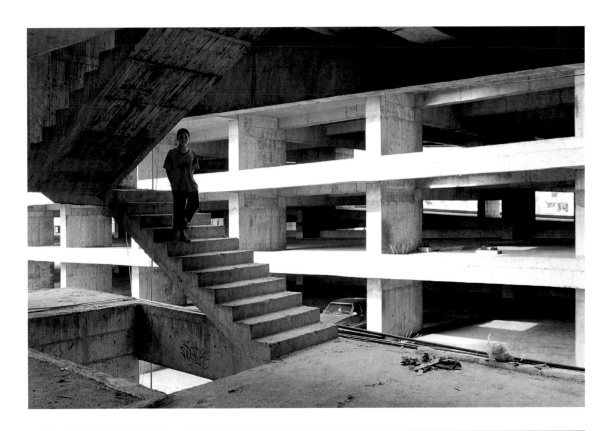

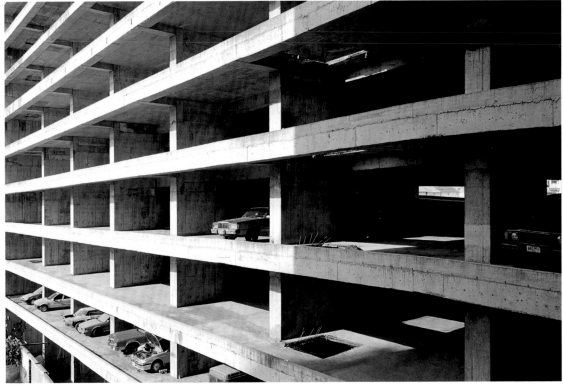

Top:
With no functioning lifts or escalators, the tower
is a 45-storey walk up apartment, 2011

Bottom:
The tower's parking garage serves as a route
for motor taxis to shuttle residents up to the
15th floor. Inhabitants then climb the rest of
their way home, 2011

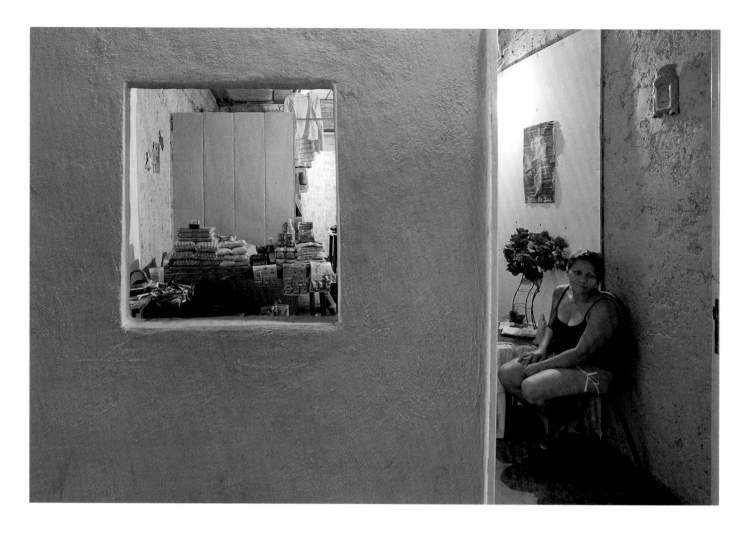

Small businesses like this general store can
be found throughout the tower, 2011

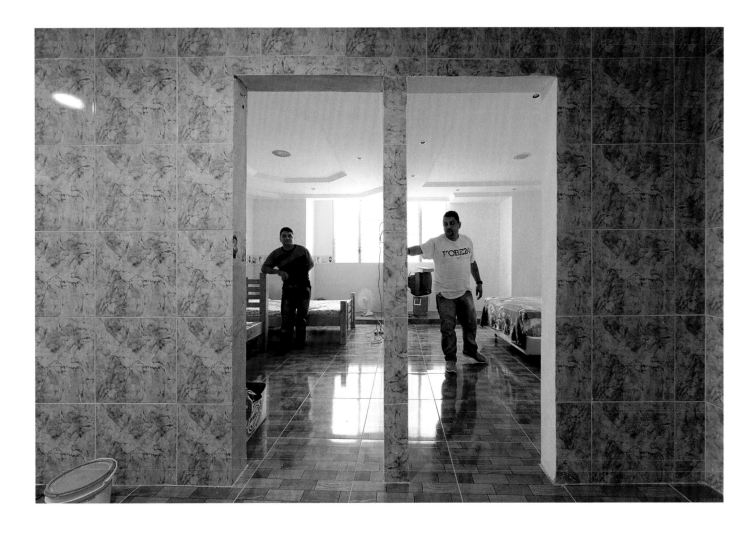

Families design and decorate their homes to suit their own
personal taste, making every living space unique, 2011

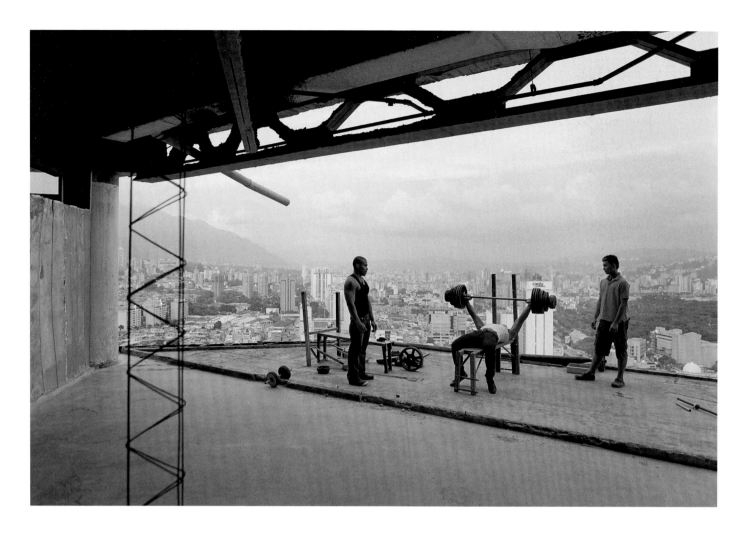

For many residents the tower offers all the services
and amenities needed for everyday life, including
an open-air gym on the 28th floor, 2011

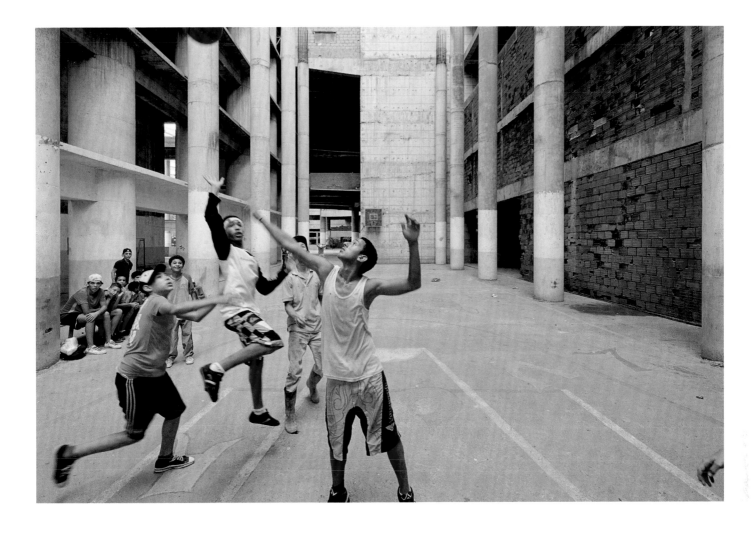

A strong sense of community runs throughout the tower.
Public spaces such as this basketball court reinforce
togetherness while giving children a safe refuge, 2011

With no official landlord or superintendent, the maintenance of the building is the responsibility of the inhabitants. From painting common areas, to organising the building's circulation, the residents take great pride in maintaining a safe and homely environment, 2011

Essay Notes

Berenice Abbott (p 43)

1 Berenice Abbott, 'Photographic Record of New York City', proposal submitted to Federal Art Project, 1935, quoted in Sarah M Miller, 'Dynamic Equilibrium, Berenice Abbott's History of the Now', in *Berenice Abbott*, ed. Gaelle Morel, exhibition catalogue, Editions Hazan, 2012, p 53

2 Hank O'Neal and Berenice Abbott, *Berenice Abbott, American Photographer,* McGraw-Hill, 1982, pp 24–25

3 Gerald W McFarland, *Inside Greenwich Village: A New York City Neighbourhood, 1898–1918*, University Of Massachusetts Press, 2006, chapter 6

4 See Hank O'Neal, 'Introduction' in *Berenice Abbott*, Thames & Hudson, 2010

5 Berenice Abbott, *The World of Atget*, Horizon Press, 1964, p xxxi

6 Ibid., pp x, viii

7 *Life* magazine, January 1938

Walker Evans (p 55)

1 Leslie Katz, 'Interview with Walker Evans', *Art in America 59*, no. 2, March–April 1971, p 83

2 Letter to Hans Skolle, 11 January 1930, Walker Evans Archive, quoted in Douglas Eklund, 'Exile's Return: The Early Work, 1928–34', *Walker Evans*, exhibition catalogue, The Metropolitan Museum of Art, New York, 2000, p 34

3 Letter dated 31 March 1925, quoted in Ann Douglas, *Terrible Honesty: Mongrel Manhattan in the 1920s*, Farrar Straus Giroux, 1995, p 35

4 William E Brooks, 'Arthurdale — a New Chance', *Atlantic Monthly*, February 1935, p 199

5 *A Portrait*, p 6

6 EE Cummings, 'Poem or Beauty Hurts Mr Vinal', included in *is 5*, New York, 1926, p 6

7 Charles Baudelaire, *The Painter of Modern Life and Other Essays*, ed. and trans. Jonathan Mayne, Phaidon Press, 1964, pp 9–10

8 By his death, Evans had amassed a collection of some 9,000 of these penny postcards. See Jeff L Rosenheim 'The Cruel Radiance of What is: Walker Evans and the South' in *Walker Evans*, p 66

9 Lincoln Kirstein, 'Photographs of America: Walker Evans' in *American Photographs*, exhibition catalogue, Museum of Modern Art, New York, first printed 1938, seventy-fifth anniversary edition, 2012, pp 195–200

Julius Shulman (p 71)

1 Cathleen McGuigan, quoted in 'Julius Shulman dies at 98', *Los Angeles Times*, 17 July 2009, www.latimes.com/obituaries/la-me-julius-shulman17-2009jul17,0,623360.story#axzz2wxpYJkKc

2 *Julius Shulman: Architecture and its Photography*, Taschen, 1998, p 16

3 This is the story of origination as told by Shulman; see Taina Rikala de Noriega, interview with Julius Shulman, 12 January – 3 February 1990, Archives of American Art, Smithsonian Institution: www.aaa.si.edu/collections/oralhistories/transcripts/shulma90.htm/

4 *Julius Shulman: Architecture and its Photography*, Taschen, 1998, p 18

Lucien Hervé (p 83)

1 Letter from Le Corbusier to Lucien Hervé, 15 December 1949, quoted in Nathalie Herschdorfer and Lada Umstatter, eds., *Le Corbusier and the Power of Photography*, Thames & Hudson, 2012, chapter 4

2 Olivier Beer, *Lucien Hervé, Building Images*, trans. by Sharon Grevet, J Paul Getty Trust Publications, 2004, p 14

3 See Véronique Boone, 'Une image de l'architecture: Lucien Hervé dans le cadre de l'évolution de la photographie d'architecture', *Lucien Hervé, L'Oeil de l'architecte*, exhibition catalogue, CIVA Brussels, 2005, p 24

4 Olivier Beer, *Lucien Hervé, Building Images*, trans. by Sharon Grevet, J Paul Getty Trust Publications, 2004, p 17

5 Ibid., p 23

6 Ibid., p 12

Bernd and Hilla Becher (p 109)

1 Köhler, M, 'Interview mit Bernd und Hilla Becher', in *Künstler. Kritisches Lexikon der Gegenwartskunst*, Munich, 1989

2 Ibid.

Stephen Shore (p 123)

1 Christy Lange, 'Nothing Overlooked', in *Stephen Shore*, Phaidon, 2007, p 52

2 Ibid., p 110

3 Ibid., p 110

4 Stephen Shore, 'Photography and Architecture', in *Stephen Shore*, Phaidon, 2007, p 138

Luigi Ghirri (pp 152–153)

1 Luigi Ghirri, *For Aldo Rossi*, in *Luigi Ghirri — Aldo Rossi: Things Which Are Only Themselves*, CCA/Electa, 1996, p 33

2 Quoted and translated by Paolo Constantini, in *Luigi Ghirri — Aldo Rossi: Things Which Are Only Themselves*, CCA/Electa, 1996, p 11, from Aldo Rossi, *Premessa: Altre Voci, Altre Stanze,* in Alberta Ferlanga, Aldo Rossi: Architetture 1988–1992, Electa, 1992

3 Luigi Ghirri quoted in Paolo Constantini, *Luigi Ghirri — Aldo Rossi: Things Which Are Only Themselves*, CCA/Electa, 1996, p 134

4 'New Topographics: Photographs of a Man-Altered Landscape' was a landmark exhibition curated in 1975 by William Jenkins at the International Museum of Photography, George Eastman House, Rochester, New York. It featured the American photographers Robert Adams, Lewis Baltz, Joe Deal, Frank Gohlke, Nicholas Nixon, John Schott, Stephen Shore and Henry Wessel Jr., alongside the German couple Bernd and Hilla Becher. The exhibition presented photographers whose objectivity and

focus upon the traditionally 'banal' redefined notions of landscape photography from a portrait of pure nature to a documentation of the industrial and urban impacts of man's interaction with the world.

5 Luigi Ghirri quoted in Christy Lange, *All Other Images* (*Frieze*, issue 143, 2011)

6 Luigi Ghirri, *For Aldo Rossi*, in, Paolo Costantini, *Luigi Ghirri — Aldo Rossi: Things Which Are Only Themselves*, p 33

7 Ibid., p 133

8 Ibid., p 133

9 Paolo Costantini, *Luigi Ghirri — Aldo Rossi: Things Which Are Only Themselves*, CCA/Electa, 1996, p 9

10 Quoted from publisher Michael Mack (who in 2012 re-printed Ghirri's self-published first book *Kodachrome*, 1978) in Hanne Christiansen, Luigi Ghirri, Dazed Digital www.dazeddigital.com/photography/article/16236/1/luigi-ghirri *Kodachrome* was republished by Mack in 2013.

11 A statement made by Ada Louise Huxtable, president of the awarding Pritzker jury, upon Aldo Rossi's winning of the prize www.pritzkerprize.com/1990/bio

12 Belgin Turan Özkaya, *The Art of Reconciliation: Autobiography and Objectivity in the Work of Aldo Rossi*, in, *Biographies and Space: Placing the Subject in Art and Architecture*, Eds. Dana Arnold and Joanna Sofaer, Routledge, 2008, p 160

13 Architectural historian Manfredo Tafuri's description of Rossi's work, quoted in ibid., from Manfredo Tafuri and Francesco Dal Co, *Modern Architecture*, 1979

14 See, *The Collective Memory*, in Aldo Rossi, *The Architecture of the City*, MIT Press, 1982, p 130

15 Carlos Jimenez, *Mystic Signs, A Conversation with Aldo Rossi*, Cite, no. 24, Spring 1990, pp 16–17

Hélène Binet (p 169)

1 Binet quoted from a lecture at Harvard Graduate Design School, 19 March 2012

2 Hejduk quoted in Mark Pimlot, *Hélène Binet: Photographs as Space*, in *Composing Space: The Photographs of Hélène Binet*, Phaidon Press, 2012, p 215

3 Ibid.

4 Binet quoted from *Space Composer: An interview with Hélène Binet by Thierry Bal*, varioussmallfires.co.uk, 11.12.12

Hiroshi Sugimoto (p 179)

1 Fox Talbot (1800–77) was a British inventor and pioneer of photography who developed the calotype process, a precursor to the photographic processes of the nineteenth and twentieth centuries

2 'I've mastered my own style of technicality. I learned a lot from Ansel Adams. He published a book of prints and negatives and lights and processes, all of his secrets. I follow his chemical formulas. He is my technical master.' Hiroshi Sugimoto interviewed by Hossein Amirsadeghi, in *Art Studio America*, Ed. Hossein Amirsadeghi, Thames and Hudson, 2013

3 *Memory*, ART:21, PBS broadcast, 23 September 2005

4 Quoted from the artist's text on his website. www.sugimotohiroshi.com/architecture

5 Quoted in the press release of *Hiroshi Sugimoto: Joe*, Gagosian Gallery, Beverly Hills, 2006 www.gagosian.com/exhibitions/september-09-2006--hiroshi-sugimoto

6 Quoted in *Contacts*, ARTE Video, 2004

7 Quoted in the press release of *Hiroshi Sugimoto: Architecture*, Fraenkel Gallery, San Francisco, 2003 http://fraenkelgallery.com/exhibitions/architecture-2#

8 Susan Sontag, introduction to Peter Hujar, *Portraits in Life and Death*, Da Capo Press, 1976

9 Sugimoto quoted by Kanae Hasegawa in introductory text to *Hiroshi Sugimoto: End of Time*, Mori Art Museum, 2006 www.studiointernational.com/index.php/hiroshi-sugimoto-end-of-time

Luisa Lambri (pp 188–189)

1 Quoted in Massimiliano Gioni, *Self-Portrait,* in *Luisa Lambri: Interiors*, Ivory Press, 2011

2 Roland Barthes, *The Eiffel Tower and Other Mythologies*, University of California Press, 1997; first published 1979

3 See Luisa Lambri interviewed by Hans-Ulrich Obrist, *NOW Interviews*, 2010

4 Quoted in Massimiliano Gioni, *Self-Portrait,* in *Luisa Lambri: Interiors*, Ivory Press, 2011

5 *The Poetics of Space: a conversation between Matthew Drutt and Luisa Lambri*, in *Luisa Lambri: Locations*, Menil Collection, 2007

6 Luisa Lambri interview with Studio Banana TV, 15 December 2010

7 Quoted in Massimiliano Gioni, *Self-Portrait,* in *Luisa Lambri: Interiors*, Ivory Press, 2010

Andreas Gursky (p 199)

1 *Rhine II* (1999) fetched $4,338,500 at auction at Christies, New York in 2011

2 Political scientist Francis Fukuyama's essay 'The End of History?' published in *The National Interest*, 1989, proclaimed the birth of a post-ideological world and the triumph of Western democratic and economic models, in response to the global waning of Communist influence. Though widely contested, Fukuyama's thesis could be perceived as visualised in much of Gursky's subject matter — both in its frequent depiction of cathedrals of commerce and in its desire to flatten the world into a zone of global equivalence.

3 Gursky quoted in correspondence with Veit Gorner in *Andreas Gursky: Fotografien 1994–1998*, Kunstmuseum Wolfsburg/Cantz Verlag, 1998

4 Gursky has stated: 'My first digital image dates back to 1992. It was a photo I took at Charles de Gaulle airport in Paris. There were certain intrusive details that would, in the end, have stopped me from using the image. And then I decided to replace them with other details that I found more interesting.' Contacts, ARTE Video, 2004

5 See as Martin Hentschel: 'As our eyes roam from one window to the next, we unconsciously slip into the stance assumed by the lead in Alfred Hitchcock's *Rear Window*. *Paris, Montparnasse* becomes a 'rear window' blown up to megalomaniacal dimensions and tailored to the present day'; in Martin Hentschel, 'The Totality of the World, Viewed in Its Component Forms', *Andreas Gursky, Works 80–08*, Hatje Cantz, 2009, p 28

Simon Norfolk (p 209)

1 For an account of early British aerial bombing of civilian populations, see Sven Lindqvist, *A History of Bombing*, trans. Linda Haverty Rugg, Granta Books, 2001, section 102

2 For a history of that resistance, see Richard Gott, *Britain's Empire: Resistance, Repression and Revolt*, Verso, 2011

3 Paul Lowe and Simon Norfolk, 'In Conversation': www.simonnorfolk.com/burkenorfolk/conversation.html

4 See Charles Tripp, *A History of Iraq*, Cambridge University Press, 2000, chapter 6

5 For a compelling and detailed indictment of the policy, see Joy Gordon, *Invisible War: The United States and the Iraq Sanctions*, Harvard University Press, 2010

Guy Tillim (p 221)

1 Guy Tillim, interview with Corin Hirsch, *a.magazine,* African Interview Series, 28 July, 2008, http://interviews.amagazine.org p 121

2 Mark Crinson, *Modern Architecture and the End of Empire*, Ashgate, London, 2003

3 Tillim interview, Hirsch, *a.magazine*

4 Georg Simmel, 'The Ruin' (1911), in Kurt Wolf, ed. Georg Simmel, 1858–1918, Ohio State University Press, Columbus, 1959, p 258–63

5 Walter Benjamin, *The Origin of Tragic Drama* (1928), trans. John Osbourne, Verso, London, 1998, p 178

Bas Princen (pp 232–233)

I am grateful to Bas Princen for making time during a very busy period to supply reference material and to clarify some aspects of his *Five Cities* project.

1 Bas Princen in Conversation with Stefano Graziani in *Bas Princen Reservoir*, edited by Moritz Küng, deSingel International Arts Centre, Antwerp, Hatje Cantz, 2011

2 Defined by the United Nations as cities with 10 million or more inhabitants. By this definition, Cairo and Istanbul are both megacities.

3 The influential exhibition, curated by William Jenkins at George Eastman House in Rochester NY, brought together works by Stephen Shore and Bernd and Hilla Becher amongst others. For more information consult *New Topographics*, text by Britt Salvesen, Alison Nordström, Steidl, 2009

4 A term used within the scientific community to describe the current stage of the Earth, whose systems are now influenced by human activity at an unprecedented scale.

5 www.domusweb.it/en/architecture/2010/05/11/refuge-five-cities-by-bas-princen.html

6 From Graziani interview in *Reservoir* as above. Princen has also cited twentieth-century German photographer and champion of the New Objectivity, Albert Renger-Patzsch, whose work shows manmade infrastructures at the scale of landscape.

7 The 'Diwan' collaborative research platform, curated by Philipp Misselwitz and Can Altay and exhibited at the International Architecture Biennale Rotterdam, 2009, and Istanbul Capital of Culture, 2010. Refuge portfolio, SUN publishers.

8 www.domusweb.it/en/architecture/2010/05/11/refuge-five-cities-by-bas-princen.html

9 Ibid.

10 Outside of the *Five Cities* commission, the products of which were exhibited in some of the places it depicted, Princen's work has primarily been exhibited and published to European and North American audiences.

11 E.g. ancient monuments, buildings maimed by war, minarets, theme park coastal infill, labyrinthine souks, record-breaking skyscrapers, the *Five Cities* work predates the mass protests that have roiled the region's cities since 2011.

12 An insightful discussion of *Five Cities* architectural references can be found in Joseph Grima's 2010 interview of Princen for *Domus*: www.domusweb.it/en/architecture/2010/05/11/refuge-five-cities-by-bas-princen.html

Nadav Kander (p 245)

1 This is imminent, if it has not already happened. See Robert J Samuelson, 'Is China No. 1 (in GDP)?', *Washington Post*, 14 May 2014

2 Nadav Kander, 'Artist's Notes', in *Yangtze — The Long River*, Hatje Cantz, 2010, np

3 There are many accounts of this extraordinary social change; for a recent analysis and editorial, see 'Where China's Future Will Happen', *The Economist*, 19 April 2014

4 The terms are drawn from Immanuel Kant, *Observations on the Feeling of the Beautiful and Sublime*, trans. John T Goldthwait, University of California Press, 1960

5 Nadav Kander, 'Artist's Notes', np

6 Nadav Kander, 'Artist's Notes', np

Iwan Baan (pp 256–257)

1 *Torre David: Informal Vertical Communities*, Lars Muller Publishers, 2013, p 110

2 I am indebted to Alfredo Brillembourg and Hubert Klumpner, co-founders of Urban-Think Tank, first for their hospitality during my visit to Caracas in 2006, and for their book about the Torre David, upon which this essay draws heavily for many of its facts

3 Numbers given as current are from 2010 to 2012, from *Torre David*

4 *Torre David*, p 40

5 In the realm of architectural photography, another memorable example is found in Adam Broomberg and Oliver Chanarin's images of occupied buildings in downtown Johannesburg

6 As with much mainstream media coverage of informal settlements across the Global South, previous reportage about the Torre has tended to focus on negative or sensationalist aspects of this 'vertical slum', including alleged associations with organised crime and violation of property laws. However, as Andres Lepik observes of the Torre David, this 'complex social experiment' lacks many of the typical characteristics of 'slums', *Torre David*, p 30–33

7 A view familiarised in part by some previous photographs by Urban-Think Tank themselves, such as those exhibited at the 2006 Venice Architecture Biennale

8 For example Tuca Viera's stunning and widely circulated 2005 image of São Paulo's Paraisópolis favela, overlooked by a gated luxury condominium with a pool on each balcony

9 http://nymag.com/homedesign/urbanliving/2011/caracas/

Selected Bibliography

General Reading

Blankenship, Jana, and Claire Fitzsimmons, Jens Hoffmann, Blake Stimson, *More American Photographs*, San Francisco, CA: CCA Wattis Institute for Contemporary Arts, 2011

Caiger-Smith, Martin and David Chandler (eds), *Site Work: Architecture in Photography Since Early Modernism*, ex. cat., London: Photographers' Gallery, 1991

Campany, David (ed.), *Art and Photography*, London: Phaidon Press, 2012 (2003)

Elwall, Robert, B*uilding with Light: The International History of Architectural Photography*, London: Merrell in association with The Royal Institute of British Architects, London, 2004

Gronert, Stefan (ed.), *The Düsseldorf School of Photography*, London: Thames and Hudson, 2009

Higgott, Andrew and Timothy Wray (eds.), *Camera Constructs: Photography, Architecture and the Modern City*, Farnham: Ashgate, 2012

Hurley, Jack F, *Portrait of a Decade: Roy Stryker and the Development of Documentary Photography in the Thirties*, Baton Rouge: Louisiana State University Press, 1972

Janser, Daniela, Thomas Seelig and Urs Stahel (eds.), *Concrete: Photography and Architecture*, in collaboration with Eva Kurz, Therese Seeholzer and Corinna Unterkolfer, Zurich: Scheidegger & Spiess, 2013

Jenkins, William, *New Topographics: Photographs of a Man-altered Landscape*, ex. cat., Rochester, NY: International Museum of Photography at George Eastman House, 1975

Leão Neto, Pedro and Pedro Bandeira (eds.), *On the Surface, Main Conference and Workshop*, International Seminar on the Surface: images of architecture and public space in debate that took place at the Faculty of Architecture at the University of Porto (FAUP), May 2010

Mack, Michael (ed.), *Reconstructing Space: Architecture in Recent German Photography*, London: AA Publications, 1999

Moure, Gloria, *Architecture without Shadow*, Barcelona: Ediciones Polígrafa, 2000

Pratesi, Ludovico and Benedetta Carpi De Resmini, *Urban Spaces: Andreas Gursky*, Candida Höfer, Axel Hütte, Thomas Ruff, Thomas Struth, Buenos Aires: Fundación Proa, 2009

Redstone, Elias, *Shooting Space: Architecture in Contemporary Photography*, London: Phaidon Press, 2014

Robinson, Cervin, and Joel Herschman, *Architecture Transformed: A History of the Photography of Buildings from 1839 to the Present*, Cambridge, Mass.: MIT Press, 1987

Sobieszek, Robert A, *Hedrich-Blessing: Architectural Photography, 1930–1981*, Rochester, NY: The House, 1981

Steinhauser, Monika and Ludger Derenthal (eds.), *Ansicht, Aussicht, Einsicht: Andreas Gursky, Candida Höfer, Axel Hütte, Thomas Ruff, Thomas Struth, Architekturphotographie*, ex. cat., Düsseldorf: Richter Verlag, 2000

Stott, William, *Documentary Expression and Thirties America*, New York: Oxford University Press, 1973

Zimmerman, Claire, *Photographic Architecture in the Twentieth Century*, Minneapolis: University of Minnesota Press, 2014

Berenice Abbott

Abbott, Berenice, Elizabeth McCausland, *Changing New York*, New York: EP Dutton & Company, 1939

Abbott, Berenice, *A Guide to Better Photography*, New York: Crown Publishers, 1941

Abbott, Berenice, 'Documenting the City', *The Complete Photographer*, no. 22, 1942

Abbott, Berenice, *The View Camera Made Simple*, Chicago: Ziff-Davis, 1948

Abbott, Berenice, *The World of Atget*, New York: Horizon Press, 1964

Abbott, Berenice, 'Photographic Record of New York City', proposal submitted to the Art Project, Works Division, Emergency Relief Bureau, in Abbott, 'Changing New York', in Francis O'Connor (ed.), *Art for the Millions: Essays from the 1930s by Artists and Administrators of the WPA Federal Art Project*, Greenwich, Conn.: New York Graphic Society, 1973, pp 158–62

Barr, Peter, 'Berenice Abbott's Changing New York and Urban Planning Debates in the 1930s', Karen Koehler (ed.), *The Built Surface: Architecture and the Pictorial Arts from Romanticism to the Twenty-First Century*, Aldershot: Ashgate, 2002, pp 257–82

Corwin, Sharon, Jessica May and Terri Weissman, *American Modern: Documentary Photography by Abbott, Evans, and Bourke-White*, ex. cat., Berkeley: University of California Press, 2010

Morel, Gaëlle (ed.), *Berenice Abbott*, translated by James Gussen, ex. cat., Paris: Éditions Hazan, 2012

Morris Hambourg, Maria and Christopher Phillips, *The New Vision: Photography between the World Wars*. Ford Motor Company Collection at the Metropolitan Museum of Art, New York, Metropolitan Museum of Art, 1989

Newhall, Beaumont, *Photography 1839–1937*, New York: the Museum of Modern Art, 1937

Newhall, Beaumont, 'Documentary Approach to Photography', *Parnassus*, vol. 10, no. 3, March 1938

O'Neal, Frank, *Berenice Abbott*, London: Thames and Hudson, 2010

Phillips, Christopher, *Photography in the Modern Era: European Documents and Critical Writings, 1913–1940*, New York: Metropolitan Museum of Art/Aperture, 1989

Van Haaften, Julia, *Berenice Abbott, New York: Aperture,* 1988

Van Haaften, Julia, *Berenice Abbott Photographer: A Modern Vision*, New York: The New York Public Library, 1989

Weissman, Terri, *The Realisms of Berenice Abbott: Documentary Photography and Political Action*, Berkeley: University of California Press, 2011

Yochelson, Bonnie, B*erenice Abbott: Changing New York*, New York: The New Press and The Museum of the City of New York, 1997

Yochelson, Bonnie (et al.), *New York Changing: Revisiting Berenice Abbott's New York*, New York: Princeton Architectural Press and the Museum of the City of New York, 2004

Iwan Baan

Baan, Iwan, *Brasilia-Chandigarh: Living with Modernity*, edited by Lars Müller with texts by Cees Nooteboom and Martino Stierli, Baden: Lars Müller, 2010

Baan, Iwan, *52 Weeks, 52 Cities*, with texts by Roland Nachtigäller and Jörg Häntzschel, Berlin: Kehrer Verlag Heidelberg, 2014

Brillembourg, Alfredo and Hubert Klumpner (eds.), *Torre David: Informal Vertical Communities*, photographs by Iwan Baan, Zurich: Lars Müller, 2013

Fenstad Langdalen, Erik and Aaslaug and Nina Frang Høyum (eds), *Hamsun, Holl, Hamarøy*, with photographs by Iwan Baan, Baden: Lars Müller, 2010

Idenburg, Florian (ed.), *The SANAA Studios 2006–2008: Learning from Japan: Single Story Urbanism*, photography by Iwan Baan, Baden: Lars Müller, 2010

Leuschel, Klaus, and Marta Herford (eds.), *Richard Neutra in Europa: Bauten und Projekte 1960–1970*, Cologne: Martha Herford, 2010

Maltzan, Michael and Jessica Varner, *No More Play: Conversations on Open Space and Urban Speculation in Los Angeles and Beyond*, Ostfildern: Hatje Cantz, 2011

Müller, Lars, Akiko Miki (eds.), *Insular Insight: Where Art and Architecture Conspire with Nature: Naoshima, Teshima, Inujima*, with photographs Iwan Baan, Baden: Lars Müller Publishers and Fukutake Foundation, 2011

Porsche Museum, Delugan Meissl Associated Architects, HG Merz and photography by Iwan Baan, New York: Springer, 2010

Racana, Gianluca and Manon Janssens (eds), *MAXXI: Zaha Hadid Architects*, New York: Skira, 2010

Sarano, Florence (ed.), *Iwan Baan: Around the World: Diary of a Year of Architecture*, ex. cat., Paris: Archibooks, 2011

Bernd and Hilla Becher

Becher, Bernd and Hilla, *Typologies*, edited and with an introduction by Armin Zweite, Cambridge, Mass.: MIT, 2004

Bernd and Hilla Becher: Basic Forms, with a text by Thierry de Duve, trans. by Gila Walker, New York: teNeues, 1999

Lange, Susanne, *Bernd and Hilla Becher: Life and Work*, trans. by Jeremy Gaines, Cambridge, Mass.: MIT Press, 2007

'Wassertürme,' *Architectural Review* 141, no 841, March 1967, pp 227–30

Weaver, Thomas, 'In Conversation with Hilla Becher', *AA Files 66*, London: Architectural Association, 2013

Hélène Binet

Binet, Hélène, *Architecture of Zaha Hadid in Photographs*, Baden: Lars Müller, 2000

Binet, Hélène, *Hélène Binet: Seven Projects*, foreword by Mark Rappolt, with texts by Daniel Libeskind and Zaha Hadid, London: Shine Gallery, 2002

Binet, Hélène, *Composing Space: The Photographs of Hélène Binet*, with an afterword by Mark Pimlott, London: Phaidon Press, 2012

Hauser, Sigrid, *Peter Zumthor: Therme Vals*, essays, Sigrid Hauser, Peter Zumthor; photographs, Hélène Binet, Zurich: Scheidegger & Spiess, 2007

Holocaust Memorial Berlin: Eisenman Architects, text by Hanno Rauterberg, photo essay by Hélène Binet, photo impressions by Lukas Wassmann, trans. Ishbel Fiett, Baden: Lars Müller Publishers, 2005

Jewish Museum Berlin: Architect Daniel Libeskind, interview with Daniel Libeskind with a photo essay by Hélène Binet, London: G+B Arts International, 1999

Mostafavi, Mohsen, and Hélène Binet, *Nicholas Hawksmoor: Seven Churches for London*, Baden: Lars Müller, 2013

A Passage Through Silence and Light: Daniel Libeskind's Jewish Museum extension to the Berlin Museum, photographs by Hélène Binet, text by Raoul Bunschoten, London: Black Dog Publishing Limited, 1997

Peter Zumthor, *Works: Buildings and Projects 1979–1997*, photographs by Hélène Binet, text by Peter Zumthor, Basel: Birkhäuser, 1999

Walker Evans

Agee, James and Walker Evans, *Let Us Now Praise Famous Men: Three Tenant Families*, Boston: Houghton Mifflin, enlarged edition, 1960 (1941)

Campany, David, *Walker Evans: The Magazine Work*, Göttingen: Steidl, 2014

Evans, Walker, 'The Reappearance of Photography', *Hound and Horn*, no. 5, October-December 1931

Evans, Walker, *American Photographs*, essay by Lincoln Kirstein, ex. cat., New York: Museum of Modern Art, 1988 (1938)

Evans, Walker, *Many Are Called*, essay by James Agee, Boston: Houghton Mifflin, 1966

Evans, Walker, 'Photography', in Louis Kronenberger (ed.), *Quality: Its Image in the Arts*, New York: Atheneum, 1969, pp 169–211

Fleischhauer, Carl and Beverly W. Brannan (eds.), *Documenting America, 1935-1943*, Berkeley and Los Angeles: University of California Press, 1988

Lange, Dorothea, and Paul S Taylor, *An American Exodus: A Record of Human Erosion in the Thirties*, New York: Reynal and Hitchcock, 1939

Lugon, Olivier, *Le Style documentaire d'August Sander à Walker Evans 1920–1945*, Paris: Macula, 2001

Mora, Gilles and John T Hill, *Walker Evans: The Hungry Eye*, London: Thames and Hudson, 1993

Morris Hambourg, Maria, *Walker Evans*, ex. cat., New York: The Metropolitan Museum of Art, 2000

Radin, Paul and James Johnson Sweeney, *African Folktales & Sculpture*, photographs by Walker Evans, New York: Pantheon Books, 1952

Rathbone, Belinda, *Walker Evans: A Biography*, New York: Houghton Mifflin, 1995

Rosenheim, Jeff L, Douglas Eklund and Maria Morris Hambourg, *Unclassified: A Walker Evans Anthology*, New York: The Metropolitan Museum of Art, 2000

Squiers, Carol, 'Color Photography: The Walker Evans Legacy & the Commercial Tradition', *Artforum*, November 1978

Szarkowski, John, *Walker Evans*, ex. cat., New York: Museum of Modern Art, 1971

Walker Evans: Photographs for the Farm Security Administration, 1935–1938; a Catalog of Photographic Prints Available from the Farm Security Administration Collection in the Farm Security Administration Collection in the Library of Congress, introduction by Jerald C Maddox, New York: Da Capo Press, 1973

Walker Evans: First and Last, New York: Harper and Row, 1978

Luigi Ghirri

Aldo Rossi, *architetture padane*, texts by Aldo Rossi, photographs by Luigi Ghirri, Modena: Panini, 1984

Costantini, Paolo, *Luigi Ghirri — Aldo Rossi: Things Which Are Only Themselves*, ex. cat., Montreal: CCA, 1996

Ghirri, Luigi, *Kodachrome*, London: MACK, 2013 (1978)

Ghirri, Luigi, *It's beautiful here, isn't it*, preface by William Eggleston, essay by Germano Celant, New York: Aperture, 2008

Pelizzari, Maria Antonella, 'Between Two Worlds', *Artforum*, April 2013, pp 206-11; 280

Spunta, Marina, 'Il Profilo delle Nuvole: Luigi Ghirri's Photography and the New Italian Landscape', *Italian Studies*, vol. 61, no. 1, Spring 2006, pp 114–36

Andreas Gursky

Andreas Gursky, texts by Bernhard Mendes Bürgi, Beate Söntgen and Nina Zimmer, ex. cat., Ostfildern: Hatje Cantz, 2007

Bajac, Quentin, 'Le regard élargi', *Les cahiers du musée national d'art moderne*, 92, Summer 2005, pp 28–41

Breuer, Gerda, 'Pictures of Paradox: The Photographs of Andreas Gursky', in Michael Mack (ed.), *Reconstructing Space: Architecture in Recent German Photography*, London: AA Publications, 1999, pp 18–25

Galassi, Peter (ed.), *Andreas Gursky*, ex. cat., New York: Museum of Modern Art, 2001

Gursky, Andreas, Ralf Beil and Sonja Fessel, *Andreas Gursky: Architecture*, ex. cat., Ostfildern: Hatje Cantz, 2008

Hentschel, Martin (ed.), *Andreas Gursky: Arbeten — Works 80–08*, Stockholm: Moderna Museet, 2008

Illies, Florian, 'Gursky gibt Gas', *Monopol*, 3, March 2007, pp 74–81

Irrek, Hans (ed.), *Andreas Gursky: Montparnasse*, ex. cat., Stuttgart: Oktagon, 1995

Tomkins, Calvin, 'The Big Picture: What do Andreas Gursky's Monumental Photographs Say About Art?', *Modern Painters*, 14, Spring 2001, pp 26-34

Lucien Hervé

Architettura in Immagini: Lucien Hervé Fotografa Le Corbusier, ex. cat., Milan: Skira, 2009

Beer, Olivier, *Lucien Hervé: Building Images*, trans. Sharon Grevet, Los Angeles: Getty Research Institute, 2004

Beer, Olivier, *Lucien Hervé*, Arles: Actes Sud, 2013

Cali, François, *La plus grande aventure du monde: l'architecture mystique de cîteaux*, Paris: Arthaud, 1956

Herschdorfer, Nathalie and Lada Umstatter (eds.), *Le Corbusier and the Power of Photography*, London: Thames and Hudson, 2012

Hervé, Lucien, 'Le siège de l'Unesco à Paris', *L'Architecture d'aujourd'hui*, no. 58, January 1955, pp 26–31

Hervé, Lucien, 'Le siège de l'Unesco à Paris', *Aujourd'hui*, no. 8, June 1956, pp 58-63

Hervé, Lucien, 'L'unité d'habitation à Nantes-Rézé', *L'Architecture d'aujourd'hui*, no. 66, July 1956, pp 2–11

Hervé, Lucien, 'À propos de la photographie d'architecture', *Aujourd'hui*, no. 9, July 1956, pp 28–31

Hervé, Lucien, 'Observatoire de Jaipur', *Aujourd'hui*, no. 9, July 1956, pp 34–37

Hervé, Lucien, 'La maison de Pierre Jeanneret à Chandigarh', *Aujourd'hui*, no. 9, July 1956, pp 62–63; 64–67

Hervé, Lucien, 'Inde et Chandigarh', *L'Architecture d'aujourd'hui*, no. 67–68, August-September 1956, pp 172–197

Hervé, Lucien, 'Chandigarh, capitale du Pakistan', *L'Architecture d'aujourd'hui*, no. 101, April–May 1962, pp 4-21

Hervé, Lucien, 'Visite à Brasilia', *L'Architecture d'aujourd'hui*, no. 101, April-May 1962, pp 22-37

Lucien Hervé: The Soul of an Architect, text by Zaha Hadid, ex. cat., London, 1998

Lucien Hervé: L'œil de l'architecte, texts by Barry Bergdoll, Veronique Boone and Pierre Puttemans, ex. cat., Brussels: CIVA, 2005

Naegele, Daniel, 'Intervista a Lucien Hervé', *Parametro*, vol. 26, January-February 1995, pp 71-83

Portraits de ville: Brasília, Chandigarh, Le Havre, ex. cat., Paris: Somogy Editions d'Art, 2007

Sbriglio, Jacques (ed.), *Le Corbusier & Lucien Hervé: The Architect & the Photographer: A Dialogue*, with introductions by Quentin Bajac and Béatrice Andrieux, and a preface by Michel Richard, trans. Teresa Lavender Fagan, London: Thames and Hudson, 2011

Nadav Kander

Nadav Kander: Night, New York: Yancey Richardson, 2003

Nadav Kander: Yangtze: The Long River, texts by Kofi A Annan, Jean-Paul Tchang and Nadav Kander, Ostfildern: Hatje Cantz, 2010

Luisa Lambri

Calvalchini, Pieranna, *Luisa Lambri: Portrait*, ex. cat., Boston: The Isabella Stewart Gardner Museum, 2012

Drutt, Matthew, *Luisa Lambri: Locations*, ex. cat., Houston: Menil Foundation, 2004

Exley, Roy, 'Into the Interior', *Portfolio: The Catalogue of Contemporary Photography in Britain*, no. 31, June 2000, pp 4–11

Hasegawa, Yuko, 'The Sensibility, Emotion and Fluidity of the Architectural Program', in *People Meet in Architecture, 12th International Architecture Exhibition*, ex. cat., Venice: Marsilio Editori, 2010

Hough, Jessica, and Mónica Ramirez-Montagut (eds.), *Revisiting the Glass House: Contemporary Art and Modern Architecture*, ex. cat., Ridgefield: The Aldrich Contemporary Art Museum, 2008

Luisa Lambri: Interiors, texts by Walead Beshty, Douglas Fogle, Adriano Pedrosa, and Kazuyo Sejima and Ryue Nishizawa, London: Ivorypress, 2011

Morgan, Susan, 'A Form of Recollection: The Architectural Interiors of Luisa Lambri', *Aperture*, no. 202, February 2011, pp 32–39

Pedrosa, Adriano, 'Untitled (Casa das Canoas, 1953), 2002–4', in *Luisa Lambri*, brochure Rio de Janeiro: Colecçao Teixeira de Freitas, 2004

Sillars, Laurence and Kyla McDonald, *Luisa Lambri*, ex. cat., Liverpool: Liverpool Biennial, 2008

Washida, Meruro and Yuko Hasegawa, 'Luisa Lambri', in *SANAA, Buildings*, Photographs, Models, ex. cat., Kanazawa: 21st Century Museum of Contemporary Art, 2005

Simon Norfolk

Burke, John and Simon Norfolk, *Burke + Norfolk: Photographs from the War in Afghanistan*, with texts by David Campbell, Paul Lowe and Simon Norfolk, Stockport: Dewi Lewis Publishing, 2011

Norfolk, Simon, *For Most of It I Have No Words: Genocide, Landscape, Memory*, Stockport: Dewi Lewis, 1998

Norfolk, Simon, *Afghanistan Zero*, Heidelberg: Edition Braus, 2002

Norfolk, Simon, *Afghanistan Chronotopia*, Stockport: Dewi Lewis, 2005

Norfolk, Simon, *Bleed*, Stockport: Dewi Lewis, 2005

Jack, Ian (ed.), *War Zones*, Granta 96, Cambridge: Granta Publications, 2007

Bas Princen

Princen, Bas, Ed van Hinte and Wim Cuyvers (et al.), *Artificial Arcadia*, Rotterdam: 010 Publishers, 2004

Princen, Bas, *Rotterdam*, Rotterdam: Witte de With, 2007

Princen, Bas, *Refuge: Five Cities Portfolio*, Amsterdam: SUN Publishers, 2009

Princen, Bas, *Reservoir*, Ostfildern: Hatje Cantz, 2011

Ed Ruscha

'Books Received: Every Building on the Sunset Strip', *Artforum*, Volume V, no. 7, March 1967, p 66

Crary, Jonathan. 'Edward Ruscha's Real Estate Opportunities', *Arts*, January 1978, pp 119–21

Edward Ruscha: Editions, 1959–1999: Catalogue Raisonné, essays by Siri Engberg and Clive Phillpot, Minneapolis: Walker Art Center, 1999

Feaver, William, 'Photo-Cliché: Real Estate Opportunities', *London Magazine*, April–May 1971, pp 11; 99–108

Finch, Christopher, 'Books: scanning the Strip', *Art and Artists*, 1, no. 10, January 1967, p 67

Hatch, Kevin, 'Something Else': Ed Ruscha's Photographic Books', *October*, 111, Winter 2005, pp 107–26

Hopps, Walter, 'A Conversation Between Walter Hopps and Edward Ruscha, Who Have Known Each Other Since the Early 1960s, Took Place on September 26, 1992', in *Edward Ruscha: Romance with Liquids, Paintings 1966–1969*, ex. cat., New York: Rizzoli and Gagosian Gallery, 1993, pp 97–108

Leider, Philip, 'Books Received: Twentysix Gasoline Stations', *Artforum*, Volume II, no. 3, September 1963, p 57

Marshall, Richard, 'Edward Ruscha Los Angeles Apartments', in *Edward Ruscha: Los Angeles Apartments 1965*, ex. cat., New York: Whitney Museum of American Art, 1990, unpag.

Mitchum, Trina, 'A Conversation with Ed Ruscha', *Journal: Southern California Art Magazine (Los Angeles Institute of Contemporary Art Journal)*, no. 21, January-February 1979, pp 21–24

Norden, Linda, 'Landmark Pictures', in *Landmark Pictures: Ed Ruscha/Andreas Gursky*, ex. cat., Cambridge Mass.: Harvard University Art Museums, 2000, unpag.

Rowell, Margit, *Ed Ruscha, Photographer*, ex. cat., New York and Göttingen: Whitney Museum of American Art and Steidl, 2006

Ruscha, Ed, *Leave Any Information at the Signal: Writings, Interviews, Bits, Pages*, edited and with texts by Alexandra Schwartz, Cambridge, Mass.: MIT Press, 2002

Spodarek, Diane, 'Feature Interview: Edward Ruscha', *Detroit Artists Monthly*, 2, no.4, April 1977, pp 1–5

Tybout, Titia, 'Statements: Ed Ruscha' in *Sonsbeek 71 part 2*, ex. cat., Arnheim: Sonsbeek Foundation, 1971, p 53

Wolf, Sylvia, *Ed Ruscha and Photography*, New York and Göttingen: Whitney Museum of American Art and Steidl, 2004

Stephen Shore

Booth-Haworth, Mark, 'Amarillo — Tall in Texas: A Project by Stephen Shore, 1971', *Art on Paper*, September–October 2000

Lange, Christy, Michael Fried and Joel Sternfeld, *Stephen Shore*, London: Phaidon Press, 2007

Lange, Susanne, 'A Conversation with Stephen Shore', *Bernd and Hilla Becher: Festchrift*, Erasmuspreis, 2002, Munich: Schirmer/Mosel, 2002, pp 47–50 Reproduced http://stephenshore.net/writing/lange.pdf [accessed 23 April 2014]

Shore, Stephen, *Amarillo: Tall in Texas*, ex. cat., New York, 1971

Shore, Stephen, 'The Road Trip', http://stephenshore.net/writing/theroadtrip.pdf [accessed 23 April 2014]

Shore, Stephen, *Uncommon Places: The Complete Works*, essay by Stephan Schmidt-Wulffen, conversation with Lynne Tillman, London: Thames and Hudson, 2004

Shore, Stephen, *American Surfaces*, London: Phaidon Press, 2005

Julius Shulman

Arteaga-Johnson, Giselle, and Jennifer Jaskowiak, *LA Obscura: The Architectural Photography of Julius Shulman*, Los Angeles: Fisher Gallery, University of Southern California, 1998

Gebhard, David, Robert Winter and Julius Shulman, *Architecture in Los Angeles: A Complete Guide*, Salt Lake City: Gibbs M Smith, 1985

Oral history interview with Julius Shulman, Julius Shulman interviewed by Taina Rikala De Noriega, 12 January–3 February 1990, Archives of American Art, www.aaa.si.edu/collections/interviews/oral-history-interview-julius-shulman-11964, [accessed 7 April 2014]

Shulman, Julius, *Photographing Architecture and Interiors*, New York: Whitney Library of Design, 1962

Shulman, Julius, *The Photography of Architecture and Design: Photographing Buildings, Interiors and the Visual Arts*, New York: Whitney Library of Design, 1977

Shulman, Julius, *Julius Shulman: Architecture and Its Photography*, preface by Frank O Gehry, edited by Peter Gössel, New York: Taschen, 1998

Shulman, Julius, *Modernism Rediscovered*, London: Taschen, 2007 (2000)

Shulman, Julius (et al.), *Malibu: A Century of Living by the Sea*, New York: HN Abrams, 2005

Shulman, Julius, *The Building of My Home and Studio*, Portland: Nazraeli, 2008

Smith, Elizabeth AT, *Case Study Houses: The Complete CSH Program 1945–1966*, principal photography by Julius Shulman, London: Taschen, 2009

Rosa, Joseph, *A Constructed View: The Architectural Photography of Julius Shulman*, essay by Esther McCoy, New York: Rizzoli, 1994

Thomas Struth

Emde, Annette, Thomas Struth, *Stadt- und Strassenbilder : Architektur und öffentlicher Raum in der Fotografie der Gegenwartskunst*, Marburg: Jonas, 2008

Kruszynski, Anette, Tobia Bezzola and James Lingwood (eds.), *Thomas Struth: Photographs 1978–2010*, texts by Armin Zweite (et al.), Munich: Schirmer/Mosel, 2010

Museum Photographs: Thomas Struth, essays by Hans Belting, Walter Grasskamp, Claudia Seidel, Munich: Schirmer/Mosel, 2005 (1993)

Reust, Hans Rudolf, and James Lingwood (eds), *Texte zum Werk von Thomas Struth*, Ulrich Loock, Benjamin HD Buchloh, Julian Heynen (et al.), Munich: Schirmer/Mosel, 2009

Sennett, Richard, *Thomas Struth: Unconscious Places*, Munich: Schirmer/Mosel, 2012

Thomas Struth: Making Time, text by Estrella de Diego, ex. cat., Madrid: Turner Publishing, 2007

'Thomas Struth interviewed by Mark Gisbourne' in Patricia Bickers and Andrew Wilson (eds.), *Talking Art: Interviews with Artists since 1976*, London: Art Monthly and Ridinghouse, 2007

Hiroshi Sugimoto

Camhi, Leslie, 'Time Traveller: Hiroshi Sugimoto Varies His Focus to Shed Light on History and Memory, Gods and Movie Palaces', *ARTnews*, vol. 98, no. 2, February 1999, pp 92–93

Hiroshi Sugimoto: Architecture, essays by Francesco Bonami, Marco De Michelis and John Yau, ex. cat., Chicago: Museum of Contemporary Art and DAP, 2003

Hiroshi Sugimoto: Architecture of Time, texts by Eckhard Schneider, Thomas Kellein and Hiroshi Sugimoto, ex. cat., Bregenz: Kunsthaus Bregenz, 2002

Hiroshi Sugimoto: Time Exposed, essay by Thomas Kellein, Stuttgart: H Mayer, 1995

Kojima, Yayoi, 'Art and Architecture: Hiroshi Sugimoto', *Casa Brutus,* Volume 4, no. 11, November 2003, pp 66–69.

Meinhardt, Johannes, 'Hiroshi Sugimoto: The Architecture of Time', *Kunstforum International* 157, November – December, pp 379 – 80

Morris Hambourg, Maria (et al.), *Sugimoto*, ex. cat., Houston: Contemporary Arts Museum, 1996

Hiroshi Sugimoto: Architecture, with texts by Francesco Bonami, Marco de Michelis and John Yau, ex. cat., Chicago: Museum of Contemporary Art, 2003

Tsukihashi, Osamu, 'Art × Architecture — Hiroshi Sugimoto', *Kenchiku Note*, no. 3, August 2007, pp 38–47

Guy Tillim

Badsha, Omar (ed.), *Amulets & Dreams: War, Youth & Change in Africa*, photographs by Guy Tillim, text by Julia Maxted, foreword by Amara Essy, Pretoria: SAHO, ISS, UNISA Press, 2002

Diserens, Corinne (ed.), *Contemporary African Photography from the Walther Collection: Appropriated Landscapes*, Göttingen: Steidl, 2011

Garb, Tamar, *Figures & Fictions: Contemporary South African Photography*, Göttingen: Steidl and V&A Publishing, 2011

Tillim, Guy, *Leopold and Mobutu*; text by Adam Hochschild, Trézélan: Filigranes, 2004

Tillim, Guy, *Jo'burg*, Trézélan: Filigranes, 2005

Tillim, Guy, *Congo Democratic*, Cape Town: Renate Wiehager and Michael Stevenson Gallery, 2006

Tillim, Guy, *Avenue Patrice Lumumba*, with texts by Robert Gardner and Guy Tillim, Munich: Prestel, Peabody Museum of Archaeology and Ethnology, Harvard University, 2008

Tillim, Guy, *Second Nature*, afterword by Els Barents, Munich: Prestel, 2012

Authors' Biographies

David Campany

David Campany is a writer, curator and artist. His books include *The Open Road: Photographic Road Trips in America* (Aperture, 2014); *Walker Evans: the magazine work* (Steidl, 2014), *Jeff Wall: Picture for Women* (Afterall/MIT Press, 2011) and *Photography and Cinema* (Reaktion, 2008). Recent curatorial projects include 'Victor Burgin: A Sense of Place' (Ambika P3, London, 2013) and 'Lewis Baltz: Common Objects' (Le Bal, Paris 2014). He teaches at the University of Westminster, London.

Owen Hatherley

Owen Hatherley is a freelance writer on architecture and cultural politics, and writes regularly for *The Architectural Review*, *Building Design*, *Icon*, *The Guardian* and *New Humanist*. He is the author of *Militant Modernism* (Zero, 2009); *A Guide to the New Ruins of Great Britain* (Verso, 2010); *Uncommon — An Essay on Pulp* (Zero, 2011); and *A New Kind of Bleak — Journeys through Urban Britain* (Verso, 2012). He received a PhD from Birkbeck College in 2011.

Sarah Ichioka

Sarah Ichioka is a cultural leader, curator and innovator with a passion for cities and their potential. She currently leads an initiative about intentional communities in urban America. Her previous positions include six years as Director of the Architecture Foundation in London, and key roles at Tate Modern, the Venice Biennale, the LSE's Urban Age project, and NYC's Department of Housing. In 2013 she was recognised as one of the Global Public Interest Design 100 and became an Honorary Fellow of the RIBA.

Justin Jaeckle

Justin Jaeckle is an independent curator, writer and artist who explores contemporary culture through criticism, exhibition-making and other diverse projects. He has worked with institutions including the Tate, the V&A and the Design Museum, London, and published and exhibited across multiple platforms. In 2009, as former Curator of Public Programme at the Architecture Foundation in London, he established the ongoing Architecture Foundation/Barbican season 'Architecture on Film'.

Kobena Mercer

Kobena Mercer teaches and writes on modern and contemporary art in the Black Atlantic diaspora and is Professor of History of Art and African American Studies at Yale University. He is series editor of Annotating Art's Histories, whose titles include *Cosmopolitan Modernisms* (MIT Press, 2006) and *Exiles, Diasporas & Strangers* (MIT Press, 2008). He also contributed the chapter on contemporary art to *The Image of the Black in Western Art* (Belknap Press, 2014).

Eleanor Nairne

Eleanor Nairne is the Curator of Collection and Public Programmes at Artangel. A regular contributor to *frieze*, she has organised conferences including 'Practice, Performance, Pedagogy' at Salt, Istanbul (2013); written catalogue essays, such as for *Self Portrait* at the Louisiana Museum (2012); edited publications, most recently *Yael Bartana: And Europe Will be Stunned* (2012); curated exhibitions, such as 'Making a Scene' at Southampton City Art Gallery (2011); and presented television programmes, including the *Your Paintings* series for BBC2 (2012). She holds an MA in Art History from the Courtauld Institute of Art.

Alona Pardo

Alona Pardo is Associate Curator at Barbican Art Gallery. She has worked closely on a number of critically acclaimed exhibitions and publications including 'Everything Was Moving: Photography from the 60s and 70s' (2012, catalogue published by Barbican Art Gallery); 'Watch Me Move: The Story of Animation' (2011, catalogue published by Merrell); 'The Surreal House' (2010, catalogue published by Yale University Press) and 'Colour After Klein' (2005, catalogue published by Black Dog Publishing). She has contributed widely to art magazines and books, including *Vitamin Ph* (Phaidon Press, 2006).

Elias Redstone

Elias Redstone is a curator, writer and editor. He is the author of *Shooting Space: Architecture in Contemporary Photography* (Phaidon Press, 2014) and the curator of the international touring exhibition 'Archizines'. He has served as a curator of the London Festival of Architecture and the Polish Pavilion at the 2010 Venice Architecture Biennale, and was Senior Curator of the Architecture Foundation in London. He is the Editor in Chief of the London Architecture Diary and was a Contributing Editor for *GQ Style* and *Arena Homme Plus*.

Julian Stallabrass

Julian Stallabrass is a writer, photographer, curator and lecturer. He teaches Art History at the Courtauld Institute of Art, and is the author of *Art Incorporated* (Oxford University Press, 2004). He is the editor of *Documentary*, in the MIT/ Whitechapel Documents of Contemporary Art series (MIT Press, 2013); and *Memory of Fire: Images of War and the War of Images* (Photoworks, 2013).

Credits

Image credits

p 3, p 29 (middle), pp 45–51: © Berenice Abbott/Getty Images. Courtesy of Howard Greenberg Gallery

p 7, p 31 (top), pp 72–79: © J. Paul Getty Trust. Used with permission. Julius Shulman Photography Archive, Research Library at the Getty Research Institute (2004.R.10)

p 11, pp 171–175: Courtesy of Hélène Binet

p 25, pp 181–185: Courtesy of Hiroshi Sugimoto

p 27: Harry Ransom Center. The University of Texas at Austin

p 28 (top, middle and bottom), p 29 (top): © David Campany

p 29 (bottom): © Walker Evans Archive, The Metropolitan Museum of Art

p 30 (top), pp 58–67: Library of Congress, Prints & Photographs Division, FSA/OWI Collection

p 30 (top): [LC-USZ62-34380]; p 58: [LC-USF342-T01-000890-A]

p 59: [LC-USF342-T01-001165-A]; p 60: [LC-USF342-T01-008256-A]

p 61: [LC-USF342-T01-008054-A]; pp 62–63: [LC-USZ62-34380]

p 64: [LC-DIG-fsa-8c52874]; p 65: [LC-USF342-T01-008224-A]

p 67: [LC-USF342-T01-008039-A]

p 30 (middle), pp 141–149: © Thomas Struth

p 30 (bottom), p 33 (top), pp 124–135: © Stephen Shore. Courtesy of the artist, 303 Gallery, New York, and Sprüth Magers Berlin London

p 31 (bottom): Courtesy of Architectural Review

p 32 (top): © MIT 1972

p 33 (bottom): © Lewis Baltz, courtesy Galerie Thomas Zander, Cologne

p 34, pp 110–119: Courtesy of Hilla Becher and Sprüth Magers Berlin London

p 35: ©DACS 2014. Courtesy of Thomas Ruff and David Zwirner Gallery, New York/London

p 36 (top): Courtesy of Rut Blees Luxemburg

p 36 (bottom): Courtesy of Adam Broomberg and Oliver Chanarin

p 37 (top and second to top): © Victor Burgin

p 37 (second to bottom): © Jeff Wall / White Cube

p 37 (bottom): Courtesy of Polly Braden

p 38: Courtesy of Jules Spinatsch

pp 56–57: Walker Evans, photographer, Library of Congress, Prints & Photographs Division, [LC-USZ62-103097] © Walker Evans Archive, The Metropolitan Museum of Art

pp 85–91: Lucien Hervé. © J. Paul Getty Trust ©FLC-ADAGP, Paris and DACS, London 2014

pp 92–93: © Lucien Hervé, Paris

pp 98–105: © Ed Ruscha. Courtesy of the artist and Gagosian Gallery

pp 155–165: © 2014 Eredi Luigi Ghirri

pp 190–193: Courtesy of the artist and Thomas Dane Gallery, London. Frank Lloyd Wright's Martin House Complex. Courtesy of the Martin House Restoration Corporation

p 195: Courtesy of the artist and Thomas Dane Gallery, London. Reproduced by permission of the Department of Cultural Affairs, City of Los Angeles

pp 201–205: Andreas Gursky / VG Bild-Kunst / DACS 2014. Courtesy Sprüth Magers Berlin London

pp 210–217: Courtesy of Simon Norfolk

pp 222–229: © Guy Tillim. Courtesy of Stevenson, Cape Town and Johannesburg

pp 234–241: Courtesy of Bas Princen

Cover image, pp 246–253: © Nadav Kander, courtesy of Flowers Gallery

pp 258–267: Image courtesy of the artist and Perry Rubenstein

Acknowlededgments

We would like to extend our special thanks to the following individuals and institutions for their invaluable support and guidance with the exhibition research, development and realisation:

Gen Aihara
Cristian Alexa, 303 Gallery, New York
Mike Althorpe, RIBA Public Programmes Manager
Martine d'Anglejan-Chatillon, Thomas Dane Gallery, London
Federica Angelucci, Stevenson, Cape Town
Meredith Bayse, Perry Rubenstein Gallery, Los Angeles
Beverly W. Brannan, Library of Congress, Washington DC
Alison Brashaw, Laumont Labs, New York
Valeria Carullo, The Robert Elwall Photographs Collection, RIBA British Architectural Library
Sebastian Coles
Jessica Collins
Sean Corcoran, Museum of the City of New York
Amy Dickson, National Galleries of Scotland and Tate
Chris Durham
Maria Fontana, Eredi Luigi Ghirri, Reggio Emilia
Pedro Gadanho, Museum of Modern Art, New York
Adele Ghirri, Eredi Luigi Ghirri, Reggio Emilia
Isabelle Godineau, Fondation Le Corbusier
Elizabeth Grant, RIBA
Leta Grzan, Gagosian Gallery, Beverly Hills
Benjamin Handler, Gagosian Gallery, Beverly Hills
Andrew Hansen, Prestel, Munich/London
Judith Hervé, Fondation Lucien Hervé, Paris
Andrew Higgott
Michael Hoppen, Michael Hoppen Gallery, London
Nancy Lieberman, Howard Greenberg Gallery, New York
Chris Littlewood, Flowers, London
Michael Mack, MACK
Virginia Mokslaveskas, Getty Institute
Anne Caroline Müller, Atelier Thomas Struth
Sebastian Nevols, Nadav Kander Studio
Stephen Pinson, New York Public Library
Alan Rapp
Elli Resvanis, Thomas Dane Gallery
Michel Richard, Fondation Le Corbusier, Paris,
Alyson Rolington, National Galleries of Scotland and Tate
Jeff L. Rosenheim, The Metropolitan Museum of Art
Justine Sambrook, The Robert Elwall Photographs Collection, RIBA British Architectural Library
Katie Schultheis, Perry Rubenstein Gallery, Los Angeles
Andrew Silewicz, Sprüth Magers, Berlin/London
Jessica Smuts, Stevenson Gallery, Cape Town
Dr Marina Spunta, University of Leicester
Ed Spurr, Matthew Marks Gallery, New York
Deborah Straussman, New York Public Library
Jessica Temple, Gagosian Gallery
Zoe Tomlinson, Nadav Kander Studio
Alessandra Trainiti
Annette Völker, Sprüth Magers, Berlin/London
Gary Waterston, Gagosian Gallery
Véronique Warburton, Michael Hoppen Gallery
Anna Wall, The Metropolitan Museum of Art, New York
Anabel Wold, 303 Gallery, New York
Timothy Wray

Imprint

Official copyright © 2014 Barbican Centre, City of London. The Authors and Artists.

First published 2014 by Prestel Publishing Limited in association with Barbican Art Gallery on the occasion of the exhibition 'Constructing Worlds: Photography and Architecture in the Modern Age', curated by Alona Pardo and Elias Redstone

25 September 2014 – 11 January 2015

Barbican Art Gallery
Barbican Centre
Silk Street
London EC2Y 8DS
barbican.org.uk

Exhibition

Exhibition curated by Alona Pardo and Elias Redstone
Assistant Curator: Ana Martinez
Exhibition Assistants: Anna Ferrari and Tatjana LeBoff
Curatorial Interns: Emily Sack, Mairia Evripidou

Exhibition Design: OFFICE; Kersten Geers, David Van Severen

Exhibition Graphic Design: Stefi Orazi Studio
and Atelier Dyakova

Publication

Prestel Verlag, Munich
A member of Verlagsgruppe Random House GmbH

Prestel Verlag
Neumarkter Strasse 28
81673 Munich
Tel. +49 (0)89 4136-0
Fax +49 (0)89 4136-2335
www.prestel.de

Prestel Publishing Ltd.
14–17 Wells Street
London W1T 3PD
Tel. +44 (0)20 7323 5004
Fax +44 (0)20 7323 0271

Prestel Publishing
900 Broadway, Suite 603
New York, NY 10003
Tel. +1 (212) 995-2720
Fax +1 (212) 995-2733
www.prestel.com

Library of Congress Control Number is available; British Library Cataloguing-in-Publication Data: a catalogue record for this book is available from the British Library; Deutsche Nationalbibliothek holds a record of this publication in the Deutsche Nationalbibliografie; detailed bibliographical data can be found under: www://dnb.d-nb.de

Prestel books are available worldwide. Please contact your nearest bookseller or one of the above addresses for information concerning your local distributor.

Project management: Lincoln Dexter
Editing: David Jenkins
Production: Andrea Cobré
Design and layout: Stefi Orazi Studio
Origination: Repro-Ludwig, Zell am See, Austria
Printing and binding: Appl aprinta, Wemding

Printed in Germany

Verlagsgruppe Random House FSC® N001967
The FSC®-certified paper Profibulk
was produced by Sappi, Ehingen

ISBN 978-3-7913-8115-2

Cover image: Nadav Kander
Fengjie III (Monument to Progress and Prosperity), Chongqing Municipality, 2007

p 3: Berenice Abbott
Rockefeller Center, New York City, 1932

p 7: Julius Shulman
Case Study House #22 (Pierre Koenig, Los Angeles, California), 1960

p 11: Hélène Binet
Jewish Museum Berlin, Daniel Libeskind, Untitled 12, July 1997

p 25: Hiroshi Sugimoto
Guggenheim Museum, New York (Frank Lloyd Wright), 1997